The Art of WILL MACLEAN

Donald and Isobel
with many thanks
and best wishes

Will and Marian

Tayport 2014.

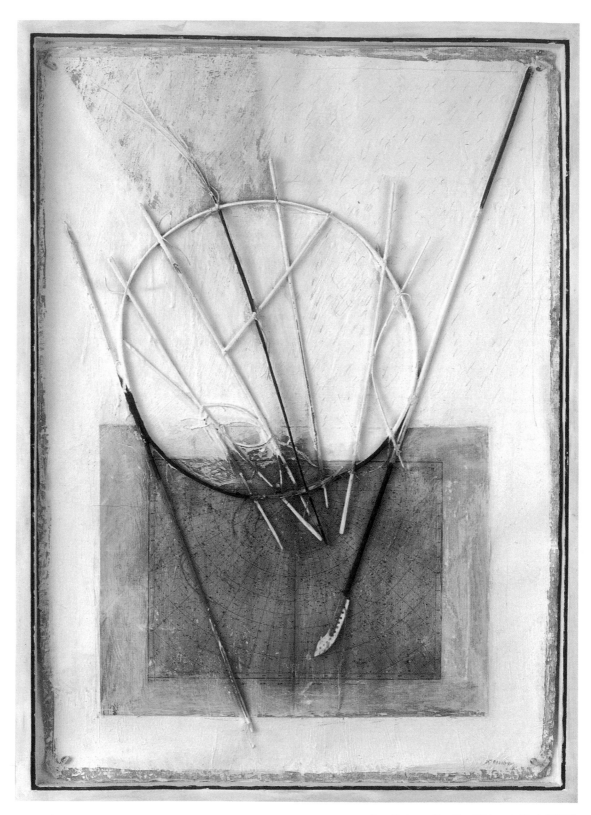

Frontispiece, *Star Chart/ Shaman Circle* (1998)

The Art of Will Maclean

Symbols of Survival

by

Duncan Macmillan

ART FIRST CONTEMPORARY ART

LONDON & NEW YORK

In association with

MAINSTREAM
PUBLISHING

EDINBURGH AND LONDON

First published in Great Britain 1992 by
MAINSTREAM PUBLISHING COMPANY (EDINBURGH) LTD
7 Albany Street
Edinburgh EH1 3UG

This edition published by Mainstream Publishing, Edinburgh and Art First, London, 2002

ISBN 1 84018 689 5

Reprinted and updated, 2002

A catalogue record for this book is available from the British Library

Typeset in Stone
Printed by The Bath Press

Photographic Credits
Prudence Cumming: Plate 43
Joe Rock: Plates 1, 2, 3, 5, 10, 22, 60, 76, 78, and 89
Colin Ruscoe: Portrait of the artist, Plates 19, 39, 84 and 86
Tom Scott: Plates 15 and 16
Aberdeen Art Gallery: Plate 58
National Gallery of Scotland: Plate 51
Robert Fleming Holdings Plc: Plate 81
Rik Sferra: Plates 90–96
Antonia Reeve: Plate 124
Rod Huckbody: Plate 104
Todd White Photographers: Plates 98, 101, 117, 113
Stornoway Gazette: Plate 104

– CONTENTS –

– ACKNOWLEDGEMENTS –

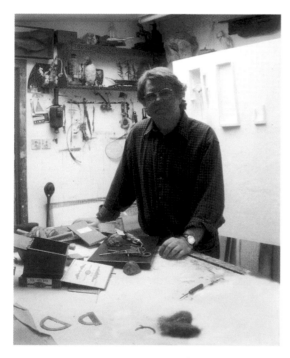

The artist in his studio
Photograph by Colin Ruscoe, 2001

Neither this book, nor the previous edition would have been possible without the generous help of the artist and his wife, Marian, and so I extend to them once again my very grateful thanks for all they have done. The artist himself also wishes to join me in extending our warmest thanks to Mrs Reenie MacLean for so kindly giving her permission to reprint here the touching and eloquent Foreword written by her late husband, Sorley MacLean, which was such an ornament to the first edition. The artist also wishes to express his own particular gratitude for the Creative Scotland Award made to him by the Scottish Arts Council in 2000, which helped make possible some of his most ambitious recent work, and also his appreciation of the support given to him by the University of Dundee. He also wishes to join me in thanking the photographer Colin Ruscoe for the work he has done in providing so many of the additional plates and, too, above all in thanking Clare Cooper and Geoffrey Bertram of Art First without whose help this new edition could not have been published.

Duncan Macmillan

– FOREWORD –

BY SORLEY MACLEAN

I was greatly honoured to be asked to write a foreword for the admirable book that Duncan Macmillan had written for Will Maclean's exhibition this summer.

The book contains a fascinating account of his own family's influence on Maclean, and especially of his father's influence. Captain John Maclean was a man who impressed me very much on the few occasions that I met him, which was at the Gaelic Society of Inverness. I did know William Reid when he was a pupil at Portree High School before the war and I liked him very much; and from a very early age I heard most favourable opinions of the Reids in general from Raasay and Braes men who were members of the crews of their fishing boats. I vividly remember the (to me) almost legendary *Star of the Sea* putting in during a very high tide at the natural jetty at Osgaig in Raasay. [William Reid was the artist's uncle and is commemorated in *Skye Fisherman: In Memoriam. Star of the Sea* was his grandfather's boat.]

We are fortunate in having Will Maclean, and Will himself is fortunate in having such an able, learned and enthusiastic interpreter as Duncan Macmillan, whose tastes are catholic and who is acutely aware, as Will himself is, that the local and contemporary and the present, and near and very near distant past are in many ways continuous, and that the local and parochial are often poignant and universal. Macmillan puts the essential qualities of Maclean's art splendidly very early in his book: 'His art . . . is not nostalgic or self-pitying; rather it draws strength from the qualities and the continuity of Highland culture, while seeking universal and contemporary metaphors from it and from the tragedy of Highland history. He should also be seen in the tradition of the Scots Renascence, however, in the way that his art relates the history and traditions of Scotland to the objectives of modernism', and, again, 'his realisation that art is not a remote, abstract and self-contained entity, but a way of reflecting on life's concerns, both immediate and wider'.

Macmillan's account of his range and development is admirable, not least in the way he brings out the complexity and subtlety of Maclean's work, with its social realism transmuted with immanent and religious and surrealist images, sometimes against a background of geology and archaeology, which adds to their universality and timelessness. To make a metaphor or another image a symbol, and to do that unobtrusively

or, as it were, unconsciously, is to my mind a mark of great natural power in any art. Among other things, I think of the way it happens, as it were artlessly, in the poetry of Mary MacDonald (Mrs MacPherson), who died in 1898, a woman of great vitality and even *joie de vivre*, who is the most individual of all the Gaelic poets moved by the Clearances and the Land League. Macmillan goes on to say that there came to Maclean the 'realisation that it should be possible to record real experience without curtailing the poetic resonance of an image, or its power to suggest'.

The book is a most perceptive and sympathetic study of the art of a man who is consciously and unconsciously aware of the philosophy, literature and visual art that Scotland has encountered and produced from the Enlightenment and Scottish Renascence to the present day; of a man passionately concerned with the whole history of his country, especially with its tragedy, and which transcends 'any lines of territorial demarcation of the arts'. Never has a common ground between art and poetry been more necessary than it is today, but that necessity is timeless and universal.

Sorley MacLean
May 1992

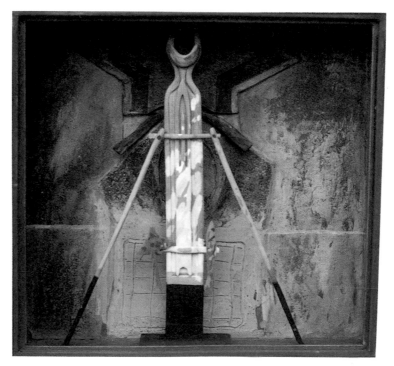

1. *Star of the Sea* (1983)

– THE ART OF WILL MACLEAN –

SYMBOLS OF SURVIVAL

William McTaggart was the greatest Scottish artist to come from the Highlands in modern times. He was also one of the very few. The reason for this certainly has nothing to do with talent. The Gaelic poets who have flourished over the same period are witnesses to this. Art is a more urban business than poetry and also, for virtually the whole of the modern period – the period in which art has flourished in the main cities of Scotland – life in the Highlands has been chronically dislocated.

The Celtic tradition in a broader sense has however played a significant part in the inspiration of a good many artists since the eighteenth century. For instance, J.D. Fergusson and William Johnstone, the two key figures in the history of modern art in Scotland, both stressed the importance to them of their identification with the Celtic past. Following Fergusson too, Ian Finlay based his history of art in Scotland on the thesis of racial continuity with the Celts[1] and it was an important element in the Scots Renaissance of the 1920s and 1930s. Nor was J.D. Fergusson's identification with the Highland tradition merely whimsical. It was based on the fact that his father was a Highlander and that there were Gaelic

speakers in his family, although he himself was brought up in Leith. It was serious enough to bring him to settle in Glasgow in 1939, which he regarded as a Celtic city, and it led him to take a lively interest in Gaelic tradition.

For all these artists though, except for McTaggart, Celtic or Highland culture was a generalised thing. Their interest was shaped more by their knowledge of the artistic achievement of the ancient Celts than by their understanding and appreciation of the modern Highlanders. McTaggart, on the other hand, came to comment directly on the present Highland situation at the end of his life in his remarkable series of paintings of the *Emigrants* and *The Emigrant Ship*.

Will Maclean is from a Highland background as McTaggart was. His commentary on the Highland situation is first hand too, and although like Fergusson he is not a Gaelic speaker, he has always been close to the present life of the Highlands. Indeed, his art has been shaped by this, though, as with the poetry of Sorley MacLean whom he greatly admired, this is not a limitation. It is not nostalgic or self-pitying; rather it draws strength from the qualities and the continuity of Highland culture, while seeking universal

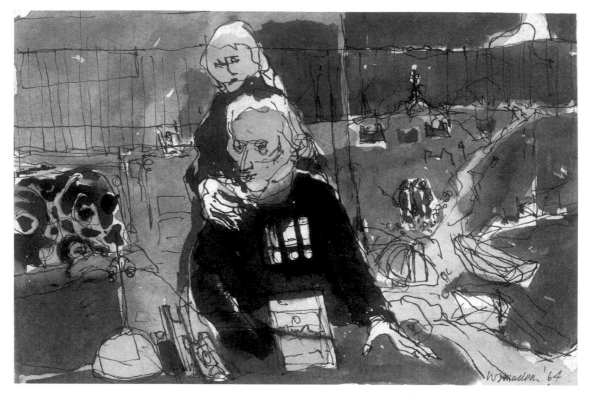

2. Study for painting of the Clearances (1964)

and contemporary metaphors from it and from the tragedy of Highland history. He should also be seen in the tradition of the Scots Renaissance, however, in the way that his art relates the history and traditions of Scotland to the objectives of modernism. It should therefore be seen alongside that of Paolozzi, Davie and Bellany.

It took him a while to reach that position and he had been working for almost ten years before he began to produce work which he now recognises as reflecting his real ambitions as an artist, though, as artists often are, he is perhaps a little hard on his early work. Certainly he describes his experience of art training as a little like maths at school. It was something you had to learn. It was difficult, but to do it at all, it

had to be done well, or it was simply wrong. In a way, his development as an artist has been the unlearning of that attitude and its replacement by the realisation that art is not a remote, abstract and self-contained entity, but a way of reflecting life's concerns, both immediate and wider.

Maclean was brought up in Inverness where his father, John Maclean, was harbour master. John Maclean had been brought up in the fishing-crofting community of Polbain in Coigach. It was a Gaelic-speaking world, largely self-sufficient, but sadly also the last community to cultivate what is now fallow land. He has left a vivid account of it in a manuscript memoir of his childhood and family history. Like most of his generation there, he only learned English when he went

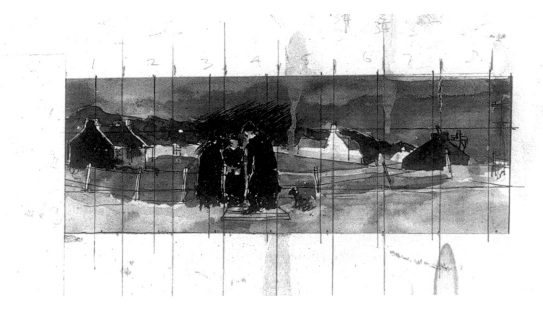

3. Study for a projected painting of the Clearances (1964)

to school and his memoir recalls a world that was vigorous and carefree even though material property was minimal and luxury unknown. It was, too, a world in part still regulated by custom and mutual help. As he looked back on it near the end of his life, it had the quality of a golden age and as such had a powerful effect on his son's imagination.

From Coigach, John Maclean went to sea. He trained as a wireless operator in Glasgow, but later, after a time as a deck-hand, he took his mate's ticket and, by then a Master Mariner, ended up in Inverness in charge of the harbour. John Maclean died in 1962, but his son's memory of him and above all his sense of the link that existed through him, back into the world of Gaelic culture that seemed to pass with his generation, has been a primary motive in his art. It is as though, through it, he could build a bridge back into that disappearing world. Indeed his mature art is informed above all by this and it reflects on the history of the Highlands and the seagoing tradition of his family there. That he has managed to build out of this an art that is of

universal relevance is a measure of his stature as an artist.

To follow in his father's footsteps and go to sea himself was Will Maclean's first ambition, however, and he began his career at the age of fifteen when he went to train for the merchant navy at HMS *Conway*. He then became an apprentice with the Blue Funnel Line and spent two years at sea, but his career as a sailor was cut short when he failed an eye-test. He had to think again and returned to Scotland to take Highers, studying for a year in Edinburgh. His choice was between art and gymnastics, the two subjects that had been his best at school, but while he was studying in Edinburgh, he went to evening classes at Edinburgh College of Art and his career as an artist began. When he went for the entrance examination for the Edinburgh College though, he was asked to draw a lady in a crinoline. He had never drawn the draped figure. All he had drawn all year was the nude. He was completely thrown and it was only afterwards that he discovered that he had been in the wrong class all year. However, in spite of this fiasco at Edinburgh, he was

accepted at Gray's School of Art in Aberdeen.

As it was at Edinburgh, the curriculum at Gray's was still highly structured. Ian Fleming was Principal, but Henderson Blyth was head of painting and it was reflecting on the situation in the painting school that Maclean produced his comparison between art and maths. Nevertheless, he speaks very warmly of his time at Gray's and of the way that the people who taught him there – Ian Fleming, Frances Walker, George Mackie, David Foulkes, Fred Stiven – supported him and remained his friends. He remembers still, not only the kindness, but also the experience of seeing the houses of Mackie, Stiven and Foulkes, a new kind of environment to him, filled with art-works and treasured objects as his own house is now.

The school also provided opportunities for students to travel to see exhibitions in Edinburgh, Glasgow or London. In Edinburgh too, he had friends at the College so he was conscious at first hand of the defiance of the establishment by his contemporaries, Sandy Moffat and John Bellany, in their exhibition on the railings outside the National Gallery in 1964. The significance of this was not just in the dramatic gesture. It was in Bellany's proposal that there was a place in painting for social subject matter of a kind that reflected the reality that the artist shared with his own community. Maclean's own work, though, was still shaped more by the stimulus of his immediate artistic environment. Surviving landscapes show his affinity to Fleming and Mackie, but also in his later work, he has remained loyal to Fleming's underlying conviction of the social involvement of art, so clearly seen in the older artist's etchings.

Most of Maclean's work at the time was landscape, however, and in a way his art has developed from that premise, for it is still very much concerned with places, with environments and the people in them. Perhaps it is landscape seen in more than just three dimensions and in that respect, though from a different angle, it is comparable to Frances Walker's economical and unsentimental vision of the underlying facts of the landscape of Scotland. Even as a student, however, he already had an interest in Highland issues, though at the time this was expressed in his art in social realism rather than symbolism.

Maclean spent the summer of 1964 at Hospitalfield. Willie Reid was still the teacher there and David McClure was the visitor, but the most important thing was the freedom and the sharing of experience with new friends in the other art schools. For instance, he and George Donald, who was at Edinburgh, taught themselves to etch. To do this they reassembled, by trial and error, E.S. Lumsden's press which was lying dismantled in a shed. At that time, etching was not an approved part of the painting curriculum, but in this and in other ways the experience of Hospitalfield broadened his outlook. He has continued to etch ever since and indeed some of his most important work has been in that form.

In spite of the example of such people as Fleming and Walker, at Gray's, says Maclean, 'Art was forced to labour in the mines of life-painting', and in this academic tradition, for their diploma shows students had to produce a large-scale, figure composition with at least three figures. Maclean's painting was prophetic of one of the central themes of his later art, the tragic history of the Highlands. It was a picture of the Clearances. It no longer survives, but its genesis is recorded in a number of drawings (*Pl. 2 & 3*). Stark and monochromatic, these are quite unsentimental.

It is not surprising that he should turn to this sad history for a subject. For in his manuscript family history, his father remarks:

There are many these days who say that

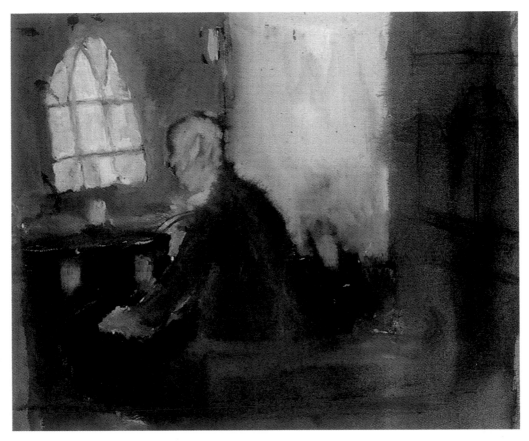

4. *Minister Preaching in the Kirk at Achiltibuie* (1964)

the Clearances should be forgotten and the hatchet buried, but I do not take that view. I think it should be kept alive and every Highlander should have copies of the histories of the Clearances along with the Bible in his bookcase. It is not right that the Clearances should ever be forgotten.

True to his father in two ways, Maclean seems to be contemplating the tragic sense of the loss of a land and its people and the wrong done to them, and at the same time the remarkable way in which the persecuted Highlanders still found dignity even within their diminishing resources, a dignity of which his own art is a continuing assertion.

One of the drawings related to this composition is of the minister preaching in the church at Achiltibuie (*Pl. 4*). It is a drawing worthy of Wilkie in its terseness. The church was leaking and the monochrome washes of the drawing reflect the cold and the damp and, by extension, the fact that there is little comfort in such a religion. Organised religion failed the Highlanders as their ministers betrayed them, but perhaps their religion reflected their reality nevertheless. Recognition of man's ineffectuality in controlling his fate and of God's arbitrariness in dispensing it is the measure of the realism of the Calvinist belief. It is not a creed of false comfort. It matches the harsh reality of a northern existence, just as the brutality of the Clearances is matched by the harshness of the Highland environment. Maclean has never

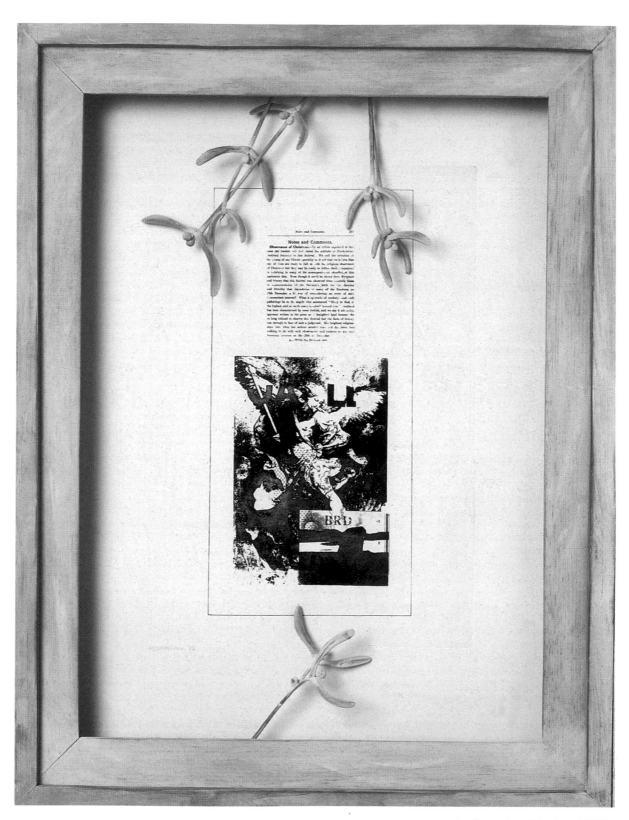

5. *Observation of Christmas* (1982)

forgiven the life-denying joylessness of the Free Kirk though. Many years later, for instance, he made a work, *Observation of Christmas* (1982, *Pl. 5*). Its centrepiece is a text warning against the celebration of the feast and, summoned by the Kirk's fulminations, an avenging angel is descending on Skye to chastise those foolhardy enough to find pleasure in it.

A constant theme in Maclean's later work is religion, though not always in such a specific and satirical way as in *Observation of Christmas*. It is more often present by implication through the analogy suggested between the objects that he makes and the objects made in the service of religion. He sees continuity from earliest times in a people's spiritual need for some kind of mediation between themselves and the natural world, expressed in a material form. In *Observation of Christmas*, this is present in a piece of carved mistletoe, linking modern Christmas to its pre-Christian origins, and elements of this kind, that are already present in this early drawing with its religious subject, often reappear subsequently.

For instance, in the drawing, beyond the minister, is the church window. In Maclean's later work, windows became a metaphor for the art work itself, allowing us to move between the real and the imaginative or spiritual, as this church window opens on to the landscape beyond. Behind the minister, too, is a board carrying a text. It is not legible, but the fact that it is even minimally carved and shaped identifies it as a religious object in a way that reaches far beyond the severe limitations of the Presbyterian tradition (*Pl. 6*). It is after all only one of many religions that may have prevailed amongst the Highland people. Each in its turn must have met their needs and as he invokes religion, Maclean comments on this underlying continuity even while he implicitly condemns the barrenness of the Free Kirk.

6. Study of Kyleakin Church Interior (1965)

Maclean graduated from Aberdeen in 1965 and spent the following year, 1966–7, on a travelling scholarship which took him to France, Italy and Greece. He himself remarked of his work of this period: 'When you grew up you were expected to become an "abstract" artist.' It sounds a bit like progressing to the wearing of long trousers and a group of paintings done on Mykonos does indeed show him working to develop a more abstract language from an observed scene. The work from this travelling year is still recognisably landscape though, and other surviving works include some beautifully economical drawings of Venice. This work was so much more overtly modern

than what he had been doing at Aberdeen, however, that, when he returned to Gray's to report on his travels, it met with little approval from Henderson Blyth.

One of the most important things that happened to him during this year abroad, and which has left a lasting impression on his art, was his discovery of archaeology. While he stayed for three months at the British School in Rome, he became friendly with the archaeologists there and was introduced by them to their subject. He visited Etruscan and early Christian sites in their company and learned the basic techniques of investigation. This experience established an interest which has remained part of his inspiration to this day. He is a keen amateur archaeologist and objects still appear in his work whose origin can be traced back to this early stage of his interest in the subject.

His whole method too, at least since he began to make constructions, presents an analogy with archaeology in the way that it depends on buried meaning. In archaeology, objects whose use may originally have been trivial or matter-of-fact assume a significance when seen in context from which we can read something of a whole culture. His constructions often work in this way and frequently contain references, not only to genuine archaeological objects. He also invents material and often combines fact and fiction to make a reconstruction, reinvented from his imagination, of something that might have existed – an imaginary museum piece such as *Museum Casket* (1989, *Pl. 7*). He has always been interested in the special imaginative quality of museums. It is an interest that he has in common with Paolozzi and is as much a fascination with the startling and arbitrary associations of heterogeneous objects that museums display, as with the objects themselves. Paolozzi's major print, *Blue-Print for a New Museum*, gives expression to this idea.

Maclean's fascination with museums had begun with the little town-museum in Inverness. In Rome, it was the Etruscan museum at the Villa Giulia (which is near the British School) which particularly interested him. It is rich in collections of objects of great beauty, but whose uses record a whole range of the activities of daily life and he spent a lot of time there. Since then, he has transferred the imaginative impact of the mystery of the Etruscans to that of the vanished communities of the Highlands in which his own immediate forebears lived. It is a process of foreshortening similar to that which happened when, through *Ossian*, James MacPherson seemed to make direct contact with the remotest past through the memories of living people.

After returning from his travelling year, Maclean married his wife, Marian. She had a teaching post, while he spent some time working as an uncertificated teacher in schools around Aberdeen, before going on to teacher training in Dundee. For the next few years, he was finding his way artistically. He had inherited from his time at Gray's the idea that, in art's stern apprenticeship, a young artist should not expect any recognition for ten years. It was perceived as a kind of period of trial. By this formula, no one should have a one-person show in less than five years from graduation, but Maclean had his first exhibition at the 57 Gallery, Edinburgh, in 1968 and then a bigger one with Richard Demarco in 1970. His first show was favourably reviewed by Edward Gage and his second by Cordelia Oliver as well. He has always valued this early and continuing critical support and he sees the opportunity offered by these exhibitions as an important stage in his career. He is also one of many Scottish artists of his generation who look back with gratitude to Demarco for giving them the opportunity to establish their names in the

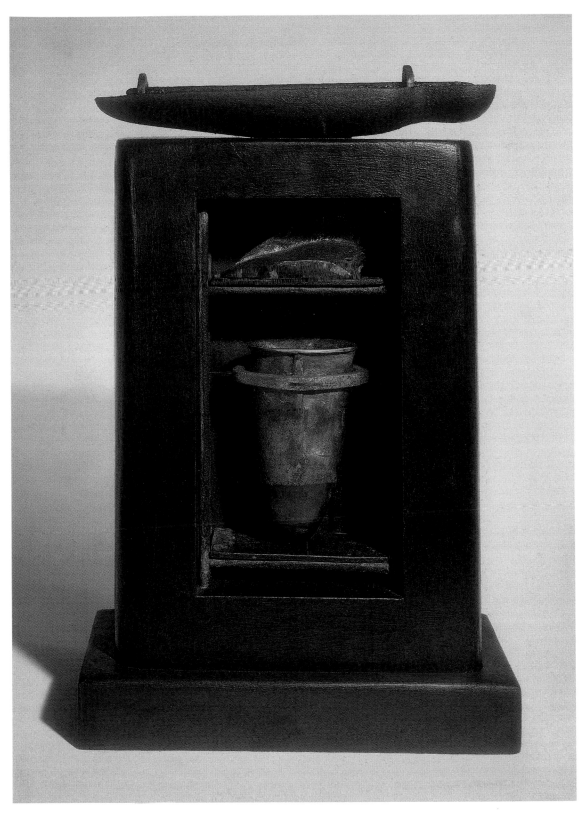

7. Museum Casket (1989)

public eye much sooner than academic convention would allow.

* * *

The work for this exhibition still reflected the prevailing artistic mood in Europe in the 1960s, however, and the idea that art was a self-contained process, though Maclean was already struggling with the unsatisfactoriness of this idea. The pop art movement was the beginning of a wider protest against such solipsism, but most of what was done in Britain in the name of popular culture was merely nostalgic and camp. It was only with such pioneers as Paolozzi that, by this route, art engaged again with any significant contemporary reality.

Subsequently Maclean's own art certainly linked up with the tradition represented by Paolozzi, and his later use of collected memorabilia and cultural artefacts as things that can be incorporated directly into an art work does perhaps reflect his origins in the art of the 1960s. The severity of Paolozzi's engagement was foreign to most artists, however, and Maclean's own first essays in a more modern idiom reflect rather the stylishness of Hockney and Allen Jones, though perhaps modified by Bellany's rather sterner example. He uses flat colours and semi-abstract shapes in which broad areas of continuous colour are contrasted to more agitated, brushed passages. This kind of art put style before content, even to the point where in Jones's art the extreme stylistic language of the fetishes of sado-masochism became a metaphor for the style of art itself.

In such moral confusion, it is under-standable that the problem of style and execution continued to trouble Maclean for a good many years and to stand between him and the realisation of meaning in his work. A different approach was offered by an important exhibition of Belgian Surrealism held in Edinburgh in 1971, however. The work of Magritte and others showed how forceful imagery could be on its own and how it could be used to set up a vivid internal drama without needing to fall back for support on the still discredited conventions of narrative. This exhibition followed the Magritte retrospective in London in 1969 and confirmed the importance of the alternative model that he offered.

For Maclean, the surrealist idea of the autonomous world of the imagination was also reinforced by reading Alain-Fournier's novel, *Le Grand Meaulnes*, around this time. (Meaulnes is the name of the principal character.) It is a novel about growing up, told through the eyes of one of the participants and against the changing perspectives of the transition from childhood to adolescence and manhood. It is told so well that it presents the possibility of the adult artist recapturing the vividness of childhood experience. To emulate the vision of children has for long been one of the objectives of modern art, but it is normally presented as the general idea of childhood. Alain-Fournier's book finds an echo in John Maclean's memoir of his childhood and it suggested to Maclean that, like Wordsworth, he could validly explore his own particular childhood experience. It suggested a way of re-entering its secret garden, an idea that has continued to inspire him as he has sought to recapture something of the imaginative power of the remembered images of his childhood and the mythic character with which memory clothes the people who inhabited it.

The imaginative contemplation of childhood experience can very easily be infused with a profound sense of loss: loss of innocence, loss of security, loss of loved ones; but for Maclean this universal sense of personal loss was compounded with his father's account of the loss of the world of

his own childhood. In this way it came to be incorporated into a larger sense of the loss entailed in the disappearance of the old way of life in the Highlands, whose people and culture were his background. From there he elaborated it into one of the fundamental themes of modern art, the opposition of innocence and experience – though in his later work it becomes increasingly apparent that these two things are inextricably intertwined and that this simple opposition cannot be sustained. Thus he was encouraged to turn again in his work of the early 1970s to the life and landscape of the Highlands, which he had already tackled in his diploma picture of the Clearances. His wide and individual reading has always been a source for the inspiration and information of his work. In the early 1970s, he began to collect books about the history and people of the Highlands and a book among these which had as profound an imaginative effect as Alain-Fournier's had done was Sir Archibald Geikie's *Scottish Reminiscences*.

Geikie was one of the pioneers of modern geology. It was he who identified and described the Ice Age, for instance. He produced a geological map of the Highlands and he was also, incidentally, a nephew of the artist Walter Geikie. His *Reminiscences* are a discursive account of his travels as a geologist in the Highlands over a period of sixty years, from the 1840s to the beginning of the twentieth century, the closing decades of the old Highlands.

He writes, as a scientist should, objectively and in a way that is quite free either of pomposity or of patronage, and his book is informed by the same sympathetic sharpness of observation as his uncle's art, but his observation also has an extraordinary depth. He sees the beleaguered people of the Highlands in the foreground, their life and language threatened by changes that they cannot control. He sees their gaiety and humour even in the face of impending tragedy and in spite of the dourness of their Church; beyond them he sees their ancient traditions, the memories of the greatness of their past and the extraordinary continuity of their culture preserved in popular memory. But beyond that too, his observation is informed by his under-standing as a geologist of an even greater continuity, the immense antiquity of the landscape itself, the framework of their history.

At one point in his *Reminiscences*, Geikie describes the pathetic scene of a village being cleared. It was a re-enactment of Wilkie's *Distraining for Rent* in its explicit injustice, for the clearance was in the interest of 'improve-ment' to redeem a wastrel landlord's debts. Geikie came across the scene by accident:

> One afternoon as I was returning from my ramble, a strange wailing sound reached my ears at intervals on the breeze from the west. On gaining the top of one of the hills on the south side of the valley, I could see a long and motley procession winding along the road that led north from Suisnish . . . There were old men and women, too feeble to walk, who were placed in carts; the younger members of the community on foot were carrying their bundles of clothes and household effects, while the children, with looks of alarm, walked alongside. There was a pause in the notes of woe as the last words were exchanged with the family of Kilbride . . . When they set forth once more, a cry of grief went up to heaven, the long plaintive wail, like a funeral coronach was resumed, and after the last of the emigrants had disappeared behind the hill, the sound seemed to re-echo through the whole wide valley of the Strath in one prolonged note of desolation. The people were on their way

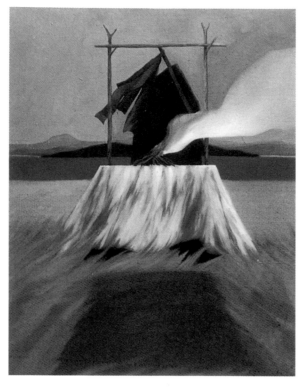

8. *Beach Allegory* (1973)

to be shipped to Canada. I have often wandered since over their solitary ground at Suisnish. Not a soul is to be seen there now, but the greener patches of field and the crumbling walls mark where an active and happy community once lived.[2]

He then goes on the recall his experience of the island of Raasay, already depopulated when he had first visited it:

When I paid my first visit . . . the crofters had only recently been removed; many of their cottages still retained their roofs, and in one of these deserted homes I found on a shelf a copy of the Bible wanting the boards and some outer pages. When I revisited the place a few years ago, only the ruined walls and stripes of brighter herbage showed where the crofts had been.[3]

The way that Geikie reports these images of desolation without embroidering them is very moving. In one man's lifetime, what is at first an eye-witness's account of a terrible spectacle of human suffering becomes history and then archaeology. One is reminded of Eliot's classic invocation of time in a landscape near the beginning of 'East Coker':

Houses live and die: there is a time for
 building
And a time for living and for generation
And a time for the wind to break the
 loosened pane
And to shake the wainscot where the
 field-mouse trots

20

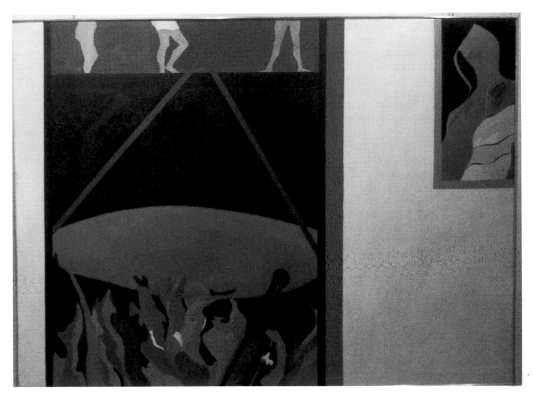

9. *Fisherman with a Broken Arm* (1973)

And to shake the tattered arras woven
with a silent motto.

Maclean did not need Geikie in order to
understand the history of the Clearances, but
Geikie's writing has an imaginative immediacy
whose inspiration reinforced his own interests.
He began to produce paintings in which a new
vision of the Highland landscape can be seen,
in which he has managed to achieve the same
unsentimental sense of tragedy and a similar
sense of time. Geikie's account of the dis-
possession of the people of Suisnish directly
inspired the painting *Beach Allegory* (1973, *Pl.
8*), one of the first in a series of works to follow
his diploma picture and which continues to
the present day with the Clearances for their
theme. Maclean's picture is an elegy. A fire is
burning on a kind of altar against a

background of a dark, deserted landscape, a
view of Borreraig. It is a spiritual fire, still
burning in a land bereft of its people. In
Highland River, Neil Gunn wrote about a heath
fire:

> The scent of a heath fire has in it
> something quite definitely primordial.
> Involuntarily it invokes immense
> perspectives in human time: tribes
> hunting and trekking through lands
> beyond the horizons of history.[4]

This is such a fire, though it is on an altar and
is not the heather burning. Maclean has
discovered and recreated a land peopled by
ghosts. The altar is within a kind of open
frame of wood, like a drying frame for fishing
nets, and on this is something resembling an

10. *Boarding Herring* (1973)

Etruscan funerary banner, a frequent motif in his later art, suggesting some kind of funerary rite. The way that the composition is roughly symmetrical round a central axis endorses this. It suggests that the arrangement is deliberate and formal as rituals are. The objects, too, suggest forgotten uses. It is as though the Bronze-Age people had returned, or never fully left; but perhaps also it is the artist performing a ritual of lamentation.

Significantly, Sorley MacLean had also found inspiration in Geikie's account of the clearance of Suisnish and had interpreted it in verse:

Bha mi latha an Srath Shuardail
agus thànaig gaior gu m'chluasan:
chuala mi corronach nan truaghan

a bha am Morair a'ruagadh
á Boraraig is Suidhisnis uaine
gu taobh eile nan cuantan.
Thug mi sùil air Dùis Mhicleòid
's cha do mheall a'bhriag mo bhròn.

I was one day in Strath Swordale
and a sore cry came to my ear:
I heard the coronach of the poor ones whom the
Baron was driving
from Borreraig and green Suisnish
to the other side of the oceans.
I looked at the land of MacLeod
and the lie did not deceive my grief.
(*The Cuillin*, VI)[5]

This parallel was the first reflection in Maclean's work of his feeling for Sorley

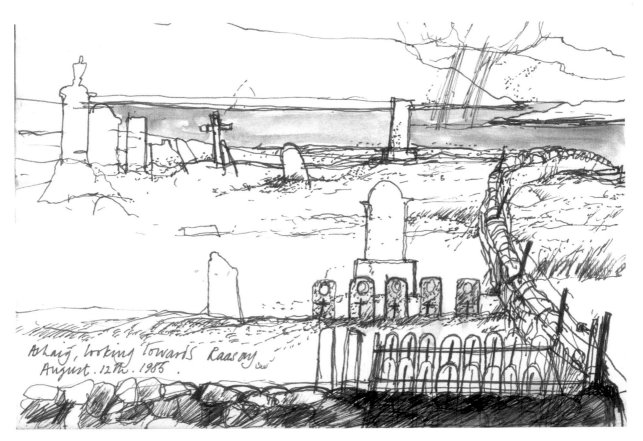

11. *View of Raasay from Ashaig*, page from a sketchbook (1985)

MacLean's poetry, which was to be both directly and indirectly a major influence on his art as it developed. Sorley MacLean's status as a Gaelic poet has remained an example for him in his own aspiration to create an art true to the Highland tradition. Indeed, one could compare Will Maclean's mature ambition as an artist to Sorley MacLean's account of his own intention in undertaking in 1938 his long poem, *The Cuillin*:

> I conceived the idea of writing a long poem . . . on the human condition, radiating from the history of Skye and the West Highlands to Europe and what I knew of the rest of the world.[6]

* * *

It took the artist some time to formulate this kind of ambition though, and to do so he drew not only on the past, but also on his own present experience of life in the Highlands. In the early 1970s, for instance, he worked on the fishing boats on the west coast during the summers and he recorded this directly in paintings such as *Fisherman with a Broken Arm* (1973, *Pl. 9*) and *Boarding Herring* (1973, *Pl. 10*). The first is a memory of Ullapool. The boat tied up at the pier after a long period at sea; the artist, tired and unwashed, is looking up from the dark and stinking hold to the light and the freshness of the girls on the pier.

This internal contrast, which is also a contrast between the sexes, suggests an affinity with the contemporary work of Neil

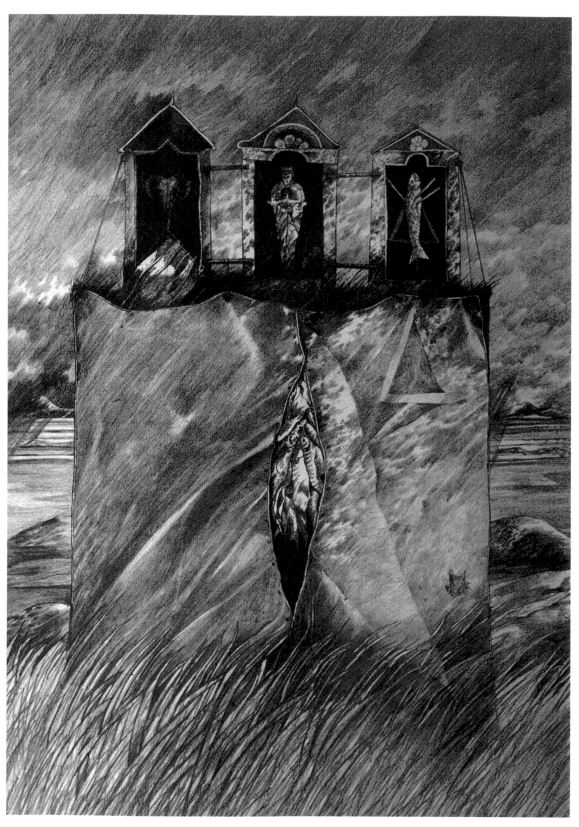

12. *Welcome to South Uist* (1981)

13. *Memorial to the Glendale Martyrs*, pencil study for the etching (1983)

Dallas Brown with whom Maclean became friendly at this time. He acknowledges the importance to him of Dallas Brown's facility as a draughtsman and Maclean's own works are based closely on drawing. These drawings can be simply notes in sketchbooks and diaries (*Pl. 11*), but from this time he also regularly produced highly finished drawings with a complex iconography. These finished drawings, such as *Welcome to South Uist* (1981, *Pl. 12*), or *Memorial to the Glendale Martyrs* of 1983 (*Pl. 13*), are also closely related to his etchings.

The fisherman with a broken arm was an individual whose arm was crushed between his boat and the pier and whose reaction to the incident was stoic indifference worthy of the legends of ancient Sparta or the American Indians – heroism among modern fishermen is not different in kind from that of the most ancient of times. It is an image of a man silhouetted by the cape and hood of his yellow oilskin, an image that recurred almost twenty years later in the collage, *Skye Fisherman: In Memoriam* (1989, *Pl. 42*), a memorial to the artist's uncle, William Reid. Another heroic image to appear in his painting at this time, and to recur much later, was that of the ship *San Demetrio*. Torpedoed in the war, terribly damaged and abandoned by her crew, she nevertheless remained afloat. Her crew came up with her again after they had unintentionally rowed the lifeboat in a circle and eventually managed to bring her into port. Maclean saw a film of her on his first visit to the cinema, taken there by his father. In a painting called *Eskimo Summer* (1975, *Pl. 14*), the torn metal of her damaged bow frames a landscape. (The title was made up by a friend because of this white igloo-shape when it was sent to exhibition untitled.)

The direct use of the people and the

14. *Eskimo Summer* (1975)

incidental details of the artist's own experience of the world of fishing and the sea is a link to John Bellany's work of the 1960s and 1970s. Bellany built on the experience of his own boyhood and family in Port Seton an iconography capable of suggesting universal themes. Within Maclean's own work though, this subject matter, dependent on his own first-hand experience, was still separated from the more generalised poetry of his Highland landscapes. The will to bring these two things together reflected the realisation that it should be possible to record real experience without curtailing the poetic resonance of an image, or its power to suggest.

An important step in this direction was the *Ring-Net* project. This began in 1973 with a promise of funding from the Scottish Educational Trust through Richard Demarco. For Maclean, the prospect of a year's release from teaching was something to leap at. Originally his intention was a fairly loosely focused enquiry into the practice of ring-net fishing and its initial, artistic inspiration was the example of the historical use of drawing as a vehicle for the recording and transmission of information. He had seen this in the way that the early explorers, like Captain Cook, took an artist with them for the recording of visual information. The worries about style and expression that had plagued Maclean since he was a student had no part in such practical skills. Paradoxically, however, it was precisely these same practical skills which

were the principal objective of the teaching that had been the source of the problem. Use of art as a documentary instrument therefore suggested a release from the burden of inherited, unsatisfactory aesthetic objectives while exploiting the same learned skill from which they were derived.

Maclean's eventual objective was a documentary exhibition, one of the fashionable modes of conceptual art at the time. It was through this means especially that one of the most important legacies of the conceptual art movement was to bring content back into art in a form that could present a complex commentary on a given area of subject matter. In Scotland, Glen Onwin's *Saltmarsh, 1974/5*, and his *The Recovery of Dissolved Substances*, 1978, are just two contemporary examples of this. They did not have a sociological dimension as Maclean's did, but they had the same assumption of almost scientific objectivity and they were also shaped by the idea that an exhibition itself can be a single work of art.

Onwin's projects also had a marine theme and this was another important area of common ground that Maclean had and still has with others of his contemporaries in Scotland – for example with Liz Ogilvie, Bob Callander and John Bellany, and also with Ian Hamilton Finlay. Finlay had developed an iconography of fishing and fishing boats which ranged from diagrammatic drawings and concrete poems using the serial numbers of boats, to works like *Star Steer* (first version 1966) in which he suggests a cosmic reflection on the whole business of navigation. Maclean's later work, too, has some affinity with the poetic complexity of meaning and exploration of history that are characteristic of Finlay.

Maclean's *Ring-Net* project, working closely with Angus Martin from Campbeltown, developed into a full-scale

research undertaking of extraordinary detail and thoroughness. His uncle, William Reid, was a ring-net fisherman and so his involvement was first-hand. The ring-net was a method of fishing that had evolved on the west coast following the Clearances and the forcible move into fishing of Highland farming people, the move that is recorded in Neil Gunn's saga, *The Silver Darlings*, and which both Maclean's father's family in Coigach and his mother's family in Skye had experienced first-hand.

The *Ring-Net* project eventually consisted of some 400 drawings (*Pl. 16 & 17*), as well as notes, photographs, press-cuttings and other documents. Some of the drawings of boats, winches and other pieces of equipment are of a very high standard of accuracy and Maclean was fascinated, not just by the single – and as it turned out final – state of the industry, but also by its development; ingenuity in the solving of problems and the dead-ends that followed wrong turnings both form part of his survey.

The project was first exhibited at the Third Eye Centre in 1978 and was eventually purchased by the Scottish National Gallery of Modern Art. This comprehensive study of a culture through its tools and its artefacts was almost a paradigm of archaeology, which is, after all, the interpretation of society through its artefacts and its material record. The whole collection records a culture and technology that had evolved over little more than a hundred years and which, by historical accident, suddenly declined and disappeared almost as Maclean finished his project. It thus became an important piece of documentary history.

Angus Martin wrote a poem, 'Dancers', about the end of the ring-net fishing. The poem is dedicated to the artist:

And I wished that I could dance
in a yellow oilskin suit,

15. *Skye Totem* (1975)

dance on the dancing water
to the slap of an old thigh boot.

They were the champions of some
greater dance
performed in a night of islands.[7]

Maclean took the title for his set of ten prints to Gaelic poetry made in 1991, *A Night of Islands*, from this poem. One print also reworks his image, *Skye Fisherman: In Memoriam*, as a specific illustration to the poem and so it too becomes a memorial to the passing of ring-net fishing.

What distinguishes Maclean's art in the *Ring-Net* from other contemporary examples of the documentary exhibition is his thoroughness, together with his historical sense and his insistence on information rather than personal interpretation. These are the

qualities that underlie the distinction of his later work too. It is often constructed around complex and precise information about fishing, whaling or Highland history and myth. Its continuity with the *Ring-Net* is therefore much more than just a question of subject matter.

The *Ring-Net* project represented a watershed in his career and, alongside the almost obsessive work on it, Maclean continued to paint. He developed the imagery of the Highlands as he had first formulated it in *Beach Allegory* and related works such as *Skye Totem* (1975, *Pl. 15*). In this mode, a key picture in his development was *Three Fires, Achnahaird* (*Pl. 18*), painted in 1975, but now lost. This takes the fire and altar image of *Beach Allegory* and repeats it three times symmetrically. The setting is a Bronze-Age site at Achnahaird which is also the subject of a

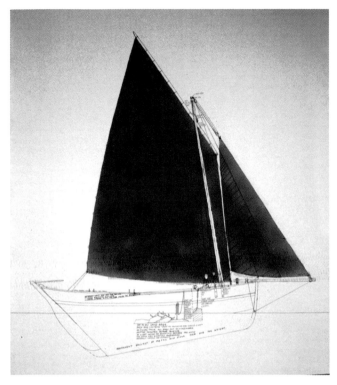

16. *Loch Fyne Skiff*, drawing from the *Ring-Net* (1973–4)

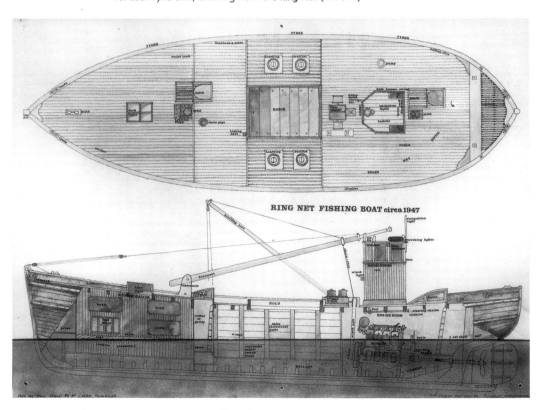

17. *Ring-Net Fishing Boat, circa 1947*, drawing from the *Ring-Net* (1973–4)

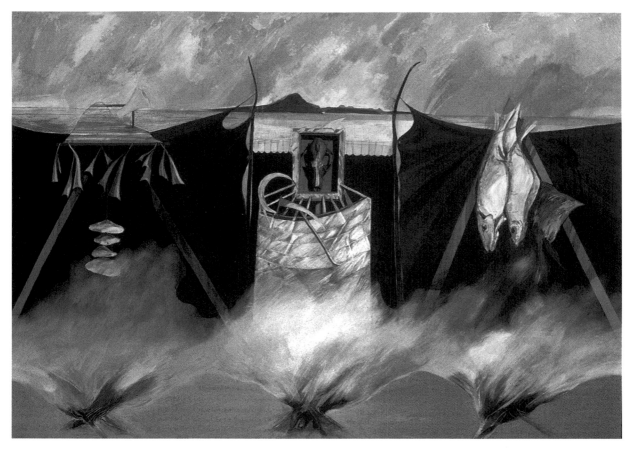

18. *Three Fires, Achnahaird* (1975)

number of drawings (*Pl. 19*). The background is a dark and sombre view of Achiltibuie. In the smoke of the altars, fish and hides are curing as though they have just been left by some Bronze-Age inhabitants. Etruscan funerary banners reappear as fish-driving lines, lines with rags attached to them that are dragged through the water to drive the shoals towards the shore. This is a detail that makes a visible reference to the continuity of the ancient technology of fishing, as though in a temporal sense the substitution for the Etruscan image was insignificant. The history of the place represents an archaeology in which the Bronze Age and the age of the Clearances are indistinguishable. Time is foreshortened just as it was by William Johnstone in his key painting, *A Point in Time*, painted almost fifty

years before; a painting which the artist described as 'a primordial landscape' – the word that Neil Gunn also used in the quotation given above (p. 21) – and which is based on the landscape of his childhood in the Borders with echoes running through it of the earlier peoples who had inhabited it.

In the centre of Maclean's composition, the skull of an animal has been mounted in a recess in the panel. This is the first step towards the constructions that have been central to his art since shortly after this picture was painted, and such a skull, or that of a fish, a bird or a small whale is a frequent motif in them. It is a macabre touch which had a parallel in John Bellany's contemporary work, but Maclean makes it his own. The skull is a real presence, a ghost and a memorial to

19. *Ceremony Site, Achnahaird* (1975)

all the inhabitants of the place, human and animal, an image of the people's livelihood; perhaps a totemic sacrifice of their forgotten religion, but a symbol, too, of their own sacrifice upon the altar of a stranger's greed.

The way this real object is set in the fictive space of the painting is a solution to a pictorial problem too, focusing the essential shift from the real to the imaginary level of the image. Technical problems still preoccupied Maclean at this time and the question was how to get beyond the aesthetic enclosure of an art in which style and form seemed to be self-sufficient, to be the only objective of the painter, to the rigorous exclusion of all other content. This device, which achieves an exchange between the enclosed object and its painted environment, breaks out of that constraint and, as it does so, it becomes a metaphor for a new kind of poetic resonance; the real object functions in the imagination's space. Maclean had brought

together the objectives of his painting with those of the constructions that he had begun to make the previous year.

* * *

The Surrealists had developed collage, assemblage and the use of found objects as the basis of a poetry of association. They had recognised that these new vehicles made it possible to bring together into a single image, things that could carry with them from their previous existence memories and associations, even as they became part of something new. This way of working became a metaphor for the way that in our experience present perception and memory, dream and reality can all coexist and intercut. Following the surrealists, the greatest British exponent of this has been Paolozzi, though a number of the pop artists also used it, notably Peter Blake. Maclean followed in this tradition and made his first true assemblage or construction in 1974, *Requiem Construction (John Maclean) (Pl. 20)*. It followed on from model-making undertaken for the *Ring-Net* and was made almost casually as a relaxation, but it involved a vital change in focus. Instead of trying to make a statement with a consciously general application, the artist worked from a starting point that was so particular that it involved using the objects themselves. It was also at first very personal.

The requiem in this construction was for his father. The work consists of a group of objects framed in a church window. Its gothic shape seems appropriately to suggest a requiem, but it also recalls the childhood experience of the kirk. Within the window are his father's pilot's cap-badge – a symbol of his professional career – some abacus beads and a twig with painted oak-apples on it. The abacus beads are a relic of primary school, but they might also represent the mathematical

calculation which is the basis of navigation. The oak-apples are a natural form. They have heroic, even druidic, associations, but in a double image typical of the artist, they also represent the model ship's lights used by his father in teaching navigation.

Maclean was teaching in Fife when he made these first constructions. He found that he could take bits of them in his pocket to carve or polish while he was at school. He could do nothing like this with painting and his whole approach could be more casual. This way of working was almost craft rather than art and so he did not really need to think of what he was doing as carrying the burdens of the 'serious' business of painting. That way, he bypassed the aesthetic impasse in which he still felt he was trapped, but he did not fully realise that he had done so until 1975. He had already made nine or ten of these assemblages, when in that year Jack Knox came to select some work for what was to be the opening show at the Scottish Arts Council's new Fruitmarket Gallery. Instead of selecting paintings, Knox became excited about the assemblages and, rather to the artist's surprise, he chose them for the exhibition.

It was the turning point in Maclean's career. He had finally broken out of the aesthetic constraints imposed upon him by his art-school training and he had done this by turning to the concrete and specific. Now he was incorporating actual objects into the artwork. He had left the artificiality of paint on canvas in favour of the simple pleasures of making, of cutting, carving and assembling; imitating the traditional sailor's forms of scrimshaw, model-making and whittling. It is the quality of the concrete and the care and skill in the artist's touch that gives their character to these assemblages. Although the themes of his painting are continued in them, the paintings seem unfocused beside the assemblages, which were carefully planned

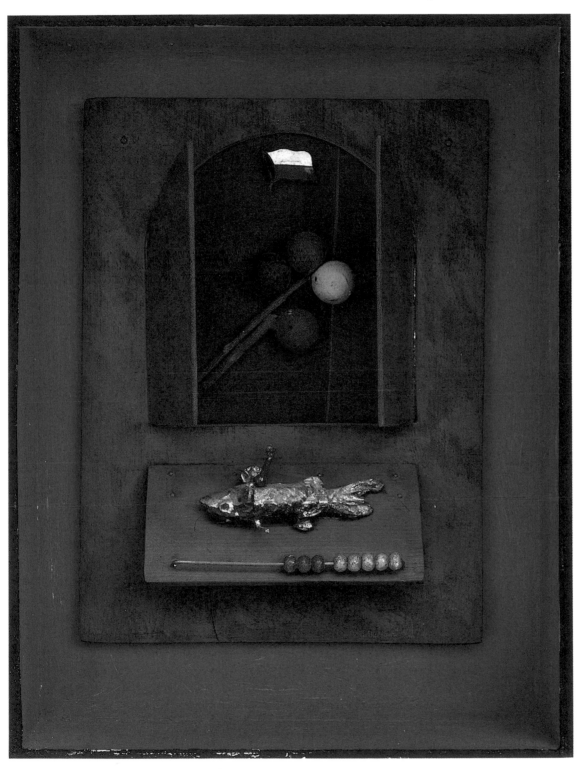

20. *Requiem Construction (John Maclean)* (1974)

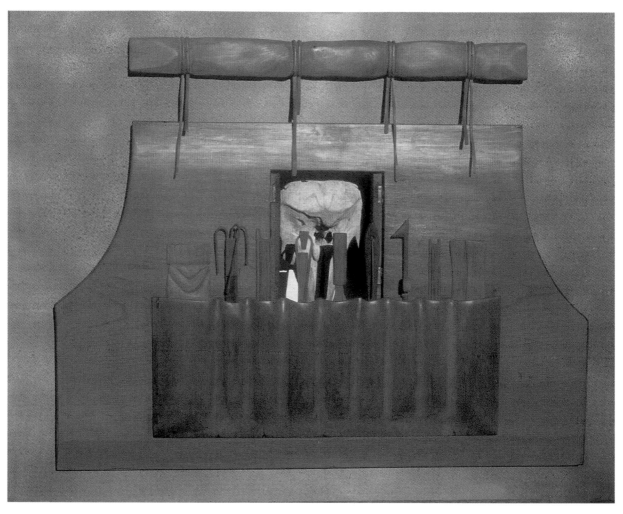

21. *Symbols of Survival* (1976)

and whose imagery is consequently often very precise. They are also extremely beautiful. Indeed, it is a feature of Maclean's constructions from this time forward that it is their beauty that makes them persuasive.

These constructions can be read as poems and in a way that is more common in poetry than in visual art, the starting point, especially of the earlier ones, is frequently some childhood memory. One consequence of working in this way with the concrete and particular is, too, that in these early constructions, his work is not generic. Because the objects from which they are composed have a quite specific set of associations and because of the way they were carefully planned, though later it became more fluid, his work at this time is not a set of variations or given motifs within the general parameters of a personal style. There is a clearly identifiable group of themes running through it and there are recurrent motifs, but the works themselves are each individual. As in Alan Davie's painting which he admires, the symbols that he uses function at a level of suggestion that is intended to be less precise than conscious meaning, but each also has its own set of references and so repays separate exegesis.

One of the most beautiful of this early group, *Symbols of Survival* (1976, *Pl. 21*), illustrates this precisely. It was in the Fruitmarket exhibition and, bought from the exhibition, became Maclean's first major sale. Its inspiration is a wartime US Navy survival kit, given to the artist by an uncle when he was a boy. One of those wartime souvenirs which to a boy at the time would have been invested with an extraordinary glamour, to the adult artist it became an object as potent with mystery in his own personal archaeology of childhood as an Etruscan bronze. He has it still. The kit is in a canvas apron with pockets. It is an epitome of life at sea and contains fishing gear, harpoons, even pork-rind for bait, but also rather improbably detailed printed instructions on how to use these things.

Made of carved and polished pine, in the assemblage – or perhaps it is a still-life sculpture – the kit is seen both open and rolled. The open apron is suspended from the rolled one. Each of the tools is faithfully reproduced with the same care as he had used in the drawings for the *Ring-Net*, but set in the centre in a window, like a window to the imagination, is a porpoise skull, a reminder of the stark simplicity of the sailor's alternative to survival – death. At the same time, Maclean's own childhood response to the magic of this strange, exotic kit is present in the finished work. The beauty of the wood and the way it has been lovingly carved and polished suggest how, as the imagination handles such a memory, it becomes a cherished thing.

Another beautiful work from these years, which follows directly on the theme of childhood memory and which uses the same technique of imitating real objects in carved and polished wood, is *Abigail's Apron* (1980, *Pl. 22* & 1966, *Pl. 23*). It is a work which in a remarkable way also opens from the memory of a specific individual towards the whole theme of Highland history and culture and the artist's perception of it. It is an oblique portrait, a marvellous still-life memorial to the artist's aunt Abie, his father's sister, Abigail Mackenzie, who had stayed in Coigach. Her apron, a garment which was typical of the Highland women of her generation, itself carved in pine, is hanging on a peg against the tongue-and-grooved pine lining of her kitchen.

In her apron pocket is a group of mysterious objects, half-recognisable as kitchen utensils. One of them looks like a wooden spoon, but it has a strange lump on it. Johnny Allie Mackenzie, one of the men in Polbain, had such a lump on his head. It was some kind of

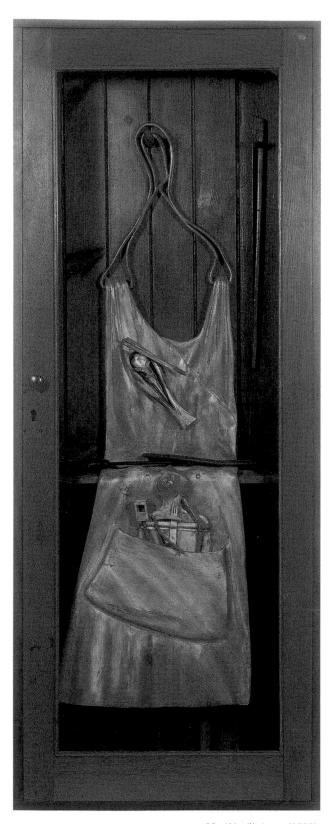

22. *Abigail's Apron* (1980)

23. Sketch of the artist's aunt, Abigail Mackenzie (1966)

benign growth. It is not included here to mock him, but is a reference to the community in which Abigail belonged and to the characteristic of the Highlands, which is perhaps common to all small, relatively isolated communities as it also is to children, of giving a very high definition to individuals, accepting their peculiarities in relief as it were, not glossing over them. In the Highlands, this characteristic is typified by the use of nicknames and here, while with gentle irony it puts this individual in her pocket, it is a way of conveying her own strength of personality.

This strength is implicit too in the bold simplicity with which the wood is carved, just as the artist's affection for her memory is implicit in the careful beauty of the finish. That we are dealing with memory is suggested by the way that the whole assemblage is set behind a glass cupboard door. This has a keyhole and handle which forms part of the work, so it is a handy way

of presenting it, but it also means that we are looking in, into the mind, the imagination, or the memory. It also suggests that the shallow space of the relief is actually the space of a picture. This is a reminder that the artist began as a painter, but at the same time it is also a way of cutting through all the confused mythology and mumbo-jumbo of modernism surrounding the significance of the picture plane. Here it is what it has always been, simply a transparent boundary between the contingent world of experience and the world of the imagination.

On the apron, too, is pinned what seems to be an outsize brooch. It is a herring with a bird's skull contained within it, which together suggest both the tragic recent history of the Highlands and the extension of memory back into remote prehistory where perhaps she would have been a priestess of some forgotten cult. It was only later that evidence in a collection of eagle-skeletons of just such a

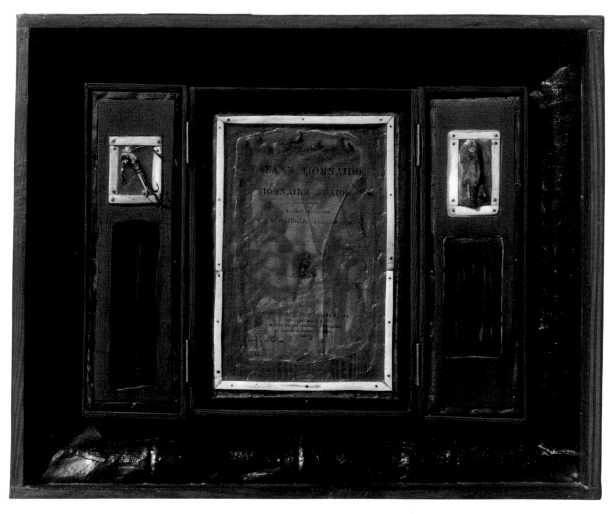

24. *Portrait of Angus Mackenzie* (1982)

Bronze-Age cult was unearthed in Orkney.

In keeping with this suggestion, like the requiem for his father, its enclosure gives to *Abigail's Apron* the quality of a shrine or a reliquary, though it contains no actual relics. It is a memorial to someone who, alive, was vividly individual, but it also invokes, if only by this brooch, what she stood for, a whole way of life that seemed to be ending after millennia of continuity. Its companion portrait of her brother-in-law, *Portrait of Angus Mackenzie* (1982, *Pl. 24*), makes this point equally clearly. It was made two years later and its central element is a page from

a Gaelic Bible, coated with transparent resin and then waxed so that it looks like a fly in amber, suspended in time. This central element is edged with bone. Angus Mackenzie was a sternly religious man, but he taught his nephew to fish and made him model boats. In the work these appear together with the whet-stones that he used to sharpen his tools. In the Iron Age, whet-stones, with their power over metal, were a symbol of kingship, reflecting the stature of such an individual in a child's eyes.

In Maclean's art as a whole, the natural sense of loss in the memory of childhood is

enrolled into the much more tragic sense of loss at the passing of Gaelic culture, and this is nowhere clearer than here in these intensely personal works. To illuminate history by personalising it in this way is in the tradition of Walter Scott. It reflects the essential understanding of history which Scott himself derived from the thinkers of the Enlightenment, that we can only reach the general through the particular. This is not something nostalgic or sentimental, but is central to modern philosophy and is at the basis of modern art. It reflects the arguments put forward by Hume and Reid which had a far-reaching impact on European art, about the nature of experience and our perception of it. The basis of all knowledge and understanding, they argued, must be in experience and so it is only through the imagination that we can transcend this limitation to the subjective. In just this way, Maclean himself approached the wider themes suggested by Highland history through his own immediate, subjective perception of it and first of all through his memory of those close to him like his aunt, Abigail Mackenzie.

Maclean's attempt to create a meticulous account of the perceived world as a means to a wider, imaginative perception such as he used in *Abigail's Apron* reaches its most elaborate form in *Interior Wester Ross* (1980, *Pl. 25*). This is a view of a domestic interior with a plant on a bookshelf, a Bible and other details of ordinary life, all of them made of carved, or turned wood. Within the bookshelf, though, is a painted landscape and so even as he was striving to reach some kind of hyper-realism by craft methods, he was also still thinking about painting. Indeed, in 1978, in *Sabbath of the Dead* (*Pl. 26*), he had already returned directly to the imagery of his paintings of five years before of the desolation of the Highlands and the ghosts of the Clearances.

Sabbath of the Dead was inspired by

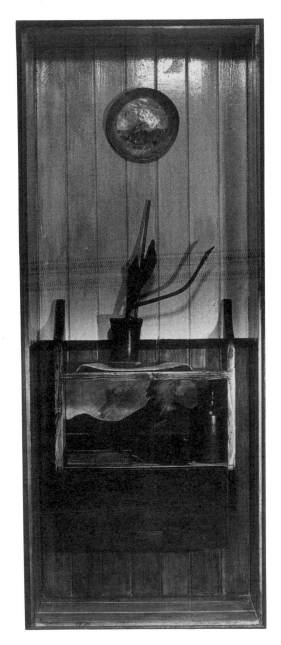

25. *Interior Wester Ross* (1980)

'Hallaig' by Sorley MacLean. It is a poem of loss, a poignant lament for the vanished people of an empty place:

Mura tig's ann theàrnas mi a Hallaig
a dh'ionnsaigh sàbaid nam marbh,
far a bheil an sluagh a'tathaich,
gach aon ghinealach a dh'fhalb.

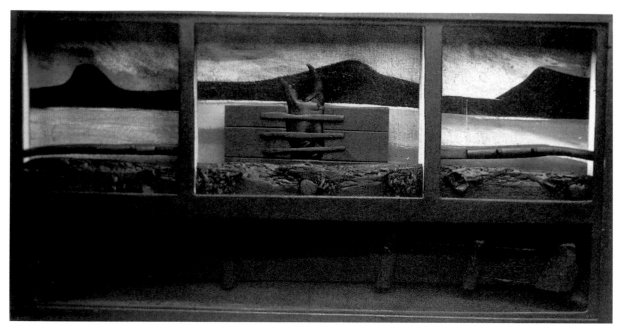

26. *Sabbath of the Dead* (1978)

Tha iad fhathast ann a Hallaig,
Clann Ghill-Eain's Clann Mhicleòid,
na bh'ann ri linn Mhic Ghille-Chaluim:
Chunnacas na mairbh beò.

Na fir'nan laighe air an lianaig
aig ceann gach taighe a bh'ann,
na h-igheanan 'nan coillie bheithe,
dìreach an druim, crom an ceann.

Eadar an Leac is na Feàrnaibh
tha 'n rathad mór fo chóinnich chiùin,
's na h-igheanan 'nam badan sàmhach
a' dol a Chlachan mar o thùs.

Agus a'tilleadh as a'Clachan,
á Suidhisnis's á tir anm beò;
a chuile té òg uallach
gun bhristeadh cridhe an sgeòil.

If it does not, I will go down to Hallaig,
to the Sabbath of the dead,
Where the people are frequenting,

every single generation gone.
They are still in Hallaig,
MacLeans and MacLeods,
all who were there in the time of
 Mac Ghille Chaluim
the dead have been seen alive.

The men lying on the green
at the end of every house that was,
the girls a wood of birches
straight their backs, bent their heads.

Between the Leac and Fearns
the road is under mild moss
and the girls in silent bands
go to Clachan as in the beginning.

and return from Clachan
from Suisnish and the land of the living;
each one young and light-stepping,
without the heartbreak of the tale.[8]

It is a congregation of ghosts, of absences in

27. *Composite Memory (Vessel)* (1987)

an empty land. Maclean's response is a painted construction in four sections. Its main features are its dark, sombre colour, only relieved by the stark light in three separate views of the hills of Raasay seen across the water. Beneath these, in a single compartment spanning the whole work, is a piece of driftwood; a plank from a boat, black-painted, but a natural material once turned into a human artefact, now wasted and reclaimed by nature like the empty, once populous island of Raasay itself. In the foreground of each of the landscapes is a dark section of beach, reminiscent of the raised beach mentioned in a later verse of the poem. Against the central section, held in a wooden cage, a black-painted crab's claw stretches to heaven like the hand of a drowning man, suggesting a powerful presence in the landscape and expressing both anguish and anger.

Sabbath of the Dead is a construction, but it is also a painting and in the early 1980s Maclean's constructions tended more and more to have a painted finish. Painting was a language that lent itself more readily to a wider frame of reference than could constructions of polished wood. Maclean has always been conscious of this and, conversely, of the risk of identifying his own art with the very different craft tradition. In 1981 he was appointed to the painting school at Dundee College of Art by Alberto Morrocco. In the company of painters once more, he began to explore again the language of painting in the painted surface of his constructions. *Star of the Sea* (1983, *Pl. 1*), for instance, is an assemblage which is called after his grandfather's boat and pays homage to it. It is made of various elements to suggest a totem figure, but its character depends on the rubbed and splashed blue paint which

manages to suggest at the same time the space against which the totem is standing and the worn paintwork of a working boat.

This use of the texture of rubbed paint led directly to experimentation with the surfaces that can be achieved with resin and plaster so that later works somehow succeed in being both more sculptural and more painterly. Certainly formal concerns have always been part of Maclean's art and their subordination to delight in the possibilities of *trompe l'oeil* was a short phase in his development.

A further stage in the evolution of Maclean's confidence in his new way of working had already come in 1977. His work was selected by Paul Overy for a Scottish Arts Council exhibition held that year, *Inscape*. It was an important exhibition and it explored in the work of a group of six Scottish artists just those areas that interested Maclean himself. The other five were Ian Hamilton Finlay, Glen Onwin, Eileen Lawrence, Fred Stiven and Ainslie Yule. Amongst these, the work of several in particular had common ground with what Maclean himself was doing. Eileen Lawrence for instance was making fastidious drawings of collections of natural objects, not unlike some of Maclean's *Ring-Net* drawings. Ainslie Yule was making drawings for sculpture of mysterious, surreal objects which suggest the same kind of pseudo-archaeological mystery that Maclean was exploring in some of his constructions. Fred Stiven was making boxes, but their use of a formal aesthetic also underlined the distinctiveness of Maclean's approach. Finlay was also using imagery of ships and fishing in a way that opened up its poetic and metaphoric possibilities, linking past and present.

In his introduction to the catalogue of *Inscape*, Overy remarks that there were no painted canvases in the show, that this was not by design, but that it simply reflected the current concerns of some of the most thoughtful artists then working in Scotland. A few years later, in 1982, Overy again selected Maclean for an exhibition, *Inner Worlds*, on a similar theme. It was drawn from a more international group of artists, but also included Finlay and John Bellany. It is interesting that in this context, the pre-occupations of the Scots did seem distinctive.

Internationally, in the mid-1970s there was a reaction against painting, but in Scotland this found a focus in the rejection of the particular, subjective, painterly ethos that prevailed in the art schools. Individuals in the older generation had always stood out against this as Fleming and Walker did in Aberdeen. With Finlay, too, this rejection had happened much earlier and it had taken him out of art altogether for a while, to return to it via poetry. Several of the younger artists in the group shared this kind of interest, though not going so far as to make concrete poetry themselves, as Finlay had done.

The title, *Inscape*, came from Gerard Manley Hopkins. It means the inner landscape of the mind and in his introduction to an exhibition of the work of Ken Dingwall the same year, Overy made a specific comparison between contemporary art and poetry. He suggested that art, like poetry, had to withdraw from the grand statement into more intimate and private territory:

> The nearest analogy to painting would be, I think, poetry. It will not have a wide audience. But it will have a density of meaning, a seriousness, and allusiveness (and also an illusiveness) which the best contemporary poetry had.[9]

This may in part be true, but the recognition of significant common ground between art and poetry was also a reflection of the opposite truth; of the way that these artists were moving away from the highly

specialised preoccupation with the formal language of art which had been dominant in the post-war years in parallel to logical positivism in philosophy. Instead, they were turning back, or rediscovering the traditions of the Scots Renaissance (and some like Finlay had never left them) and finding inspiration in areas of experience for which, because they were real and actual, the lines of demarcation between the art forms used to describe them were irrelevant. It was a shift in which the exchange once again became possible between the concrete and the metaphysical, of which Hopkins's poetry, like Sorley MacLean's, was a conspicuous example. This had been one of the objectives of progressive painting since the eighteenth century. Recently in Scotland, it had been a characteristic objective of the work of James Cowie and William Johnstone and it was also currently the distinctive characteristic of Finlay's work, but it ultimately derived from the central concern of Scottish empirical philosophy, the relationship between the mind, morality and the external world.

Reviewing *Inscape*, Marina Vaizey compared Maclean's work to the box constructions of Joseph Cornell,[10] one of the masters of this kind of intimate narrative, at the same time semi-private and based on the actual. Cornell's work was a revelation to Maclean, who had not known it before. He had of course been familiar with the Dada and Surrealist use of collage and assemblage, his own starting point, and years later he acknowledged this directly when he paid homage to Kurt Schwitters in *Calotype for Schwitters* (1986, *Pl. 28*). It is a collage in Schwitters's manner with a ticket to an exhibition of his work as its centrepiece. Maclean was obviously familiar, too, with the work in the 1960s of artists like Peter Blake who had learnt from Americans like Cornell and Rauschenberg. There were also

contemporaries like Fred Stiven, who had taught him at Gray's, or Barry Cooke, who both made boxes of a rather similar character, but apart from the obvious abstract-expressionist painters and the pop artists, American art was still not well known in Britain. It is not surprising that he should not have been aware of Cornell.

Cornell's work was distinctive because he used the technique of assemblage, or rather what Paul Overy calls 'bricolage'[11] (an assemblage made from found objects which preserve something of their original identity) in a novel way. He had made it a vehicle for a kind of narrative. In Cornell's boxes therefore, Maclean found justification for the kind of narrative based on the collection and fastidious arrangement of objects that he himself had begun to explore independently. This helped him to realise how great the potential was of this way of working.

The influence of Cornell was more one of general encouragement rather than of specific indebtedness and Maclean's own iconography and formal language continued to evolve along lines that were already established. The latter depended on the wider surrealist tradition as well as on those nearer his own generation, but in the former he also came increasingly close to the indigenous Scottish tradition which had evolved from the work of the Scots Renaissance poets and artists and their successors.

Maclean's art represents an interweaving of themes. Through his own childhood, it reflects the history of the Highlands and the life of sailors and the sea and then draws from these wider metaphors. Perhaps by its title alone, the key work in this period is *Memories of a Northern Childhood* of 1977 (*Pl. 29*). It still shows his interest in *trompe l'oeil* and is in fact actually organised like a particular kind of seventeenth-century *trompe l'oeil* still-life of which in Scotland the best known example is

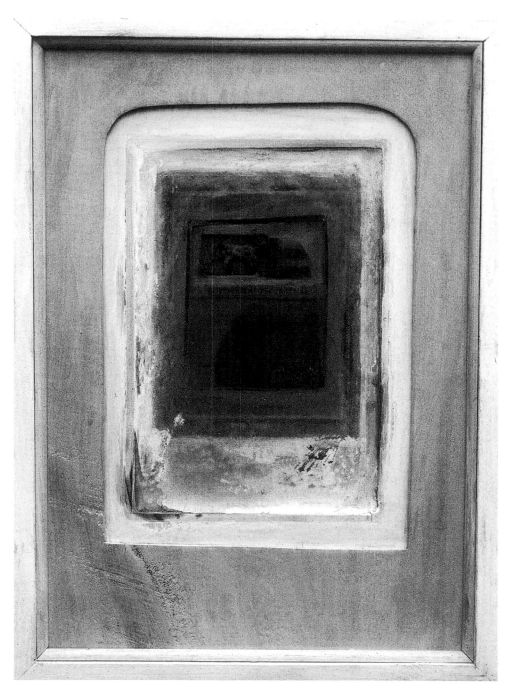

28. *Calotype for Schwitters* (1986)

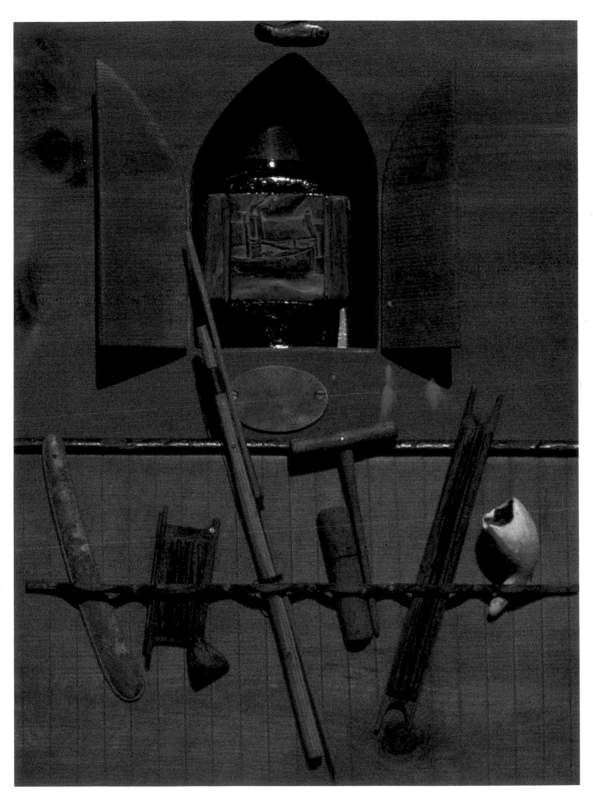

29. *Memories of a Northern Childhood* (1977)

Thomas Warrender's painting in the National Gallery of Scotland. Though this particular one was unknown in the 1970s, it is a common type, representing an arrangement of objects held by straps or bands to a board or wall. These objects, which include things like playing cards, quill pens and clay pipes, often seem to have a personal, or even autobiographical significance for the artist, though this is not always explicit.

In *Memories of a Northern Childhood*, there is such a set of objects: a clay pipe, fishing and net-making gear and a cut-throat razor. These are arranged against the wainscot of a Highland cottage. Above them is a tabernacle, its gothic doors opening onto a dark interior. Inside is visible a slate relief of a ring-net fishing boat, a votive image on an altar, carved like a Pictish stone. The title and the objects together suggest a boy's perception of manhood in a fishing community. It is once again the archaeology of the artist's childhood, but the dark tabernacle with its open doors also distinctly recalls the opening plate of Blake's *Jerusalem*. There, the artist stands in front of just such a darkened, gothic doorway. It is the gate of perception and he has a lantern in his hand as he prepares to enter and bring light where there is darkness.

Maclean's gate is the gate of the memory of childhood, but childhood is one of what Paolozzi called 'Lost Magic Kingdoms', the title of an exhibition that he selected in the Museum of Mankind in 1985. In it, he brought together the artefacts of 'primitive' peoples and his own art works. He was making a double point: an ecological one in which he demonstrated how we are all impoverished by the destruction of such cultures, but also how this destruction in itself mirrors our ignorance of our own 'primitive' needs; needs which we still cater for in unrecognised ways, creating totems, fetishes and structures of magical belief.

These are the needs which both Paolozzi and Alan Davie see their art as serving and, in this way, they demonstrate our community with those whom we mistakenly regard as different because we regard them as 'primitive'.

Paolozzi was also interested in survival and adaptation as non-western people took over the materials and the artefacts of technological society. As they did so they invested them with new imaginative power, as he himself sought to do and just as Maclean had done for instance with a US navy survival kit in *Symbols of Survival*. Though Duchamp had led the way, it was Paolozzi who had first argued explicitly that we have to take into account all the products of our visual culture if we are to understand it, not just those sanctified as 'fine art'. In the Dada tradition, he aimed to break down the barriers which isolated art from reality and which emasculated it as it confined it to 'the Fine Arts'. In so doing, he sought to realise the actual, imaginative potential locked in so much of what we regard as trivial, especially in the imagery with which we surround ourselves. In *Lost Magic Kingdoms*, he extended this to explore the continuity between cultures, whether or not they are technologically advanced, and thus the common ground, the ground in which our shared humanity resides.

Maclean was pursuing a similar line independently, exploring through the traditions of the Highlands actual contact with the primitive in our own culture. On the one hand, he uses specific imagery and found objects in a way that Paolozzi does, combining them in non-linear structures including, but not simply dependent on, narrative techniques. On the other hand, like Davie, whose exploration of Jungian symbolism closely parallels the way Paolozzi – often literally – cuts through the surface of

the conventional reading of an image to other potential meanings, Maclean is deeply interested in the symbolic value of imagery and its ability to resonate in the unconscious areas of the mind. Davie, in the way that he does this, identifies himself with the shamans of primitive religion. He proposes that his art mediates between the conscious and the unconscious, or between the material and the spiritual. In a primitive context, this could be between the living and the dead, a subject that is implicit in Maclean's images of the Clearances.

As the very first of them, *Requiem Construction (John Maclean)*, made clear, Maclean's early constructions were formally reliquaries. Historically, reliquaries are, of course, containers for the relics of saints. Their contents were objects hallowed by association which could act as mediators between the spectator and the saint. Maclean's works continued to have this form as long as he continued to incorporate actual objects in his construction, but even later when he came to use casts and other methods of reproducing the significant, collected elements in a construction, he often still used the idea of the reliquary. Of course, Maclean does not use this in a simple, religious way, but he does use it to mediate between the spectator and the subject of his work which is invoked by association. The religious overtones are often there too though, as they are here both in the gothic window and in the word requiem. Sometimes the works are actually called reliquaries as in *Fladday Reliquary* (1978, *Pl. 30*). At other times, he will use some associated religious word in the title like ex-voto, offertory, tabernacle, shrine, or icon, as in *Icon for a Fisherman* (1978, *Pl. 31*), and moving out of the Christian tradition altogether, his later works are frequently called totems.

There are also more playful images though. *Black Priest's Box* (1982, *Pl. 32*), for

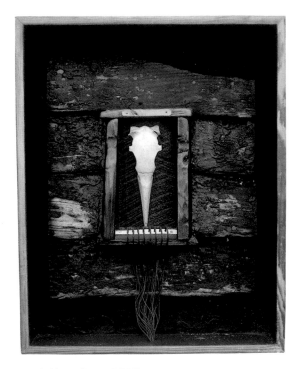

30. *Fladday Reliquary* (1978)

instance, is a kind of imaginary tool-kit for a travelling Bronze-Age priest. It contains all the equipment that such a priest might need to set up an alignment of standing stones; a cord measuring a megalithic yard contained in a bone tube, cords for setting straight lines such as gardeners use, even model standing stones. Similarly, *Fire Figure* (1985, *Pl. 33*) is a torso made from the fork of a laburnum tree, hollowed out to contain pseudo-religious fire-making equipment.

These are the kind of thing that one can imagine Naomi Mitchison describing in a novel set in Bronze-Age Orkney and this whole imaginary side to his art presents a literary analogy that illuminates Maclean's exploration of the past, for it extends the parallel with Johnstone's painting *A Point in Time* and Maclean's links with the Scots Renaissance. For instance, Johnstone's interest in time and the presence in the landscape of history and prehistory simultaneously with

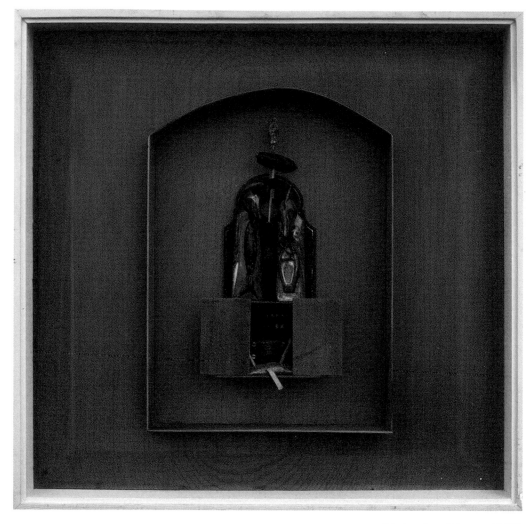

31. *Icon for a Fisherman* (1978)

our continuing present experience has close parallels in the novels of Neil Gunn and Lewis Grassic Gibbon. Like Maclean, Grassic Gibbon was fascinated by archaeology and in the *Scots Quair*, he constantly reaches back from the narrative present to the remote past. For instance in *Sunset Song*, in moments of crisis, Chris always goes to find comfort in the standing stones on the moor above Blaweary. In his essays, following a lead given by Patrick Geddes, he sought to make sense of the present in Scotland by opening the enclosed perspective of modern history to include the much longer perspective of the prehistoric past – it is as though the conscious mind was represented by history and prehistory was the subconscious. Civilisation originated in Scotland from Ancient Egypt, he argued in his essay, 'The Antique Scene':

> And from that central focal point . . . the first civilisers spread abroad the globe the beliefs and practices, the diggings and plantings . . . of the Ancient Civilisation. They reached Scotland in some age we do not know, coming to the Islands of Mist

in search of copper and gold and pearls,
Givers of Life in the fantastic theology
that followed the practice of agriculture.[12]

Then in 'The Land', he sets out the same
thesis and concludes:

They are so tenuous and yet so real, those
folk . . . The ancient men haunted those
woods and hills for me, and do so still.[13]

Maclean comes even closer to Neil Gunn
than to Grassic Gibbon, though. Gunn's
themes of fishing and the Clearances in
novels such as *The Silver Darlings*, *Morning
Tide* and *Butcher's Broom* suggest an obvious
analogy, but it is Gunn's masterpiece,
Highland River, which best illuminates the
symbolism and the underlying themes as
well as the subject matter of Maclean's art. It
is an extraordinary book, its narrative built
up with all the intricate, layered con-
volutions of Celtic interlace.

The hero, Kenn, an adult revisiting his
Highland home, recalls his childhood during
the course of a single journey from his
birthplace at the mouth of the river there to
its source. Thus the novel interweaves
simultaneously time and space in the
geological and historical dimensions of the
landscape, with time and space as we
experience them in an individual life and at
the present moment. Within these com-
plexities is further interwoven a quest. It is
like the quest for the Grail, but it has two
forms, the adult hero's search for the source of
the river and the boyhood story of his pursuit
of a fish. The fish is a salmon. Obliquely, the
author identifies it as the salmon of wisdom,
the legendary salmon 'the tasting of whose
flesh confers all knowledge',[14] while the hero,
Kenn, just like a salmon, travels up the river to
find at its source, the source of himself.

In the end, as in Johnstone's painting,

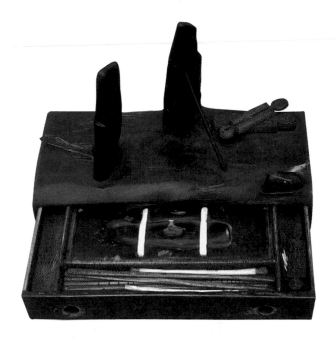

32. *Black Priest's Box* (1982)

these things become simultaneous as the
novel brings together in a single moment of
experience the present and the primeval.
The hero passes through a wasteland,
reminiscent both of the wasteland of the
Grail myth and of the battlefields he had
known in the first war, 'a primeval no-man's
land of outspewings like waterlogged shell
holes', to reach his grail in a pure and
virginal loch and 'a moment in which all
conflict is reconciled, in which a timeless
harmony is achieved'.[15] Kenn has left home
and is a scientist. His father was a Highland
herring fisherman and at one point Gunn
amplifies the significance that he sees in the
archetypal business of hunting fish as the
restless search for knowledge, linking it to
Kenn's own pursuit of science:

Galileo, Tycho Brahe, Kepler, the great
Newton, Cavendish, Faraday, Roentgen
. . . They were the men who stood
behind the fishermen in Kenn's

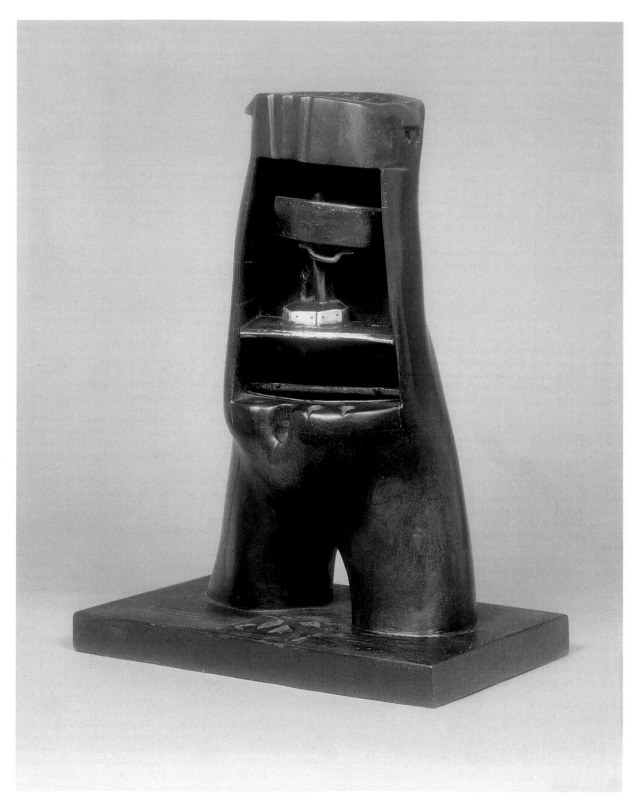

33. *Fire Figure* (1985)

growing mind. From fishermen to them was a natural progression.[16]

In *A Drunk Man Looks at the Thistle*, MacDiarmid uses the figure of Melville and Captain Ahab's pursuit of the white whale in a similar way as a symbol of the quest for knowledge:

'Melville, sea compelling man,
Before whose wand, Leviathan
Rose hoary-white upon the deep,'
What thou hast sown I fain 'ud reap
O' knowledge yont the human mind.[17]

Later, in his whaling imagery, Maclean too comes close to Melville's contemplation of the ambiguousness of this pursuit, but in his themes of time, childhood and dispossession in the Highlands and in the way that he uses the imagery of fishing too, he is here closest to Neil Gunn. His personal link with the tradition of the Scots Renaissance, however, is not through Gunn, but through his association with Sorley MacLean in whose poetry, of course, these same themes occur. It is an important link, for in this tradition the search for identity in the fusion of history and locality, which began with Scott, was developed to incorporate new ideas of time and relativity, and the extension of history itself to include remote prehistory and our subconscious memory of it. For as the surrealists pursued the possibility of drawing images from the unconscious, Jung enlarged this further to suggest that such imagery itself might be drawn from the reservoir of a collective consciousness, shaped by human experience over that vast tract of time. Early in the century too, anthropologists like Frazer and literary critics like Jessie Weston, were enormously influential as they began to argue for similar continuity in the actual survival of memories from prehistory within the present in our own society in both folk custom and literature.

It was this shift that helped to bring the ancient Celtic tradition forward as an inspiration to modern art and literature. In Scotland, this had begun with Patrick Geddes. He is often misrepresented as a revivalist, lost in an imaginary Celtic twilight, but what he actually argued for was a modern culture so well integrated with a sense of national identity that it could draw on these deeper springs of consciousness while dealing on equal terms as a partner in the culture of the wider modern world. It is in keeping with this ambition that the inspiration of the Scots Renaissance was diverse in the English-speaking world, to say nothing of Continental Europe. Geddes himself was closely in touch with nationalist culture in Ireland, and Yeats and Joyce were important for the Scots (similarly for Maclean, Seamus Heaney has been an important inspiration), but to novelists like Gunn, so were Hardy and especially Lawrence from England. Like Lawrence too, Wyndham Lewis tried to break with the prevailing gentility of English culture and he was an important influence on MacDiarmid as well as on Fergusson, McCance and Johnstone. There was also inspiration from America through Eliot and Pound, and among the artists, William Johnstone was clearly influenced by Arthur Dove and Georgia O'Keefe, who were asking similar questions about identity, history and place in an American context. Johnstone was, however, an important advocate of surrealism and of a Jungian view of imagery, a view which in his later life became closer to that of Zen.

An independent, though equally important figure was James Cowie, whose highly personal interpretation of surrealism was a distinctive contribution to Scottish art

34. *Settlement Site* (1982)

in the 1930s and 1940s. Although Cowie's iconography is otherwise very different from that of Johnstone for instance, and for him history's continuity is to be seen in the specific continuity of western art rather than in anything more diffuse. It is interesting, nevertheless, that the farm that was his birthplace constantly appears in the background of Cowie's paintings and in a similar vein, Johnstone once remarked that it was the landscape of his boyhood that made him a painter.

In fact, the Scots Renaissance developed very much as Geddes proposed and as MacDiarmid sought to realise it, on a strong national base, but drawing on a wide international culture. It developed a distinctive character and was given an urgent, social and political dimension by MacDiarmid. In the person of Sorley

MacLean, though, and losing none of its political urgency, the evolving Renaissance converged with the living tradition of Gaelic culture.

This background, still central to Scottish culture in the late twentieth century, was a key factor in the emergence of Joan Eardley, Eduardo Paolozzi, Ian Hamilton Finlay and Alan Davie, as a group of outstanding artists from Scotland in the 1940s and 1950s. These four either had links with the circle of J.D. Fergusson in Glasgow, or with William Johnstone in London. In turn in the 1960s, John Bellany was directly inspired by MacDiarmid and all this was not just a matter of some kind of mystic laying on of hands. These individuals all represented a clear and articulate tradition which went back at least to Geddes. They were, too, in the best sense profoundly serious. For them,

art and literature had a social function and were essential tools of imaginative understanding. They were not a pastime, but a forum in which values are forged and the basic questions of history and identity examined and debated. Sorley MacLean writes of 'A poet struggling with the world's condition',[18] and MacDiarmid says of poetry:

> . . . [it] wins to a miraculously calm, assured,
> Awareness o' the hidden motives o' man's mind
> Noch't else daur seek.[19]

Will Maclean follows in this tradition. Of the painters of the older generation, though, in many ways he is closer to Cowie whose metaphysical still-lifes often work in the same way as his constructions. When Maclean's drawings are considered this parallel seems even closer too, but in a wider sense the search to express the temporal and psychological unities that characterised the novels of Neil Gunn and the paintings of William Johnstone is also still very much part of his art. It is implicit in his interest in archaeology which is directly invoked in one of his most elaborate works, *Bottle Beach Settlement* (1988, *Pl. 35–7*). Here he presents an archaeological find of his own as a still-life with his own commentary. It is a fifteen-piece work which records the discovery on a beach of a buried cache of nineteenth-century bottles (the same beach that appears in *Settlement Site* (1982, *Pl. 34*)), but, documenting time and place, he has developed this prosaic fact into a poem that celebrates the qualities that give archaeology meaning.

Each element in the piece represents an aspect of the context of the find, the elements of the sea and the shore, but too, of time and history. It is this confrontation with time and continuity which is the imaginative dimension of all archaeology. Maclean brilliantly sets this out in the shift from light to dark which extends over the whole sequence of the fifteen separate pieces of this work. It is the diurnal transition, the basic unit of our awareness of time that rolls on so far beyond our comprehension. The passage of time from the moment of burial of this cache to the moment of its discovery has been measured by the succession of night and day, like the ticking of a clock in indifferent regularity and numberless progression.

* * *

These bottles are a memory of whoever buried them. Apart from the diurnal succession which measures our lives, it is only through memory that we can move in time's dimension, whether it is with the individual or with the race. Time is implicit in the images from the artist's own memory and in his historic images from the Clearances that are such a central feature of his art, but it is also implicit in the imagery of fishing which he so often uses to unite these. In a beautiful image in *Comus*, Milton wrote of the movement of the tides, for instance:

> The Sounds, and Seas with all their finny drove,
> Now to the moon in wavering Morrice move.[20]

As Milton saw it, the tidal dances of the sea are dances to the music of time itself; dances in which men join as fishermen more than they do in any other condition; as in Angus Martin's poem they are dancers, dancing between the tide and eternity. Perceived in this temporal dimension, fishing is an activity that links us to our earliest ancestors, to the hunter-gatherers and the state of nature. As Neil Gunn wrote of the fishermen in *Highland River*:

> They were hunters, hunting the northern

35. *Bottle Beach Settlement 1* (1988)

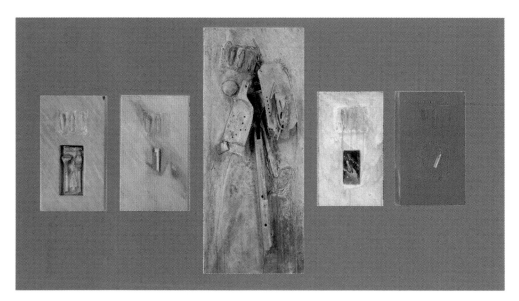

36. *Bottle Beach Settlement 2* (1988)

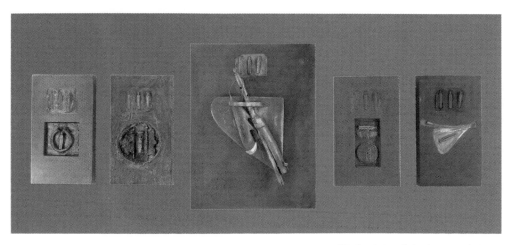

37. *Bottle Beach Settlement 3* (1988)

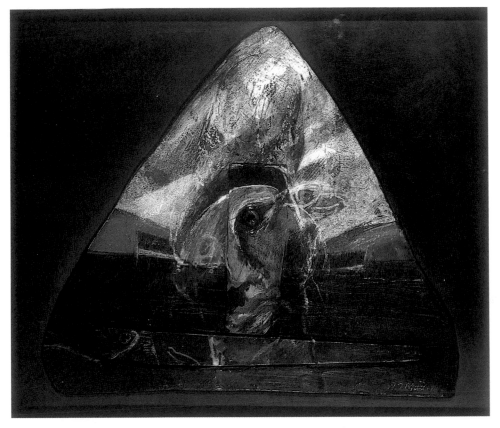

38. *Fisherman Listening for Herring* (1988)

and western seas as their remote ancestors had hunted the forests and the grasslands.[21]

Even in a technological age, fishing still preserves this link with our remotest past. Those who practise it are in immediate contact with, and have unqualified dependence on nature herself. No more than a generation ago, they made many of their tools from wood and bone in ways and in forms that were visibly reminiscent of the artefacts of our Neolithic ancestors. They were, too, as close to nature and as dependent upon her. In an extraordinary image *Fisherman Listening for Herring* (1988, *Pl. 38*), Maclean records the practice of the ring-net fishermen of listening for the sound of the fish, identifying the

herring by the quality of the noise they make leaping from the water. It is an image that suggests a communion with the natural world as intimate as that of Australian aborigines, and the artist has caught that analogy in the style of the work.

As Maclean knew it as a boy, fishing was on the edge of a technological revolution, but at that time there were still such links to the most ancient traditions in the items of equipment that were hand-made that so often appear in his work and in the dependence of fishermen on inherited skill and personal courage. *Nostalgic Locker* of 1976 (*Pl. 39*) reflects on just these characteristics in an arrangement very similar to *Memories of a Northern Childhood*, with a tall, brown-sailed fishing-boat in the half-open

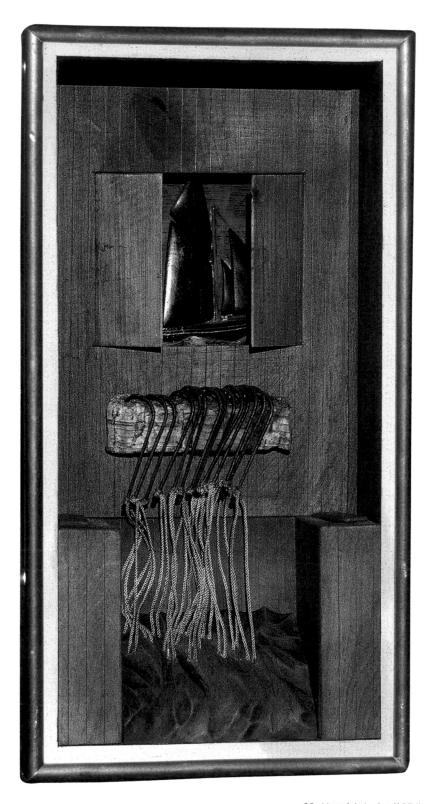

39. *Nostalgic Locker* (1976)

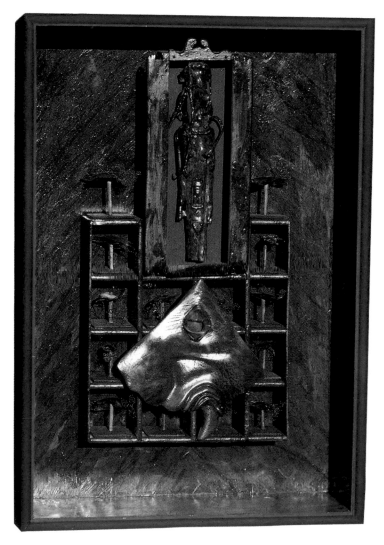

40. *Ray Fish Shrine* (1976)

tabernacle and a row of iron fishing-hooks above a carved, wooden sea. In the same year, *Ray Fish Shrine* (*Pl. 40*) is a work which, on the one hand, links this imagery directly to the *Ring-Net*, for its inspiration is an old photograph collected for the *Ring-Net* project of a group of fishermen standing with a giant ray that they have caught. On the other hand though, this real image is transformed into a votive altar for some forgotten religion, perhaps for one of the rites of the 'Fisher King', for the idea of the fisherman as

the archetype of 'natural man' has an impressive pedigree.

Jessie Weston had identified the Fisher King – *le Roi Pêcheur* – as at the heart of the story of the quest for the Grail. She argued that in that story, the whole symbolism of Fish and Fisher are central symbols surviving from the earliest nature rituals:

> The fish is a life symbol of immemorial antiquity . . . the title of fisher has from earliest ages been associated with Deities

57

who were held to be specially connected with the origin and preservation of life.[22]

In the legend of the Grail too, according to her interpretation, it is because of his catching a fish that Brons, brother of Joseph of Aramathea, came to be called the Fisher King and the fish that he caught was identified by some authorities with the salmon of wisdom of Celtic legend,[23] an identification that is imaginatively potent, no matter whether it be authentic. Because of T.S. Eliot's poetic interpretation in *The Waste Land* – one of the best-known poems of the twentieth century – of Jessie Weston's theory of the origin of the story of the Grail in ancient nature ritual, it has been a familiar topic in modern literature. It was clearly an important element in Neil Gunn's *Highland River*, for instance, and it would not be surprising if Maclean's iconography should draw on this kind of symbolism.

He sees it, though, through the immediate example of fishing in the present, but here the immemorial intimacy of the relationship of the fisherman and his prey is being disrupted by technological change. *Rudder Requiem* (1985, *Pl. 41*), for instance, is a requiem for fishing in its ancient form. The work is in the shape of a rudder, but shaped from the end of a church pew and decorated with carving rather as a Polynesian steering oar might be. On it is the image of a man, his head full of fish, an image both of his dedication and of his skill. It is also, though, a memorial to the particular individual who inspired it and so it is a colloquial image too, for he was described by his friends as having 'his head full of fish'.

Rudder Requiem is therefore an emblematic portrait of the kind that began with *Abigail's Apron*, or even with *Requiem Construction (John Maclean)* and which continued in *Portrait of Angus Mackenzie*. The most moving of these is

also an image of fishing and it too is both personal and archetypal. This is *Skye Fisherman: In Memoriam* (1989, *Pl. 42*). A yellow life-jacket, heavy rubber gloves and other paraphernalia of the fisherman are combined in a painted relief. It has a powerful presence as a memorial to the actual individual commemorated (who was the artist's uncle, William Reid), but there is also something of Phlebas the Phoenician in *The Waste Land*, or Puvis de Chavanne's *Poor Fisherman*, or perhaps, faceless and grand, his yellow oilskin like a suit of armour and carrying as his regalia the tools of his trade, he is the Fisher King himself, the king who must die.

Like Eliot and Puvis, Maclean, in a single image, can reach from the immediate topicality of the present and personal to the permanence of myth, or indeed beyond, for the sea itself underlies all our consciousness, like the ultimate Jungian symbol:

> An image o' the sea lies underneath
> A' men's imagination – the sea in which
> A' life was born and that cradled us until
> We cam' to birth's maturity. In waves bewitch
> Us still or wi' their lure o' peacefu' gleamin'
> Or hungrily in storm and darkness streamin'.[24]

Like memories of childhood, fishing is another kind of living archaeology, an opening to a magic kingdom of memory and myth. As fisherman, man can be seen as a creature of nature, in touch with and dependent upon the natural world. The power of these fishing metaphors is that in this way they present man as once having had a place within nature's apparent harmony. Primitive religion and the ritual preserved in the romance of the Grail, according to this view, were a way of reinforcing that harmony, though the religion of the fishing people of Scotland,

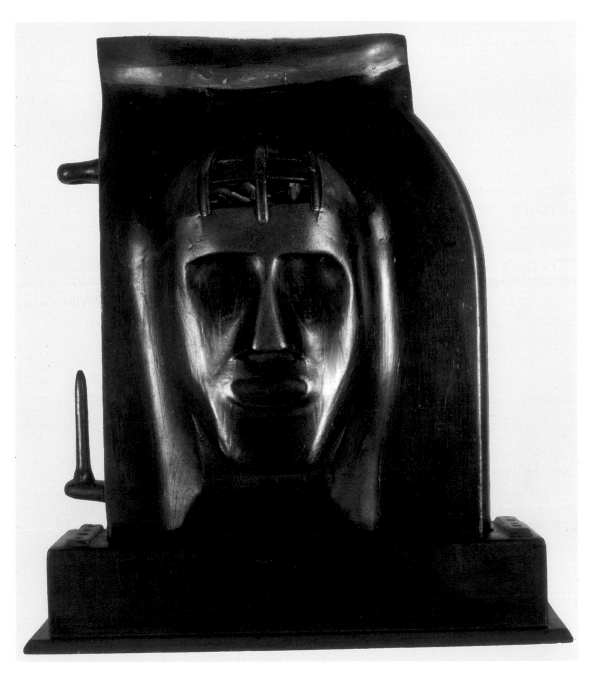

41. *Rudder Requiem* (1985)

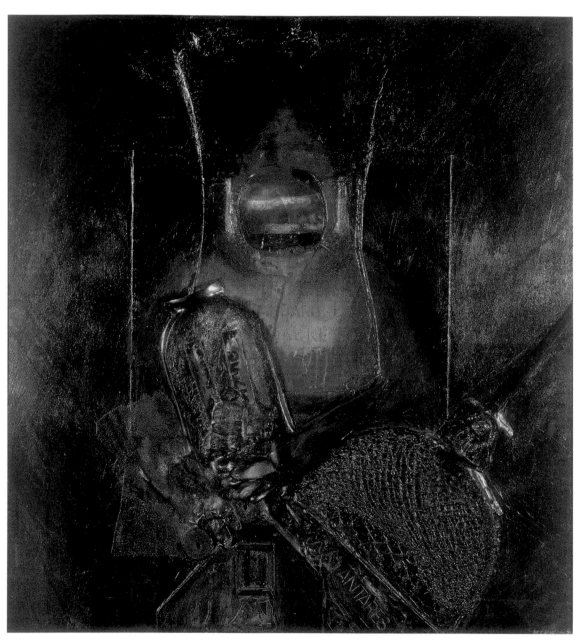

42. *Skye Fisherman: In Memoriam* (1989)

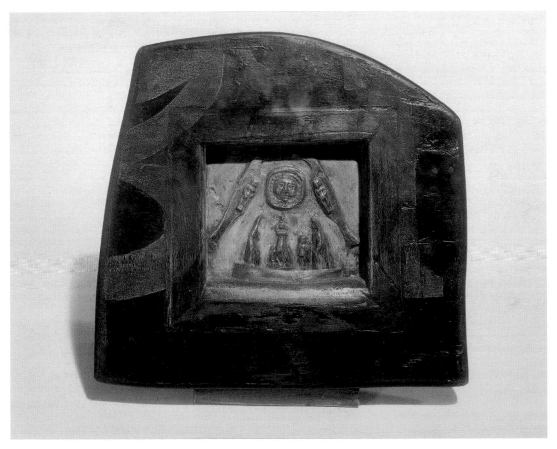

43. *Sea Lectern* (1989)

too, reflected their environment in a primeval way. Just as primitive man translated his understanding of nature into religious form, the unforgiving god of Calvinist predestination evoked in works by Maclean such as *Sea Lectern* (1989, *Pl. 43*) personifies the fierce indifference of the sea.

* * *

Within the western tradition, since the eighteenth century, time, perceived through history and even more through history's imaginative corollary, folk-memory, has been seen by artists as a way into the deeper levels of the imagination and back to an imagined, natural state buried beneath our modern consciousness. It reflects the belief that at some remote point in time, as it were before our minds were made up according to the patterns of civilised convention, our beliefs and values assumed a simpler, more natural configuration. It is a version of the myth of the Golden Age; a myth as old as mankind; in one form it is in the book of Genesis and it was first called the Golden Age by Hesiod. It assumed a new importance in the eighteenth century in theories of the evolution of human society and its moral structure and in the political interpretation given to them by Rousseau, but it was with Wilkie and John Galt that the specific contrast between past and present, though on a much shorter time scale, was for the first time used as a vehicle

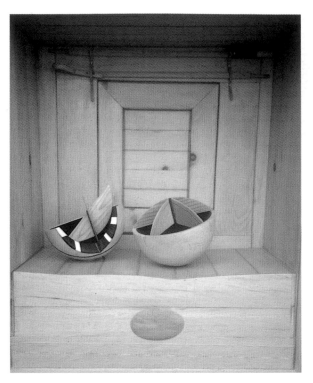

44. *Navigator's Locker* (1982)

for direct, social criticism. After them, it was taken up by Thomas Carlyle who, with some help from the Germans, gave the idea a definitive form for the nineteenth century in his appropriately named book, *Past and Present*.

The surrealists endorsed this tradition and substituted the psychologists' idea of the unconscious as the representative of the state of nature for the older, philosophical idea of the imagination and its corollary, the relationship between freedom of imagination and purity of moral sense, but the motive remained the same; the moral ideal that man could not have been created as selfish and as wantonly destructive as recorded history suggests that he always has been. The Old Testament myth of the Fall – itself a version of the myth of the Golden Age – presented an alternative which, secularised, has served as one of the principal, underlying motives of

modern art, but it is seen as a fall, not from the grace of God, but from nature. The sense of loss for the innocence of childhood – which could be equally the childhood of the individual or of the race – is seen as originating in loss of this natural communion.

If post-modernism stands for anything, it is really the recognition by critics of what has been understood by the most far-seeing artists for a long time, that the simplicity of this optimistic idea, the idea on which modernism was based, is attractive, but that its origins in the Utopian philosophy of the eighteenth century are so entangled with the origins of the idea of progress that in the end it is morally suspect. Modern history has shown that the concept of progress is profoundly at odds with the real truth about the ambiguous part that nature plays in the compound human nature. His insistence on this point has caused Ian Hamilton Finlay a deal of trouble and, like Finlay, Paolozzi too recognised this long ago. Their art is imbued with a note of far less sentimental realism.

Finlay, too, uses fishing as Puvis de Chavannes did, as an image of the austerity of the true pastoral tradition, which he sees as a state of nature characterised, not by absence of rigour, but by the opposite: the supreme, intellectual and moral discipline needed to maintain it. It is a similar perception which gives moral complexity to Maclean's fishing imagery. Fishing in its ancient form epitomises the ideal relationship of man and nature; in its modern form, like the Clearances, its breakdown. Like Finlay, Maclean's subject is not the ideal balance, but the destructive tension between man and nature – between Captain Ahab and Moby Dick. In this, his implied belief in the role of the artist, if not his actual vision, is true not just to his post-modern contemporaries, but like them too,

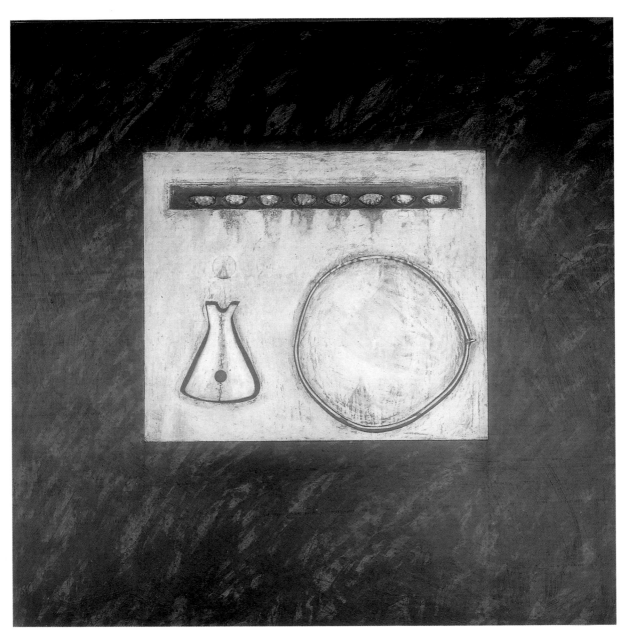

45. *Diviner's Wall* (1992)

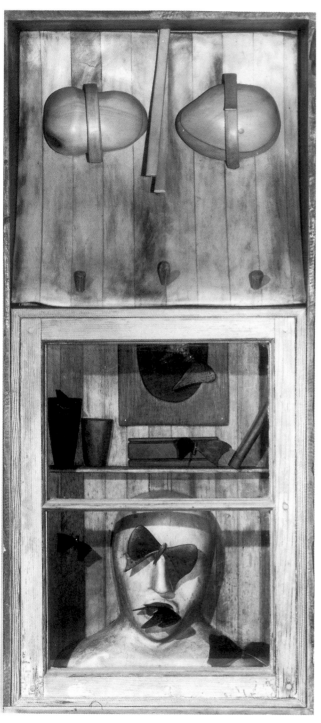

46. *Window Visitation, North Uist* (1980)

to the much older tradition of the bards. Blake saw himself as a bard in this sense and in the Highlands, where the tradition of the bards survived for so long, this view does genuinely reflect something of their social role, recording, exhorting, celebrating and in the end standing for the transmission and evolution of values. MacDiarmid and Sorley MacLean stand for the revival, or perhaps the perpetuation of this tradition and Will Maclean joins them, for in his art he presents the ultimately insoluble, moral complexity of our situation, where innocence and experience must constantly coexist and are sometimes indistinguishable.

* * *

Outside the formality of religion, superstition and belief in the supernatural have always been instinctive ways of seeking to reconcile this paradox. Exploration of these areas and of experience at the edges of conventional consciousness has also for long been part of the literary tradition in Scotland, from the 'Bodach Glas' in *Waverley* to the importance of second sight in Neil Gunn's novels. It is a natural part of Maclean's art too therefore, and in pursuit of such ideas he turned in the late 1970s to explore these traditions in the Highlands, recorded in such books as John Gregorson Campbell's *Superstitions of the Highlands and Islands of Scotland*.[25] As well as following the literary tradition though, in doing this he was acting very much along lines pioneered in visual art in Britain by Paolozzi and Davie. When Davie compares the artist's role to that of a shaman, he is suggesting that he can be an intermediary between this world and a metaphysical one, in primitive terms a world of spirits. William Johnstone was a pioneer of this Jungian view of art in Britain and through Johnstone, Davie and Paolozzi are

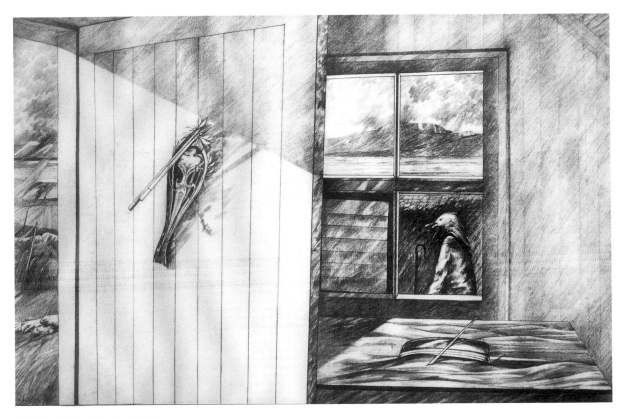

47. *Two Sights of the Sea* (1982)

also linked to the Scottish poets and the novelists. All three though are ultimately indebted to the surrealists, and Maclean too is equally dependent on their inspiration.

In his work, it is possible to see the direct influence of Magritte, for instance in the painted landscape within the bookcase in *Interior Wester Ross*, but also beyond the surrealists, the influence of De Chirico who was such an important inspiration to them is also apparent. In *Navigator's Locker* (1982, *Pl. 44*) for example, two white spheres sit on a shelf in a white-painted, but empty space. This luminous, structured emptiness recalls De Chirico and so do the shapes themselves, though they are also reminiscent of James Cowie. They are made up from cut and reassembled navigation instruments whose

geometric shapes suggest the kind of enigmatic, pseudo-mathematical forms often seen in De Chirico's painting. Perhaps too, they suggested some kind of anarchic or metaphysical system of navigation.

Museum for a Seer makes a direct connection between surrealist iconography and Highland prophecy. The seer in the title is the Brahan Seer. He had a divining stone and it appears as an enigmatic object in the foreground, carved from wood. The rest of the work is equally enigmatic, for it is shrouded in a cloth, also carved and painted. To us the future is concealed. Only the seer can lift the cloth. The simplicity of this work and the way it is executed recall Magritte's subversive realism, but perhaps once again the work of De Chirico. *Window Visitation, North Uist* (1980,

48. *China Nights* (1983)

Pl. 46) shows a similar inspiration and in this case the artist is explicitly exploring the transitional territory beyond the margins of conventional consciousness.

In technique, this work is close to *Abigail's Apron*. It is beautifully made of wood and is basically a simple representation of something seen. The face of an old man, pale and obviously ill, glimpsed at a cottage window inspired it. The artist has reproduced the window, framing the man's face, and the stone weights holding the roof in place, but at the man's mouth and eyes are black butterflies. According to one Highland superstition, it is in this form that the soul leaves the body[26] and so here the butterflies are a premonition of death, or of the soul's transference.

Few places, at least in the west, present such vivid and tenacious folk memory as the Highlands. Premonition and second sight are, of course, central among Highland superstitions and the idea of the possibility of a shift between actual and spiritual vision is a constant theme with Maclean. One important drawing of this period, for example, is *Two Sights of the Sea* (1982, *Pl. 47*). It is an actual view of the corner of a room with a view through a window and it includes in the foreground an image of the related, contemporary construction, *The Drowning*, with an image of an upturned boat in the waves. In the drawing, there is a view of the outside world and the sea beyond, both through the door and through the window – a visual pun on the Gaelic for second sight which is literally 'two sights'.

An old man can be seen sitting outside the window against the open view, but he has

49. *Wheelhouse Triptych* (1981)

been given a bird's head, like a primitive ceremonial mask. As a bird, he is a creature of nature and can move freely in the world beyond. Miró uses birds as images of spiritual or imaginative freedom, freedom in this case to move in the imaginary landscape reached through the window. Bellany, too, uses them as Maclean does, as metamorphic figures in much the same way as animal and bird masks are used by primitive people, not as a pretence or disguise, but to claim identity with the creature represented.

Windows are one of the most frequent motifs in these constructions. Sometimes they are used to enclose the work, but at other times they are more directly part of the iconography. This is especially true when they are the windows of the wheelhouses of fishing-boats, which are in effect the subject of several works, for instance, *China Nights* (1983, *Pl. 48*), *Wheelhouse Triptych* (1981, *Pl.*

49) and *Wheelhouse Study II* (1981, *Pl. 50 &* 1973, *Pl. 51*). The first has echoes of Conrad, memories of the east, invoked by a broken bamboo screen and a junk mysteriously, but only indirectly visible in a mirror in the dark interior of the work. In *Wheelhouse Study II*, a dog-fish and other fishes are visible in the wheelhouse window. The sailors have undergone a metamorphosis and there is salt trapped between two panes of glass. Like Actaeon, the hunters have joined the hunted. It is a ghost ship, under water.

Wheelhouse Triptych is more ambitious. It is a large work made up of three sides of a wheelhouse, opened out and laid flat to create a triptych. Within the windows, the fishermen are seen in metamorphic form as seals and birds, creatures that can move freely in their natural element. The ship itself invoked by the wheelhouse is part of the metaphor too. With its freedom to move over the sea, it is a

50. *Wheelhouse Study II* (1981)

early 1980s, *Bard McIntyre's Box* (1984, *Pl. 54*).

Maclean's interest in Gaelic culture naturally led him to the bardic poetry which is such an important part of it. Later he produced an important series of prints illustrating this body of verse and including this poem, but *Bard McIntyre's Box* was one of his first works in this field. This kind of exploration of the territory of the imagination was of course the business of the bard and the poem called 'The Ship of Women' in the *Book of the Dean of Lismore* from which the image is taken is an example of its richness:

What ship is this on Loch Inch, or can it be reported? What has brought the ship on the loch? . . .

An old ship without anchors, without oak timber;
we have not known its like; she is all one ship of leather:
she is not a ship complete for sea-going.

What is yon crew in the black ship, pulling her among the waves? – A crew without fellowship, without sense, a woman band of mind disordered.

A band loud-voiced and talkative, loquacious, chanting, negligent; flighty, quarrelsome, greedy, ravenous, evil, of ill desires.

A party thick-rumped and lascivious is that around the two sides of Loch Inch; they have all been cast into the ship on the chill ridge of the sea.

A good woman would not venture into the Ship . . .[27]

metaphor for the movement of the work of art within the imagination; or in Sorley MacLean's poem, 'The Ship', the ship is Gaelic culture itself. Like Bellany's mask figures, the figures reflect the idea of metamorphosis, codified by Ovid in his *Metamorphoses* on the basis of primeval folk-memory, as a way of describing the spiritual continuity which underlies the apparent difference between man and the other creatures of nature. It is a belief that of course appears in Highland superstition in many forms, of which the best known is the silkie, the man-seal, visible here in the window of the wheelhouse. The ship in *Wheelhouse Triptych* is a fairy ship therefore, one that can sail beyond the world of men. Such magical vessels of course also play a part in folk-tradition and in fact just such a ship inspired one of Maclean's best-known works of the

Worthy of Dürer or Breughel, this ship with its crew of crazy women is a kind of ship of fools,

but also, perhaps, of temptation. The bard's high moral tone implicitly acknowledges the seductive power of such anarchic femininity. In Maclean's construction, three grotesque women present themselves to us like figures in a black mass. The central one has a grotesquely oversized vagina formed from two seal's teeth, truly the *vagina dentata* that weds fear with desire. In the dark water below the boat, threatening fish swim like the mind's unacknowledged motives swimming in the darkness of the unconscious.

A variation of *Bard McIntyre's Box* is also the subject of one of the etchings in the set *Night of Islands* with the title, *The Author of this is . . .* (The published poem is headed with the words 'The Author of this is the Bard McIntyre'.)

Such imagery is a reminder that neither the true Highland culture, nor Maclean's metaphoric use of it, is any more morally simple than human culture anywhere. We do not have in his work, therefore, merely the opposition of idealised past innocence to present corruption, but a moral universe in microcosm in which this polarity is perpetual and under constant tension. This polarity is nevertheless frequently presented as a temporal opposition however, and as such it is an important element, not just in Maclean's art alone, but in the whole tradition to which he belongs.

* * *

The image of the ship in *Bard McIntyre's Box* is part of Maclean's iconography of the sea. The strange sailors in *Wheelhouse Triptych*, for example, could be compared to Bard McIntyre's bizarre crew, but, as we have seen, fishing itself is an integral part of Maclean's imagery. Like the history of the Highlands of which it is part, as he uses it though, it is the tap-root of a wider metaphor. It is a

51. The wheelhouse of the *Fortitude* (1973)

metaphor though which also starts in his own personal experience. In *Memories of a Northern Childhood*, for instance, as he did in *Symbols of Survival*, he took the imaginative intensity of his own remembered childhood as the starting point.

This work shows how much fishing had encompassed his ambition as a child, but there was also boyhood fascination with tales of adventure in the Arctic. A good many works of the 1980s, like *Log Book I – Polar Voyage* (1986, *Pl. 52*), *Log Book II – Winter Voyage* (1986, *Pl. 53*), *Pole Marker Triptych* (1987, *Pl. 55*), *Arctic Signs 1, 2, 3 & 4* (1984–6), *Winter, North Atlantic* (1988, *Pl. 56*) or *Arctic Sea Marker* (1987, *Pl. 57*) or *Stern-Sheet Icon* (1987, *Pl. 58*) reflect the artist's fascination with such stories. *Polar Voyage*, for instance, takes its subject from one of Franklin's voyages and a prominent detail is a representation (upside-down) of a folding boat that he took with him. *Pole Marker*

52. Log Book I – Polar Voyage (1986)

53. *Log Book II – Winter Voyage* (1986)

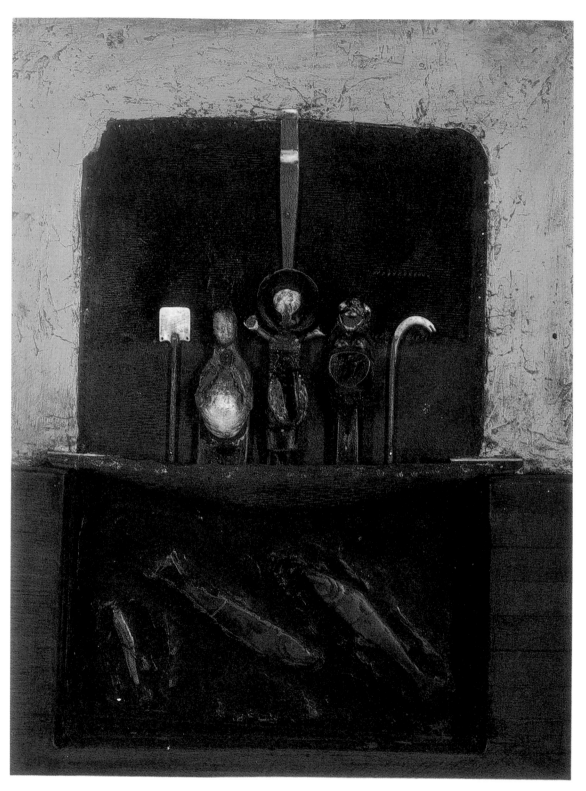

54. *Bard McIntyre's Box* (1984)

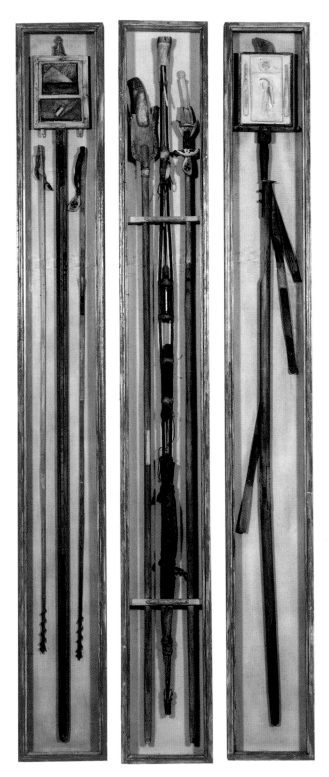

55. *Pole Marker Triptych* (1987)

56. Winter, North Atlantic (1988)

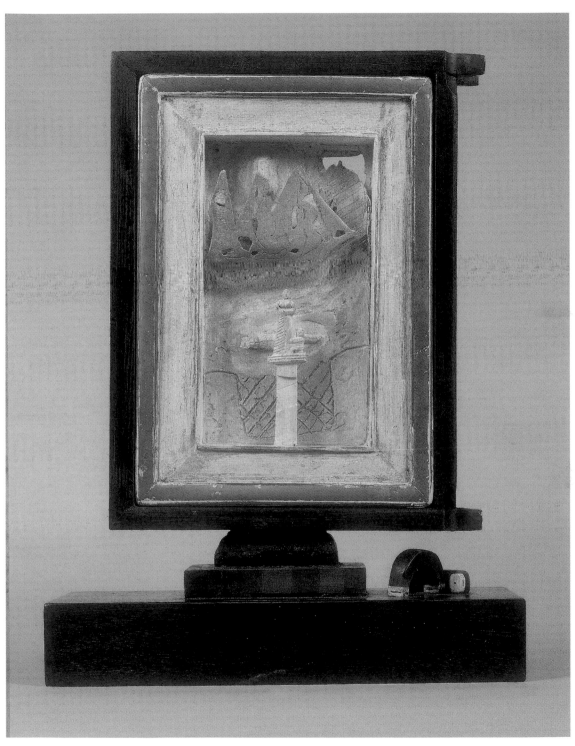

57. Arctic Sea Marker – front (1987)

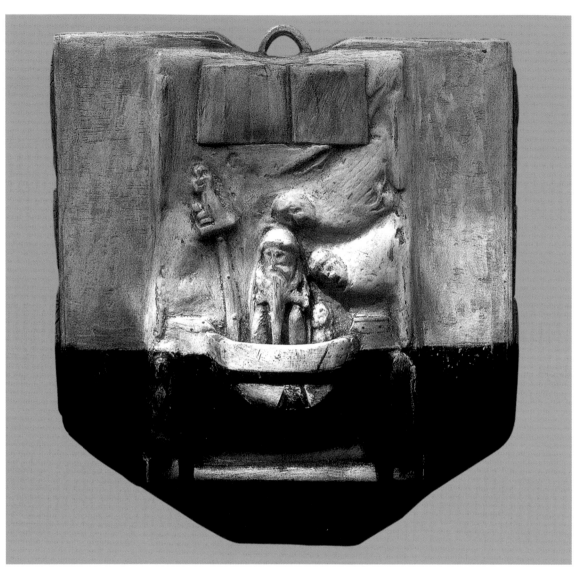

58. *Stern-Sheet Icon* (1987)

59. *Black Vessel Foundering* (1994)

Triptych was inspired by an account of Peary, in effect being taken to the North Pole by three Eskimos. They were not seen as heroes, so this is their memorial.

At one level such works invoke the simple atmosphere of sailors' yarns, even if touched with irony. Such tales of men living in the face of nature can work at two levels, though. As Melville showed, they can be both a good story and a metaphor of the original human condition, and something of a complexity of vision which Melville and Conrad, too, built out of such material is there; the dark side revealed when men follow their instincts. For instance, Maclean has made various works on the theme of shipwrecks, and in particular the *Raft of the Medusa*. These latter contain an obvious reference to Géricault in their subject, but he has also gone back to the original testimony of the survivors to provide his own commentary on the horror of the tragedy. *Raft of the Medusa II*, originally part of a three-part work, is a schematic model of the raft, scored by cutlasses and blood-stained from the fighting over a lemon, one of the last scraps of food left to the survivors, while fish wait ominously below. In *Black Vessel Foundering* (1994, *Pl. 59*), a ship sinks beneath the sea, people still trapped in the hold. In *Fisherman's Log* (1987, *Pl. 60*), a fish, in the shadowy form of a shark, threatens a sailor directly as he clings to the raft. *Raft*, a work on this theme made in 1990, superimposes a modern, inflatable life-raft over a photo-etching of the engraved plan

60. *Fisherman's Log* (1987)

of the *Medusa*'s ill-fated timber construction.

This recognition of the dark side of man's relation to the natural world and of its brutality informs Maclean's whaling imagery too. In *Leviathan Elegy* (1982, *Pl. 61*), for instance, there are three rows of relics of a whale. The first shows the detached arrangement of a museum display. The second is like a group of Eskimo artefacts and tools. The third presents the brutality of modern whaling. *Arctic Signs No. 3 Line Box*

(1984, *Pl. 62 & 63*) shows rows of whales' tails, stamped with the poundage of oil extracted from each creature, and presented as the whaling captains recorded them in their log-books themselves. Below are the instruments of torture, the harpoons, the boats and the log-books themselves.

Arctic Signs No. 4 – Mayday (1986, *Pl. 64*) presents a more complex idea. At the centre of it is a wreath. This is a reference to the sailors' practice of hanging a wreath on the

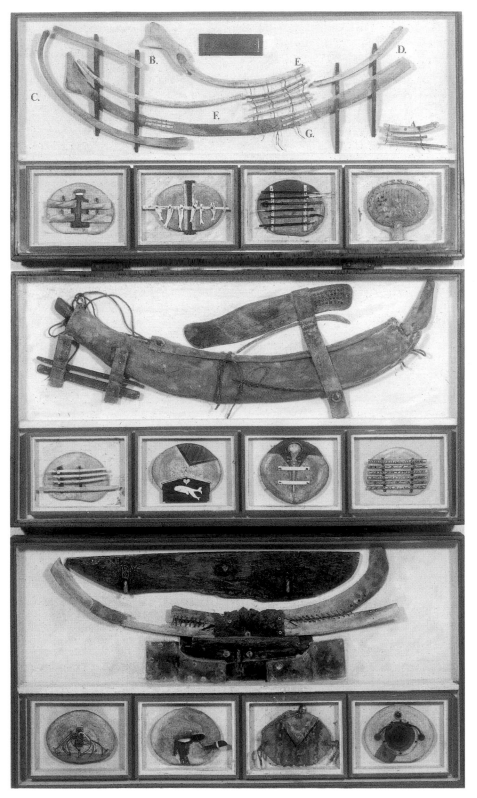

61. *Leviathan Elegy* (1982)

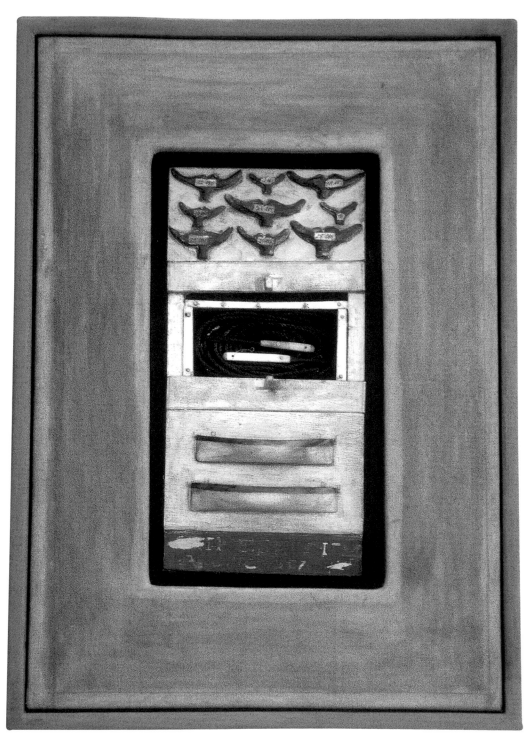

62. Arctic Signs No. 3 Line Box (1984)

63. Study for *Arctic Signs No. 3 Line Box* (1984)

same rich textures, using paint, metal and inlay, but again this beauty underlines the cruelty of the image. With these and related works, the construction itself is set into a wide, painted, flat surround which now functions very much as a picture field, rather than as a simple framing device.

* * *

The histories of deep-sea fishing and whaling encapsulate the duality of the relationship of man and nature which religion has sought to resolve in the idea of the Fall. On the one hand, nature represents the ideal of the innocence of Eden, on the other hand, also in Eden, it is on the natural side of humanity that the darkness lies. Had Adam refused the apple, he would not have been true to his nature. As fishing has evolved from a kind of living archaeology, the same is true. It only

mast on Mayday. When the ship docked, the town boys raced up the mast, competing for the wreath as innocently as girls competing to be May Queen. Above this wreath is a ship carved from whalebone, a sailor's memento of a whaling voyage and an image that reappears in several related works, but below is a harpooned and dying whale. The pun on Mayday makes a cruel contrast as the whale cries for help. It is an image in which innocence and experience are indivisible.

The irony is reinforced by the beauty of this work, which is also an outstanding example of the artist's use of the techniques of painting in his constructions. It is a rich blue, rubbed to white so cleverly that the recessed boxes work both as containers and as pictorial space, but the iconography makes it clear that there is no simple purity even in such beauty. *Arctic Signs No. 3* shows the

64. *Arctic Signs No. 4 – Mayday* (1986)

65. *I didn't go willingly, I went sadly* (Detail) (1983)

a beautiful work, *I didn't go willingly, I went sadly* (*Pl. 65*) which presents the consequences of the dislocation of Highland life in terms of the Expulsion from the Garden. This is the title of a poem by Murdo MacFarlane of Lewis and the subject is the sadness of all the girls sent out to exile in domestic service, far from their Highland homes. At the centre of the work is a photo-etching of such a group of girls. The rest, infused with melancholy, suggests the bareness of an attic in a stranger's house with a sprig of bog-cotton in a jam-jar, a pathetic reminder of home.

In the 1970s in Scotland, one of the most effective presentations of the linkage between past and present in the disastrous march of progress in the history of the Highlands was *The Cheviot, the Stag and the Black, Black Oil*, written by John McGrath and performed by the 7:84 Theatre Company. Since then, the signs of impending ecological disaster have been added to this black picture. The Clearances prefigured the present situation, reflecting the same ruthless, shortsighted exploitation of resources in the interest of gain, which in the end was to leave only an empty land. Now, it seems, it will leave us an empty sea as well, for the same situation has evolved in the fishing industry. There technological change and the departure from historical methods are clearly leading to ecological disaster and have already seen the beginning of social changes which will eventually bring about a transformation as calamitous as the Clearances themselves.

In the early 1980s, Maclean extended this theme to include the new image of the nuclear submarines which are a constant threatening presence on the west coast, the epitome of destruction and a fearsome, vengeful metamorphosis of the whale. This also reflects his close association with Sorley MacLean and *Sabbath of the Dead* was followed by a series of drawings on this theme. In his

needed technology to show where men are concerned, how quickly the innocence of the state of nature can become the cruelty of experience. Thus illustrations of the metaphor of the Fall are easily found in modern life.

The Clearances themselves, Maclean's own starting point, are a perfect illustration of the destruction of a way of life by science in the service of economics, of the conjunction of knowledge and greed, just as when Adam plucked the apple – in this case these were represented by new agricultural methods employed in the interest of economic improvement. Indeed in 1983, Maclean made

66. *Death Fish Study II* (1983)

poem, 'Screapadal', the poet associates the destruction of the Clearances directly with this new image of violent destruction (in these verses, Rainy was the individual responsible for the clearance of Screapadal):

Dh'fhàg Rèanaidh Screapadal gun daoine
Gun taighean, gun chrod ach caoraich,
Ach dh'fhàg e Screapadal bòidheach;
R'a linn cha b'urrainn dha a chaochladh

Thogadh ròn à cheann
Agus cearban a sheòl,
Ach an diugh anns an linnidh
Togaidh long-fo-thuinn a turraid
Agus a druim dhubh shlìom
A'maoidheadh an ní a dheanadh
Smùr de choille, de lianagan's de chreagan,
A dh'fhàgadh Screapadal gun bhòidhche
Mar a dh'fhàgadh e gun daoine . . .

Tha tùir eile air a linnidh
A'fanaid air an tùr a thuit
Dhe mullach Creag a'Chaisteil,

Tùir as miosa na gach tùr
A thog ainneart air an t-saoghal:
Peireascopan's sliosan slioma
Dubha luingeas a'bhàis . . .

Rainy left Screapadal without people,
with no houses or cattle, only sheep,
but he left Screapadal beautiful;
in his time he could do nothing else.

A seal would lift its head
and a basking shark its sail,
but today in the sea-sound
a submarine lifts its turret
and its black sleek back
threatening the thing that would make
dross of wood, of meadows and of rocks
that would leave Screapadal without beauty
just as it was left without people . . .

There are other towers on the Sound
mocking the towers that fell
from the top of the Castle rock,
towers worse than every tower

83

67. *Death Fish* (1983)

that violence raised in the world;
the periscopes and sleek black sides
of the ships of death . . .[28]

In a series of drawings, the nuclear submarine appears as the death-fish, a sinister, man-made Leviathan, identifying not only the Clearances, but also the persecution of the whale with the destructiveness epitomised by the nuclear submarine. In 1983, *Death Fish* (*Pl. 67*) and *Death Fish Study II* (*Pl. 66*) show the metamorphosis of the submarine's sinister shape into that of a shark. In *Inner Sound* (1984, *Pl. 68*), the malign, dark shape of the submarine's conning tower is seen through a broken, boarded-up window in an abandoned cottage. It is a sinister gloss on two lines from 'Hallaig' and a new and even more destructive incarnation of the forces which drove away the people who once lived there:

Tha bùird is tàirnean air an uinneig
troimh'm faca mi an Aird an Iar

The window is nailed and boarded
through which I saw the West . . .[29]

Hebridean Cruise (1985, *Pl. 69*) has an ironic title and in it, a piece of military hardware found on the beach echoes the shape of the conning tower of a submarine. In another drawing, *Hunter's Vision* (1989, *Pl. 70*), three submarines move past as though under water, but the scene is in a forest. Bird skulls hang like macabre creepers and in the background, the sleeping shape of the Celtic god of hunting, Herne the Hunter, antlered like Actaeon, can just be made out. He is a mysterious figure from Celtic art and mythology who reappears in a number of Maclean's works, for instance in *Winter Kyle Elegy* (1989, *Pl. 71*). The submarines themselves seem partly entangled in the fluttering rags of funerary banners, like the rags on the Cloutie Well on the Black Isle.

These suggest the nets of fishing-boats as the entangling of nets by submarines in this

68. *Inner Sound* (1984)

69. Hebridean Cruise (1985)

70. *Hunter's Vision* (1989)

way has been the cause of too many tragedies on the west coast. One of the worst was the sinking of the *Antares* in 1990. In an extraordinary and disturbing coincidence, even an experience of second sight, Maclean had incorporated the name of the *Antares* from a fish-box into his work *Skye Fisherman: In Memoriam* a year before. Thus the memorial predated the tragedy.

These reflections on the dark side of progress are a constant theme in the work of the writers of the Scots Renaissance. For instance, specifically invoking the fall from a forgotten Golden Age, Gunn wrote in *Highland River* (in the novel the hero had been gassed in the First World War):

Voices of foreign secretaries as solemn today as the voice of Memphis. More

money. More high explosive. More gas. In the name of Civilisation, we demand this sacrifice . . . It's a far cry to the golden age, to the blue smoke of the heath fire and the scent of the primrose! Our river took a wrong turning somewhere.[30]

Maclean's own art continued to develop these themes of social concern, but in a new direction, following a visit to America in 1989 and his exposure there to the dark side of modern capitalism. The purpose of the trip was to visit the whaling museums of New England which are repositories of wonderful collections of the kind of things that had been central to his inspiration for so long. Ironically, though, he found a different inspiration, its underlying concern the same, but now more urgent in his response to the

71. Winter Kyle Elegy (1989)

experience of America and the diminution of humanity that results from the stark facts of urban alienation which he witnessed there. He recognised in it the same dissociation of sensibility as created the moral blindness that, in the name of wealth and profit, had destroyed the communities of the Highlands. This was the more ironic as it was America that had been the destination and the promised land of so many of those who were driven out. *The Emigrants, America* is, for instance, the wildest and most tragic of McTaggart's paintings on this theme painted a hundred years earlier.

Continuing the saga, in response to what he saw, Maclean created a series of images of modern America as telling and, because of the development of his technique, even more immediate than his own earlier works, *Central Park* (1989, *Pl. 72*), for example, is a graphic account of homelessness. At its centre, a man is sleeping with a cardboard box on his head and another on his feet, just as the artist saw him in Central Park. In *Manhattan* (1988, *Pl. 73*), Maclean contrasts the soaring beauty of the Empire State Building with the human darkness at its feet. *Nantucket Front and Back* (1989, *Pl. 74*) is a dark totem which dramatically opposes the front, the now tidy world of the whalers in the New England museums, all death and danger safely distant, all passion spent, to the insane tidiness of a poor woman seen in a bus waiting-room, crazily packing news-papers into a left-luggage locker, her fractured sense of order as remote from reality as the whaling museums.

In these and other works of the time, although he continued to develop the underlying themes that had been his preoccupation for so long, Maclean began to use a much freer, more open manner. Previously, using drawings, he had generally planned his work carefully. Collage or assemblage, too, had been his main medium since 1975, but increasingly he combined it with painted surfaces which serve a properly pictorial purpose in a way that reflects his original training and its preoccupations. *Manhattan*, for instance, includes a directly pictorial image of a skyscraper. *Fisherman with Coalfish* (1990, *Pl. 75*), *Island Ferry – Cape Cod* (1990, *Pl. 76*) and *Bone Circle* (1990, *Pl. 77*) are paintings as much as constructions. In all of these, intelligibility of the image depends on the use of paint and colour.

The discovery of the new medium of assemblage had been a liberation from the constraints of painting and it had allowed the artist to develop a rich and complex subject matter, but he had never become a narrative artist for whom formal con-siderations were secondary to its demands. They went together and had it not been for the skill and economy with which he unifies his image so that we are always struck first by its apparent simplicity, his art would not be so effective.

The Dada artists and the surrealists used these techniques to promote startling conjunctions in which the objective was to break down the expected, or conventional associations of familiar objects and to replace them with new ones. The theories of Freud and Jung led artists to see that such processes might reflect deeper, unconscious con-nections in the mind. Just as Paolozzi saw non-western societies adapting western products to more imaginative uses, such images can then have an autonomous power like that with which a totem is endowed; autonomous because it is not dependent on any explicit intention or interpretation, but is an intrinsic quality of the image. To create something truly totemic in this sense has been one of the driving ambitions of western artists since the surrealists. Maclean's art, too, reflects this ambition.

72. *Central Park* (1989)

73. *Manhattan* (1988)

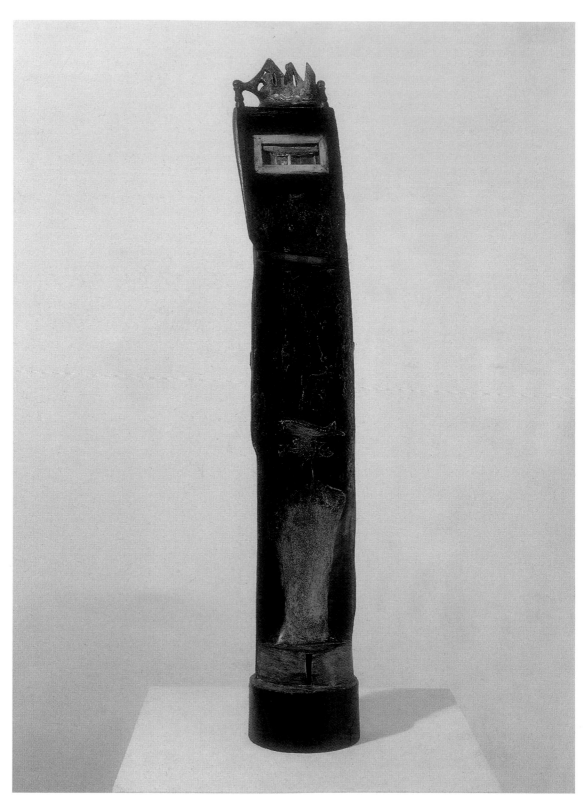

74. *Nantucket Front and Back* (1989)

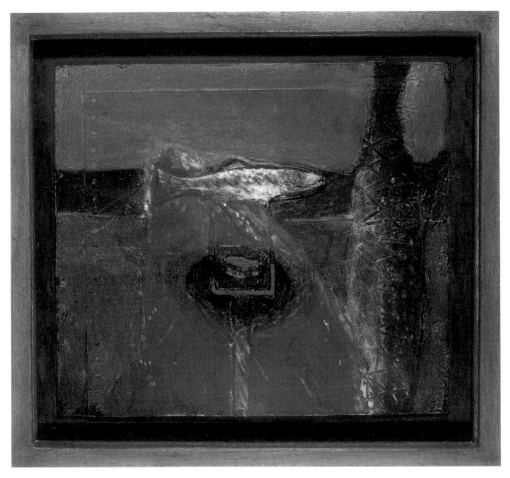

75. *Fisherman with Coalfish* (1990)

The shrine-like quality which is such a common characteristic of so many of his works is a reflection of this. Even when there is also a particular set of references invoked, it gives his art a hieratic quality and he frequently stresses the central, vertical axis so that the image becomes formal, suggesting some kind of primitive ritual image. Other works like *Sea-Creed Banner* (1984, *Pl. 78*), *Enigmatic Figure* (1984, *Pl. 79*), *Tide Column* (1986) and *Ancestor Figure* (1986, *Pl. 80 & 81*), all free-standing, are intended to be mysterious and to work at a level of imaginative suggestion without precise context, though in the latter, suggestively the figure in the work is carved from the butt of a shotgun. Sometimes these works invoke a particular kind of mythological image, though without suggesting a precise interpretation. *King Fisherman* (1989, *Pl. 82*), for instance, uses a cast of an Egyptian figurine to suggest an ancient king standing on a boat, like a kingfisher on a branch. The Skye fishermen used to call a successful fisherman a 'king fisherman', so he became a kingfisher, but once again, and this time explicitly, he is also the Fisher King.

Apart from the symbolism that it invokes,

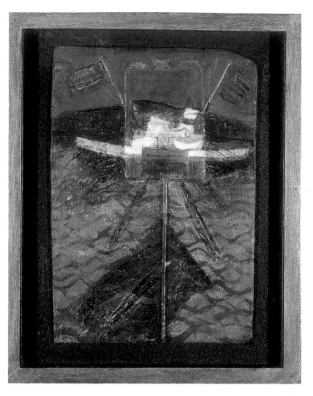

76. *Island Ferry – Cape Cod* (1990)

this little figure is also an example of the artist's use of casting, which began about this time. This freed him from the obvious constraint that he was under when, as he generally did earlier, he incorporated a unique object into an assemblage. He could only use it once, but casting allowed him to combine and recombine objects in different ways and so much more freely. A beautiful example of this way of working and one which also invokes some of the central themes of his art is *The Archaeology of Childhood* (1989, *Pl. 83*).

In this work, he uses toys and tiny china pudding-dolls (porcelain charms to be hidden like sixpences in a pudding). Some are on sticks like primitive standards, others are ranged hieratically like figures in a shrine or on an altar frontal. Using paint and resin, he combines them in a unity whose scumbled, bluish-white surface seems insubstantial.

Some of the forms are shrouded too, as though glimpsed in a dream. Whereas in his earlier work, memory was invoked additively, this is now done by suggestion. The image is incomplete, inchoate. Because of the freedom of execution, the spectator's imagination is also free. The links between the world of modern children and that of the religious imagery and ritual objects of primitive or preclassical art are suggested, not stated, and so are given greater imaginative force.

In this new way of working therefore, the structure of associations that he sets up is much more intuitive, musical even. *Red Ley Marker* (1989, *Pl. 84*), for instance, is a work that uses an image familiar to the artist, a red-triangle warning beacon at the entrance to the harbour at Kyleakin. In a sense therefore, this is a landscape, but the work is not tied to that reference. Instead, it takes a familiar sign and reinvests it with mystery, but it does this pictorially. The central placing of the red triangle and the definiteness of its form within a roughly painted context are what give the image force. In such works, he was confidently incorporating into his own pictorial language the formal lessons of abstract expressionism and its successors in the early 1960s, Rauschenberg and Johns – a pictorial language that had given him such difficulty twenty years before. This kind of freedom is even more vividly apparent in the series of collages made in Italy in 1992 on the theme of the *Stations of the Cross* and these follow on from the freedom of the etchings in the suite *A Night of Islands* (see below).

He did not abandon his use of symbolism though, even as he constructed his images more freely. *Bird Altar* (1988, *Pl. 85*), for example, was one of the first works of this kind and it combines both found objects and casts or mouldings taken from them with a freely painted surface. As an image, it looks

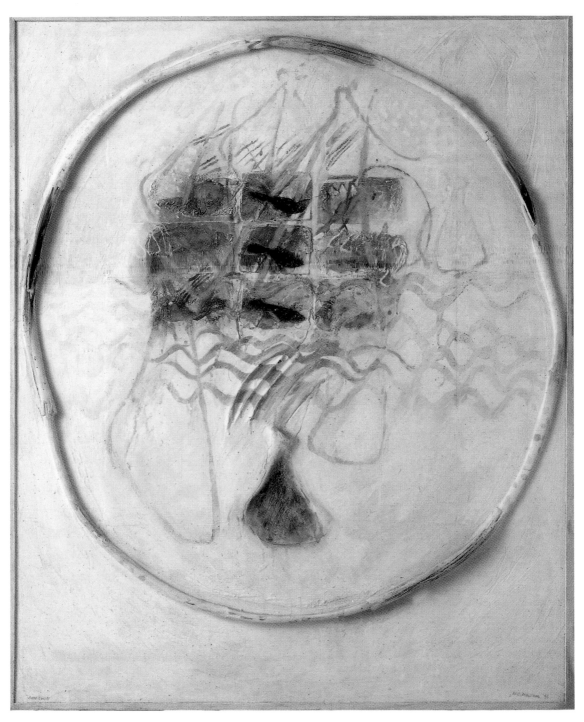

77. Bone Circle (1990)

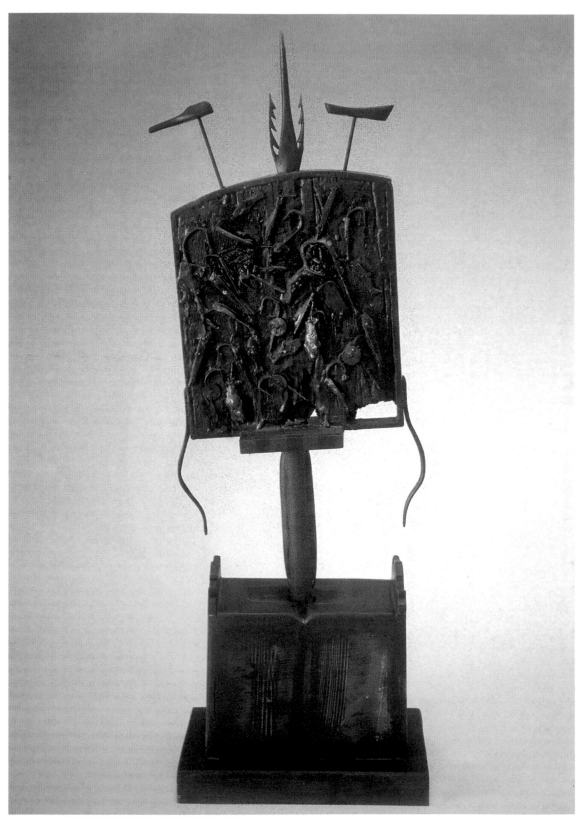

78. *Sea-Creed Banner* (1984)

79. Enigmatic Figure (1984)

80. *Ancestor Figure* (1986)

Second Lady for Ancestor ~~figure~~ *(at Dunvegan) Head*

81. Study for *Ancestor Figure* (1986)

right back to his first constructions like *Memorial for a Clearance Village* (1974, *Pl. 86*) and the paintings contemporary with them, works like *Beach Allegory* and *Three Fires, Achnahaird*. Its freedom leaves interpretation open, but is powerfully suggestive.

The idea echoes the discovery of the remains of a bird cult on Orkney. In *Bird Altar* there are half-formed bird skulls in the upper corners, suspended in the lightness of the sky. Between them hangs a kind of shrine with an ominous skull. It is looking down on a little figure, crouched like Atlas holding up the heavens. He is on a narrow and insubstantial platform while beneath him surge the creatures of the sea. Among them a tiny ship is overwhelmed. Between death by

air and death by water, it is an apocalyptic vision, but it is surely a topical one. It is an image of man in nature and Maclean's whole art explores the relationship between this and its corollary, or obverse, nature in man. It is their imbalance which has led to our present environmental crisis.

There is another dimension to this work, too. According to the myth, not Atlas himself, but his brother Prometheus was the sacrificial victim on just such a bird altar. His crime was to steal fire from Olympus and give it to men. Like the apple in Eden, it was a dangerous gift which, although it has borne untold benefits, has also ultimately evolved into the ominous shape of the nuclear submarine as the poets and artists describe it. Patrick Geddes foresaw the consequences if human nature got out of balance with itself, or with the natural world. He described it in terms of Stevenson's metaphor for the twentieth century, Dr Jekyll and Mr Hyde, the divergence between the raw fact of human inquisitiveness and ingenuity and the humanity which should temper them.

In some memorable lines in his long poem *The Cuillin*, Sorley Maclean also invokes the legend of Prometheus:

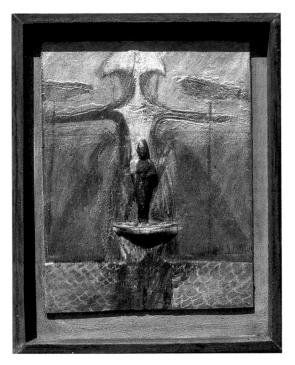

82. *King Fisherman* (1989)

'S ioma car a chuir an saoghal
on chunnaic Aeschylus aogas
suinn-dé-duine crochte màbte
air Caucasus nan sgurra gàbhaidh:
an dia fhuair dealbh air cruth daonda,
Iupiter borb, le iadach claoine
ag cur nam biatach acrach mùinte
a shrachad's a dh'ithe ghrùdhain:
an cinne daonna air na creagan
ag ceusadh anama fhéin ri sgreadan
nan eun is nam brùidean fiadhaich
a fhuair an toirt fhéin on bhiathadh.
Dh'aom Iupiter, an gealtair brùideil,
agus Iahweh an t-Iùdach
ach cha dànaig ám riamh
's nach d'fhuair uachdarain dia

a chrochadh air na beanntan cràbhach
colann ìobairt nan sàr fhear.
Chrochadh Crìosda air crois-ceusaidh
agus Spartacus le cheudan;
bha ioma biatach dé am Breatainn
a rinn an obair oillteil sgreataidh,
agus cheusadh ioma Criosda
an uiridh agus am bliadhna.

Many a turn the world has taken
since Aeschylus saw the likeness
of hero-man-god hanged, lacerated
on Caucasus of the dangerous peaks
the god fashioned after man's image
barbarous Jupiter, with oblique jealousy
sending the hungry, obedient vultures
to tear and eat his liver:
mankind on the rocks
crucifying his own soul to the screeches
of the birds and savage animals
that got their own good from the feeding.
Jupiter, the brutal coward has failed

99

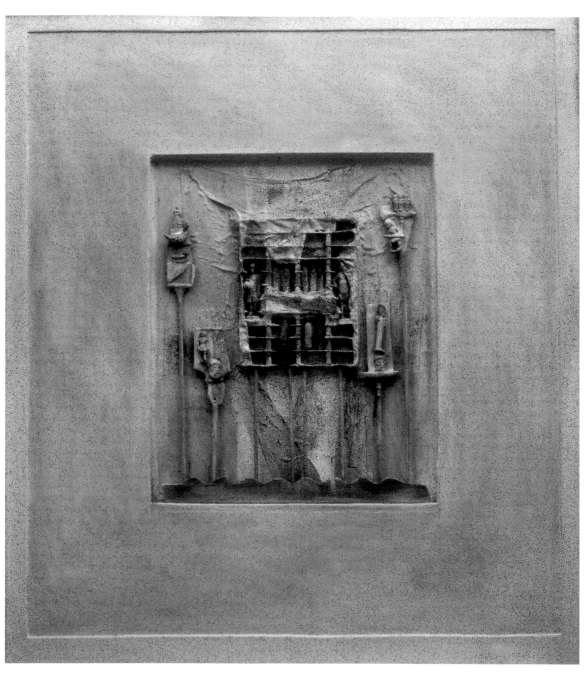

83. *The Archaeology of Childhood* (1989)

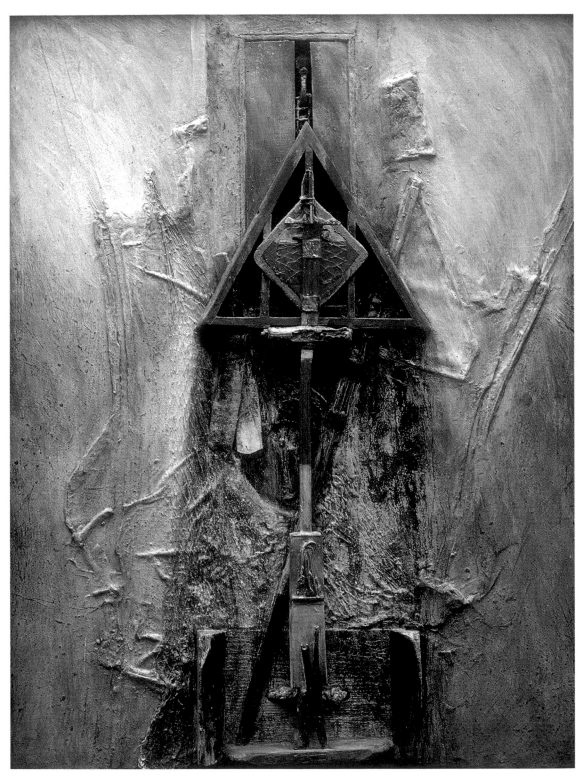

84. *Red Ley Marker* (1989)

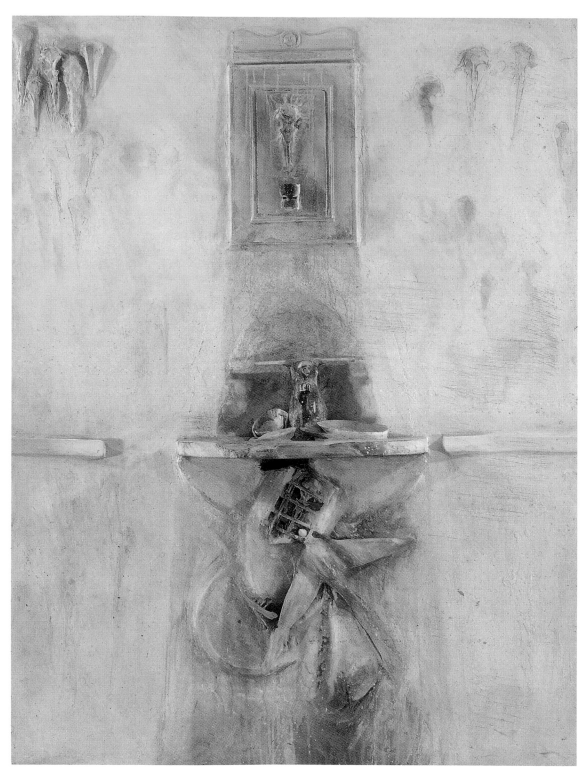

85. *Bird Altar* (1988)

and so has Jahweh the Jew.
But a time has never come
when rulers have not found a god
who hangs on pious mountains
the sacrificed bodies of surpassing men
Christ was hanged on the cross
and Spartacus with his hundreds;
there were many god-vultures in Britain
who did the loathsome hateful work
and many a Christ has been crucified
last year and this year.
(*The Cuillin*, VII)[31]

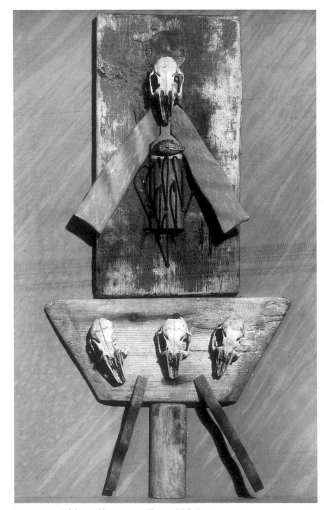

86. Memorial for a Clearance Village (1974)

The poet seems to gloss the legend to suggest that Prometheus was a sacrificial victim on just such a bird altar as the artist has created. In the poem, too, he uses the image to condemn man's inhumanity to man and, like Blake in his *Illustrations to the Book of Job*, he unmasks the way that we elevate the structures of law that we create for ourselves into forms of religion and then justify our inhumanity by our obedience to them. Blake's view was the same as Geddes's. He saw that this kind of religion was the consequence of a split between reason and imagination; between the factor's perception of the economic advantage to be gained from the cleared land and the failure of imagination in his inability to perceive and sympathise with the human suffering entailed in its clearance. For Adam Smith, sympathy, as the agent of the imagination, was the cement that binds society and was the vehicle of morality, so for Blake, as for Geddes and the artists of the Scots Renaissance who have followed him, to avoid this kind of consequence, reason and imagination had to be unified and art was a principal agent in the realisation of that unity.

In the context set by the whole of Sorley MacLean's poem, there is a shift from the local history of the Highlands to a universal symbolism. It is this same shift which Will Maclean achieves in his mature work.

Among his most important works is the set of ten prints to Gaelic poetry, *A Night of Islands* (1991, *Pl. 89–95*), which was commissioned by Charles Booth-Clibborn. It is a summary of these concerns. These are large and complex coloured etchings involving as many as four plates in each. Unlike his earlier etchings which followed his drawings, these take their form from his constructions. Each has a framing border which relates to the central image which is in a reserved area like the window, or the box in his constructions. One of the most moving images illustrates Derick Thomson's poem,

'Strathnaver' (*Pl. 94*), which commemorates one of the most notorious of all the Clearances, undertaken on behalf of the Duke of Sutherland by his factor, Patrick Sellar. The etching is dark. The border suggests smoke and in the centre is an image made up of the horns of sheep piled in a creel. Above this are raised two smoking roof-timbers from a destroyed cottage. The roof-timbers were essential for shelter. Their destruction left the people without protection beneath the stars, and in the print the sky above is dark and starry.

In the last of the ten prints in the set *A Night of Islands*, Maclean takes for his text the poem, 'Clann Adhaimh' or 'Adam's Clan' by George Campbell Hay:

> Sud bàrca beag le antrom gaoìthe sìorruidh
> 'na siùil chaithte, a'dìreadh cuain gun chòrsa,
> s i leatha fhéin an cearcal cian na fàire,
> is gul is gaireachdaich troimh chéil' air bòrd dhith.
>
> Tha Bròn, Aoibh, Aois is Oige, Sàr is Suarach
> a'tarruing nam ball buan a ha ri'bréidibh;
> tha Amaideas is Gliocas, Naomh is Peacach
> air a stiùir mu seach is càch 'gan éisteachd.
> Fo speur tha uair grianach, uair sgreunach,
> – clais is cìrein – fèath is doinionn – théid i,
> gu fàire nach do leum siadh riamh no sùilean,
> s a lorg s a h-ùpraid ghuth 'dol bàs 'na déidhse.

Ceangal

> Sud i is brù air a siùil s i 'deuchainn gach sgòid,
> long àrsaidh le sunnd is sùrd is léireadh air bòrd,
> fàire làn rùn nach do rùisgeadh fo cheann a croinn-spreiòd,
> is cop uisge a stiùrach a'dúnadh s'ga chall sa'mhuir mhóir.
>
> *Yonder sails a little bark, with the grievous burden of an eternal wind on her worn sails,*

climbing an ocean that has no coast, alone within the distant circle of the horizon, with a confusion of weeping and laughter aboard her.

Grief, Joy, Age and Youth, Eminent and Of-No-Account are heaving at the everlasting gear that trims her canvas; Folly and Wisdom, Saint and Sinner take her helm in turn, and all obey them. Under a sky now sunny, now lowering – trough and crest – calm and tempest – she goes on to a horizon that neither stem nor stern nor eye yet overlept, and her tack and her tumult of voices die astern of her.

Envoi

There she goes with a curve on her sails, putting each sheet to the test, an ancient ship with bustle and cheer and suffering aboard her; a horizon full of secrets unrevealed under her bowsprit head, and the foam of her wake closing and losing itself in the great sea astern.[32]

Maclean illustrates this beautiful poem with a view through the rigging of a nineteenth-century sailing ship, careering through the sea like the *Flying Dutchman*. Both poem and print recall Bard McIntyre's ship and Sorley MacLean's ship of Gaelic poetry in his poem, 'The Ship', but now instead of the ship of Gaelic culture alone, it is the ship of all the world.

* * *

Just such a ship is the subject of *The Emigrant Ship* of 1992 (1992, *Pl. 96*), a major work which again draws on the story of Strathnaver and so focuses the artist's central concerns thematically, but which also again demonstrates the way in which they open towards a universal symbolism. Its title is a homage to McTaggart's

The Emigrant Ship. This was painted almost exactly a hundred years earlier and the artist makes a direct reference to it in a little vignette at the centre of his own picture. But *The Emigrant Ship* is also a major statement of one of Maclean's central themes. It looks back to *Emigrant's Voyage* for instance, to the etching, *The Melancholy of Departure* (1986, Pl. 87 & 88) commissioned by An Lanntair in Stornoway on the occasion of the exhibition on the theme of the Clearances, *As an Fhearann*, organised by that gallery in 1986, or to the major work, *Composite Memory (Vessel)* (1987, Pl. 27). The latter is a construction shaped like a cross-section of a boat. Within It is visible a dark, confused jumble of figures whose unnatural disorder suggests their suffering and is iconographically reminiscent of Rodin's *Gates of Hell*. It was inspired by the tragic story of the *Exmouth*, in effect a slave ship carrying emigrants to America in 1747, but wrecked off the coast of Islay with terrible loss of life.

The dominant image in *The Emigrant Ship* is a graffiti drawing of a sailing ship, but a large slate is also incorporated at the centre of the work. This is scratched with the diamond pattern of the glass of the window of the church at Glencalvie in Sutherland. Within the diamonds of the panes are written various inscriptions relating to the story of the people of Strathnaver. One of these is a quotation of something actually written on the window of the church. When they were driven out of their homes by Patrick Sellar, exposed to the elements, they sought shelter in the church at Glencalvie, but they were refused admission. In the confusion of their innocence, they scratched on the window that it was they who were 'the wicked generation'. Inexplicably, in their despair the crucified people took upon themselves the guilt of those who persecuted them. They could not believe that they were the victims of such inhumanity without being

87. Study for etching, *The Melancholy of Departure* (1986)

88. *The Melancholy of Departure* (1986)

89. *Froach*, coloured etching from *A Night of Islands* (1991)

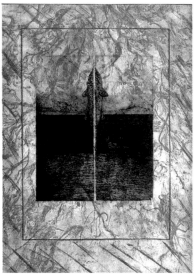

90. *The King's Fish*, coloured etching from *A Night of Islands* (1991)

91. *A Highland Woman*, coloured etching from *A Night of Islands* (1991)

92. *The Author of this is the Bard McIntyre*, coloured etching from *A Night of Islands* (1991)

93. *Trio*, coloured etching from *A Night of Islands* (1991)

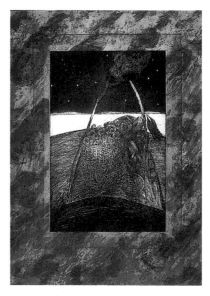

94. *Strathnaver*, coloured etching from *A Night of Islands* (1991)

95. *Adam's Clan*, coloured etching from *A Night of Islands* (1991)

96. *The Emigrant Ship* (1992)

somehow guilty themselves. They present us with a tragic paradigm of the perpetual struggle between innocence and experience which is the nature of morality and the human condition. This is not just a nostalgic lament for Highland culture, therefore. Maclean's art draws on the past, but it does so to speak urgently to the present.

The Emigrant Ship was a key work for Maclean. It continued his long series of reflections on the Clearances. The central image of a ship is based on a child's drawing scratched in the plaster of a ruined school house on Mull and so is twice a witness to the desolation of an emptied land. The school fell derelict only when there were no children left to fill it, but the image of a ship is itself a witness to the sad voyages into the unknown that had forcibly emptied the land. The picture also makes a direct link to one of the earliest artistic commentators on that sad history, McTaggart. But before

McTaggart, another great Scottish painter, David Wilkie, in one of the greatest Scottish icons, his *Distraining for Rent*, had offered a commentary on the forces that had brought about the dislocation that McTaggart conveys so graphically and that Maclean echoes. Adam Smith had identified sympathy as the force that binds society. He saw, too, that sympathy was a function of the imagination. So the dispossession of the Highland people, like that of the native Americans, the Bantu, or the Palestinians, and of so many others in the name of civilisation and economic advance was caused by a failure of sympathy and so, at root, by a failure of imagination. But imagination is the province of art, or at least it has been since the time of Adam Smith and his great contemporaries, David Hume and Adam Ferguson.

Thus Maclean's concerns in a work like the *Emigrant Ship* are not peripheral, his own

quirky preoccupation with an episode that took place in an isolated corner of the world and was soon forgotten. They reflect the central concerns that have shaped modern art and given it its moral validity. For that reason, recognising his concern with sympathy is perhaps also a key to understanding much else in his art too, for it is not only present in images that reflect the history of the Clearances and the particular Highland experience of man's inhumanity to man. Sympathy was also the basis of primitive man's relationship with his fellow creatures. Even as he hunted them, he respected them. The painters of Lascaux or of Altamira could not have painted as they did without profoundly imaginative and sympathetic projection into the lives of the creatures that they represented. Maclean constantly invokes this kind of connectedness in his imagery of totems and shamanism and of the different spiritual guides of other times, but it is also a key aspect of his central imagery of fishermen, sailors and the sea. Seamen depend for their lives on their understanding of their environment and fishermen in addition depend for their livelihood on their knowledge of the creatures that inhabit it. The loss of this knowledge, the failure of that sympathy, if it led to the Clearances, may now lead us also to ecological disaster.

These are profound themes which are frequently framed in Maclean's work, and indeed in the *Emigrant Ship* itself, in one of the most ancient of all metaphors: the idea that life is a journey, which is probably as old as human society. The spirals and labyrinths carved on megalithic monuments may already represent this idea as part of a prehistoric system of belief. This journey may lead from this world into an unknown future, or it may follow a quest that leads through unknown dangers in this world to some kind of illumination or spiritual goal. Certainly in myth such quests and journeys are an ancient and frequent narrative form. Jason and the Argonauts sailed in search of the Golden Fleece and Sir Galahad travelled in search of the Holy Grail. Nor is it only in the remote past that we find this. In the much more recent Protestant tradition the narrative of a journey as a metaphor for a spiritual quest was given epic form by John Bunyan in his *Pilgrim's Progress*, a book once found in every Scottish household. It was second only to the Bible and indeed the cover of a nineteenth century Gaelic edition appears in Maclean's own *Pages from a Library* (2000, *Pl. 135–40*)

At the very beginning of the birth of the modern consciousness, too, *The Odyssey*, one of the works that has defined western literature and which is set in the real maritime world of prehistoric Greece, has at its heart the narrative of just such a journey, a perilous voyage by sea through the unknown, beset by dangers, natural and supernatural, against which the only defence of Odysseus, the sailor, was his courage and his cunning, defining himself as an individual through these trials. It is a journey that already has a moral dimension.

The voyages of Odysseus, of Orpheus into the Underworld, but perhaps especially that of Jason, who was already a mythical hero when Homer composed *The Odyssey* and who deliberately sailed beyond the limits of the known world, are examples that have come down to us from beyond the edge of history itself. They record a kind of voyage into the unknown of which there must have been countless examples in the unrecorded millennia stretching back even beyond that heroic age and which took the human race across the oceans of the world.

Whether these prehistoric travellers were driven by curiosity and a sense of adventure;

97. Temple Vessel (reworked) (1992)

by hope of finding a better world; by desperation or by despair of any future in the world that was familiar; by force, as slaves carried against their will; or because, driven from their homes they had no alternative, the sum of all this is a human tide that includes the ancient Celtic saints, the Vikings, and the great explorers from Vasco da Gama to Hudson, Cook and Shackleton. These latter are men whose names are remembered, but almost within living memory, the slave ships of Africa and the emigrant ships of Scotland and Ireland carried a multitude as anonymous as all those thousands who must have made voyages into the unknown that were at least as difficult and dangerous long before history could record their deeds or geography describe the routes they took.

It is in just this way that sea voyages have been a constant topic in Will Maclean's work. They are at once both myth and history, metaphor and record. Indeed in his print *Adam's Clan* (1991, *Pl. 95*), he reminds us that we are all forever making such a voyage, but a voyage whose destination is unknown and over whose direction we have little control. The ship in *Adam's Clan* is therefore akin to the Ship of Fools, which was a theme that Maclean had touched on much earlier in *Bard McIntyre's Boat*. He was delighted to discover subsequently while reading Foucault that it might have a real historical origin in mediaeval Germany when apparently those who were regarded as insane were put onto boats and condemned to sail forever up and down the great German rivers, settling nowhere. It is a dark metaphor for human life. We may believe we are skilled at navigation, but nevertheless in the end it seems we cannot find our way.

In another major work from the early 1990s, *Temple Vessel* (1992, *Pl. 97*), part of the image again suggests the Ship of Fools, but he also presents the ship in this work as a votive offering. The clustered bells in the upper part suggest an act of prayer, for in both east and west bells are rung, not only to call the faithful, but also in ritual at moments of special sanctity. A votive offering is also a prayer, but one given material form. It is presented either in hope or in gratitude, but either way, as it acknowledges a superior power, it implicitly acknowledges our own powerlessness to control our fate.

Ex-Voto South Minch (1993, *Pl. 98*) is a similar votive piece. Shaped like an altar, it includes in the lower section a variety of images that suggest offerings, including various boats. These are secular pieces certainly, but, as so often, the artist uses imagery derived from the forms of popular religion which, though it is usually dismissed as superstition, may reflect something instinctive and perhaps much deeper than the dogma of formal religion. These votive boats are a vivid part of this kind of instinctive and no doubt ancient religious practice. They are commonly seen in sailors' chapels in Catholic countries, at Notre Dame de la Garde by Marseille harbour for instance, or at the Saintes-Maries de la Mer, where model boats and ships are hung as offerings. Similar models were also used by the Egyptians in a religious context. As grave goods they were a representation of the Ship of the Dead, a vessel for the deceased to cross over to the afterlife. There is even a suggestion of the form of these models in the inverted boat and tabernacle in *Temple Vessel*. The notion of the spiritual voyage is deeply rooted in us.

The boat shapes in *Temple Vessel* also mirror each other as though, as it did in Egyptian belief, the voyage of this life continues into an unknown world that somehow mirrors this one.

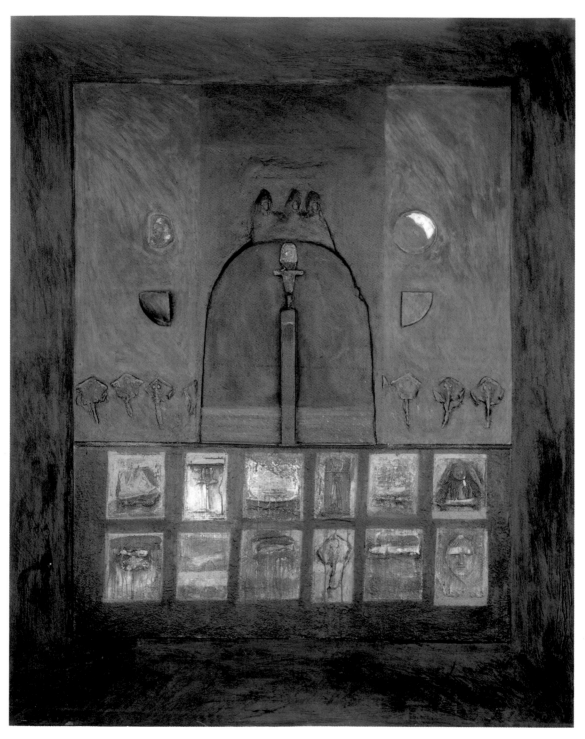

98. *Ex-Voto South Minch* (1993)

The exchange in that mirror image is also deeply embedded in our consciousness in another way. From the time of our earliest ancestors it seems we have looked up to the stars, to the heavens, as a perfect realm, unchanging and eternal which our own limited existence can only reflect imperfectly, but which can shape our aspirations. If in Christian belief the origin of the idea of heaven in this celestial perfection may be obscured by notions of personal salvation, our language still preserves it in the double use of such words as 'celestial' and 'the heavens'. But since the dawn of navigation sailors have also steered by the stars, relying on their immutability to guide them across the trackless surface of the sea. As Maclean reminds us in the work that is the frontispiece to this book, *Star Chart/Shaman Circle*, shaman-priests and sailors both once studied the stars in order to find guidance there. It follows that our physical and our spiritual voyages may not be as different as we are inclined to believe. Some of Maclean's chosen titles for his exhibitions held in the 1990s, *Voyages*, *Atlantic Messengers* and *Cardinal Points* guide us towards this zone of exchange; between the practical and the spiritual, between navigation and metaphysics, and located poetically in the idea of the voyage, it is a central concern in his work; perhaps it is *the* central concern, for in truth all his imagery does seem to return in the end to this fertile poetic ground and the metaphors it suggests.

But because the metaphor of life's voyage is so deeply embedded in the imaginative traditions of the West, the fact that Maclean's subject matter is so often the history of the Highlands and the enforced voyages of the Highland people is a contingent, not a necessary condition of the poetry of what he does. Indeed from early on his work has examined a much wider range of subject matter than the history of the Highlands alone, investigating as it does the experience of the explorers of the North Atlantic and the Arctic as well as the dangerous quest-voyages of the whalers, which were given epic form in modern times by Herman Melville in *Moby Dick*. Melville's epic novel demonstrates how persistent this mythic form is, how close to us it is still in the modern world, and in *Moby Dick*, too, it is not only the form of the quest that is significant. The intimate relationship between Captain Ahab and the great white whale, Moby Dick, is also an echo of the atavistic sympathy of hunter and hunted. In just the same way Maclean explores experiences that are rooted in recent history, yet which, as he turns them into poetry, can partake of this mythic quality and touch the universal because they are already transmuted by collective memory. Indeed the poetic voyage on which he takes us is really across the misty seas of memory, past ghostly, half-forgotten islands of the mind.

This is not just individual memory, though of course it plays its part and his own experience of the Highlands and indeed of the sea is naturally and inevitably his point of entry to all this. Somehow he also seems to catch hold of the insubstantial threads that link individual memory to some wider common consciousness, the Jungian collective memory perhaps. This is inherent in the way he makes his work. He does not make pictures in the sense of simple representations, though more and more paint has in fact been part of the process he uses. Instead he makes metamorphic objects: one thing becomes another, although, mysteriously, it somehow also remains itself. It is a very primitive idea, deeply embedded in us. It is this kind of metamorphosis that is the source of the spiritual power of the totem, an object from the ordinary world

99. *Totem Head* (2001)

that also becomes part of the spirit world.

In modern art generally, Maclean's own chosen methods of collage and assemblage exploit metamorphosis in a way that is directly akin to this. The thing that the artist adopts to incorporate into his work, even as it remains identifiable, also changes its identity and is invested with the imaginative power of a new and different reality. Art, like the totem, becomes the locus of metamorphosis and thus a gateway between the mundane and the imaginative. Maclean is the master of assemblage, taking found objects and transforming them into a new reality. Not surprisingly, he also frequently invokes totems in his work, with this generic

title identifying for us the ancient magic in this modern process. *Totem Head* (2001, *Pl. 99*) is a recent example, but there are numerous other works over the years in which he directly associates the processes of assemblage and collage with the way that a totem is invested with meaning.

He also makes objects that seem to carry their own history in surfaces which are rubbed and scumbled with paint, or layered with wax and resin to suggest the patina of time. They often seem to be composed of objects that are at once both definite in their form and mysterious in their purpose and so seem to bear witness to some forgotten use. Indeed in the late 1980s (see p. 16 *Pl. 7*) he began to make a series of objects which have continued in various forms since then and which he calls simply *Objects of Unknown Use* (*works in progress*). These are quasi-archaeological objects, imaginary museum exhibits, which seem to carry an imaginative aura, a sense of meaning and purpose that is very real and yet is not made explicit. Indeed as they are entirely invented, it cannot be. This deliberate imprecision is, however, also a gentle way of reminding us not to look too hard for a precise meaning in any of his work. It touches us imaginatively by its allusiveness, by its very lack of precision and by the way multiple meanings and references are layered through it because of the way it is made physically.

Two works, *Nansen's Log* and *Ocean Letter* (1999, *Pl. 100*), both refer directly to this poetic lack of precision. He was delighted to find that Nansen, an early hero, chose as an illustration to his book describing his Arctic voyage, *Farthest North*, an illegible page from his log-book. It is like the black page in *Tristram Shandy*, a piece of absurdity that somehow sheds light beyond the limits of any legible text. It reminds us that though we may crave logic, lucidity and the predictable, they too are at the mercy of the greater power of

the illogical, the unpredictable and the absurd. In his own version of *Nansen's Log* Maclean makes a work that both pays homage to Nansen and preserves the inscrutability of what he did. In *Ocean Letter* he makes a similar illegible text and then later in *Pages from a Library* he pays further homage to Nansen's sense of the absurd by including an illegible page from one of his own diaries.

Nevertheless his work can start from something that is quite specific, a reference to the story of St Kilda, for instance, or a place like the quarantine island for emigrants in the St Lawrence River called Grosse Île, or to the voyages of explorers like Shackleton or Henry Hudson, but then this detail will open up connections that lead us from the precise to the allusive and from the particular to the universal. It is a process of association that is close to the way memory works and thus through his allusive and sometimes elusive subject matter, Maclean explores the mythic and indeed the epic, not as something remote, but as close to us even in real time. He himself says that now, thirty years on, his experience with the ring-net fishermen and the things he learnt from that project continue to be a resource for him. This is, he says, because in a way, with them, he encountered – and indeed he was so deeply involved that he was part of it – one of the last hunter-gatherer societies to survive in the modern western world. *Bureau Veritas* (1995, *Pl. 101*) is a memorial to this way of life that ended almost as he completed his project and that represented a tradition unbroken since the first fishermen took to sea. Whatever vessels they contrived in that primeval time, they were certainly made of wood and the wooden structure of a fishing boat is a prominent feature of this work. So too are the fish in a boat's wooden hold. The title is derived from an early kind of certificate of seaworthiness.

100. *Ocean Letter* (1999)

As he treats it, the Highland experience reflects the universal conditions of life and illuminates the continuities that lead us out of our incorrigible temporal provincialism, the sense that our time and our little bit of history are different from any other, to a recognition of the continuing relevance of the wider story that has shaped us. Nor does the story of the Highland Clearances only reflect the dark side of human history. One of Maclean's most important projects of the 1990s celebrates the triumphant reversal of the long story of decline and dislocation in one corner of the Highlands at least. On the

101. *Bureau Veritas* (1995)

Isle of Lewis towards the close of the nineteenth century, and indeed into the twentieth, there was successful resistance and in 1992 Maclean became involved in a project to commemorate the Land Raiders as they became known who fought back and ensured that in this part of the Western Isles at least, the community reclaimed its own

and continued its way of life. The critical events involved staged civil disobedience and heated, not to say violent, confrontations with the authorities over a period of more than forty years. There were arrests and imprisonments, but in the end it was the local people who won the propaganda war as the justice of their case became undeniable. If Lewis is now the heart of the Gaelic-speaking community of the Highlands and home of the largest Gaelic-speaking population, this too is in no small part due to the success of the Land Raiders.

The project to make some kind of monument to commemorate these people and their victory was formed in Lewis by members of the community including local historian and former weaver Angus McLeod. A committee was formed and while pursuing the project they found that money from the Gulbenkian Foundation might be available if an artist was involved directly in the design. It was Roddy Murray, Director of An Lanntair, the publicly funded art gallery in Stornoway, who proposed that Will Maclean would fit the bill. Although unpaid, Maclean thereafter effectively took over the design and realisation of what was originally to have been a set of four monuments at four sites round the island where the decisive confrontations had taken place. It was not an easy task and because of local difficulties eventually only three monuments were built, but it is enormously to the credit of the artist that he carried the community with him as he developed his designs.

What he proposed was that the monuments should be in the form of cairns, or at least that was the word that he used to describe them. But as his ideas took shape it became clear that what he was talking about was really a kind of massive, stone-built, architectural sculpture. The builder was Jim Crawford who entered into the spirit of the project with enthusiasm and brought to bear on it his own extensive knowledge of local stone and traditional building techniques.

The first cairn to be completed was the *Pairc Cairn* (1994, *Pl. 102*) at Lochs on the southern edge of Lewis, looking across towards Harris, which was opened with much celebration in 1994. The event that took place here in November 1887 was the Park Deer Raid when a group of men deliberately provoked a confrontation by invading the nearby deer forest that had been created by the local laird at the expense of the former inhabitants of that stretch of country who were still excluded from the land even though it had lain empty and without a tenant for a number of years. The raiders shot several deer and held a defiant barbecue of the venison for the local people before being arrested. The cairn is in the form of an open, circular tower. It looks like a miniature Pictish broch, but is in fact a lookout tower. Inside it a stair leads up to a platform from which you can survey the landscape that was the scene of the confrontation and whose ownership and productive use was itself the issue at stake. Set in the rim of the parapet are three prominent stones which, like gun sights, are aligned on the places where three crucial encounters took place.

The second cairn to be built was at Griais, (1996, *Pl. 104*) but it in fact commemorates the last act in the drama, the confrontation over the farm raid of Griais and Coll between Lord Leverhulme and the local people who he intended should provide the workforce for his proposed fishing industry. Though his intentions were of the best, in the end as a good capitalist he could not accept that his workforce should have the independence that continued crofting would bring them. In other words they refused to become a dispossessed proletariat and put themselves at the mercy of

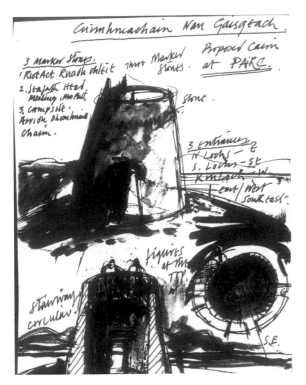

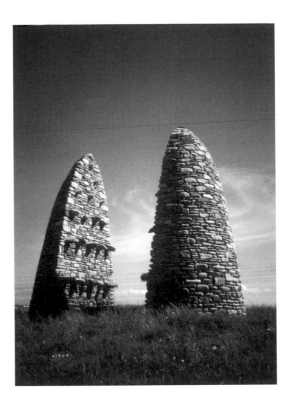

102. Sketch for the *Parc Cairn* (1994)

103. The *Aignish Cairn* (1996)

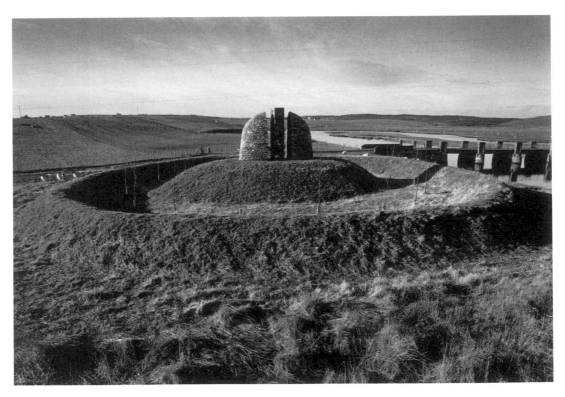

104. The *Griais Cairn* (1996)

the capitalist economy even in this benign form and no matter what benefits it offered them. The cairn symbolises this confrontation between Lord Leverhulme and the people of Lewis: a square pillar representing Lord Leverhulme is squeezed between two massive, rounded forms that seem to rise out of the ground. The male part of the workforce was comprised of the men who had returned from the First World War and the cairn is raised at the centre of a bank and ditch that could be either an ancient Iron-Age encampment or a memory of the trenches where they had fought and where so many died. Either way it invokes the ancient warrior tradition of the Highlands rooted in the independence of mind that in the end defeated Leverhulme's enlightened capitalism.

The most violent confrontation in this historical drama was the farm raid at Aignish in January 1888. The inscription on the cairn there tells the story in simple and moving words:

> The cairn was erected in memory of the men and women of Point who raided the farm at Aignish on January 9th 1888. They did so because they were driven beyond endurance by destitution and oppression. Instead of acting to relieve their distress the authorities used the majesty of the law and the armed might of the military to crush the people. Thirteen of the raiders were sentenced to prison terms ranging from 6 months to 15 months.

The cairn at Aignish (*Pl. 103*), which was opened in 1996, was the last to be built and stands on a narrow isthmus that leads to a churchyard on a small peninsula. Two massive hunched shapes, edged with stone teeth on their inner faces, confront each other across a narrow space. The unveiling of

this monument on a bright and blustery summer day was a great festival for the people of Lewis. In the celebrations due honour was paid to the artist. There cannot have been many occasions in recent times where that has happened and where a modern artist has earned the spontaneous gratitude of a community in this way. That this was so is certainly a credit to Maclean's diplomatic and personal skills, but also more fundamentally it is testimony to the way his art really is rooted in collective experience and so is accessible to us all.

When the *Pairc Cairn* was opened, the top of the tower with its gunsight stones had not been finished as the artist had planned it. It was only ten years later that the original design was finally instated. The work on the three cairns therefore spanned a ten-year period, though most of the work was done in the first part of that period. This was a huge undertaking and, for the record, Maclean's contribution to his home institution, Duncan of Jordanstone College of Art, over these same years was very considerable.

This was a crucial period in the college's history, during which it joined the University of Dundee, but the fact that it did so from a position of strength was largely due to the success of Maclean and his colleagues in focusing the energies of the college on the need to compete successfully in the unfamiliar business of research. That the output of the staff of a college dedicated to the creative arts could be assessed on such a quantifiable basis as research was a wholly new idea. It was also a rather improbable one, but Maclean, appointed Professor in 1994, was one of those who helped steer the College into these unfamiliar waters with great success.

Given the weight of these academic commitments as well as the work involved in the cairns, his own output over these years was remarkable. After his exhibition at the

Talbot Rice Gallery in 1992, he produced, as well as a number of individual works, contributions to group exhibitions and commissions, work for seven further major exhibitions between that date and 2001, four at Art First in London, one touring in North America and Canada, one at Dundee University and one at DCA, Dundee Contemporary Arts, the major contemporary art facility that opened in Dundee in 1999.

In 1994 he also showed a single multiple piece, *Religio Scotica* (1992, *Pl. 105–8*) at Art First. It was inspired by a book of the same name written in the nineteenth century by the Rev. R.C. Maclagan, a kind of Scottish Mr Casaubon of immense and useless learning who sought to tie Scottish culture and mythology into his own bizarre synthesis with the mythologies and cultures of other peoples. The artist describes the book as a kind of quarry full of arresting visual description and from this inspiration he created a set of imaginary religious objects. In some ways this parallels his later creation of imaginary museum exhibits. This was followed in 1995 by the major exhibition *Voyages*, also held at Art First, where the *Emigrant Ship* and *Temple Vessel* were key works and where he also began to develop the theme of the first of these two to follow, as it were, the emigrants in their voyages across the North Atlantic. *Passage to America* of 1995, a small but particularly beautiful work with a ship, sails set, passing over a threatening sea filled with manifest, but unknown dangers, sets the theme.

As it happened, the classic account of the history of Highland emigration to North America, A *Dance Called America* by James Hunter, was published in 1994, just as Maclean was pursuing his own reflections on this theme as he prepared work for this exhibition. The book provided him with valuable documentary detail about Canada and the immigration port on the St Lawrence through which the Highland emigrants passed with its dreadful quarantine island, Grosse Île. This is invoked in works like *Quarantine Passage/Grosse-Île* and *Canada Passage/Cholera Bay* (1994, *Pl. 109*). In the latter the packed berths on an emigrant ship seem to be transformed and to multiply without any intermediate state into ranks of anonymous graves. In both these works and in the related *Yellow Quarantine Bird I* and *II* (1995, *Pl. 110*), the artist incorporates bird imagery. The birds that move freely over the ocean make a poignant contrast to the poor travellers packed like so much cargo into the foul-smelling holds of the emigrant ships. But characteristically Maclean does not stop at a single reference. He layers his imagery so that we are not limited to one meaning, but are invited to reflect on a complex compound image. He himself comments, for instance, that the bird image in *Yellow Quarantine Bird I* could be a reference to the Isle of Skye, once a happier island that some at least of the emigrants had left behind them, and poetically known as 'winged island' because of its shape. The image is also a reflection on the name of Grosse Île, however, whose full form is Grosse Île des Oies, the island of the geese, after the snow geese which over-wintered there. The geese were also migrants, but following the natural order of things, the geese found refuge where their unhappy human counterparts too often found only death and despair.

The emigrants commemorated in these pieces, whose lives ended in such tragic anonymity, and who passed into the eternal realm before they could reach their earthly destination were following much earlier travellers across the dark waters of the North Atlantic. The earliest sailors whom we know undertook this voyage were the Irish saints of the sixth and seventh centuries. St

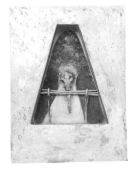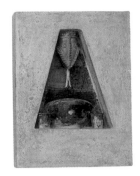

105. *Religio Scotica/The Artifacts of Ceremony* (1992)

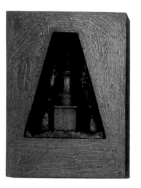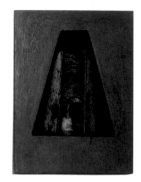

106. *Religio Scotica/The Mask of Absolution* (1992)

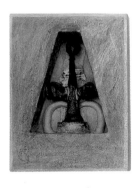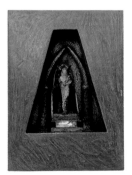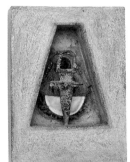

107. *Religio Scotica/The Rituals of Myth* (1992)

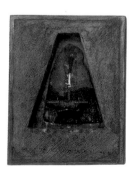

108. *Religio Scotica/The Salmon of Knowledge* (1992)

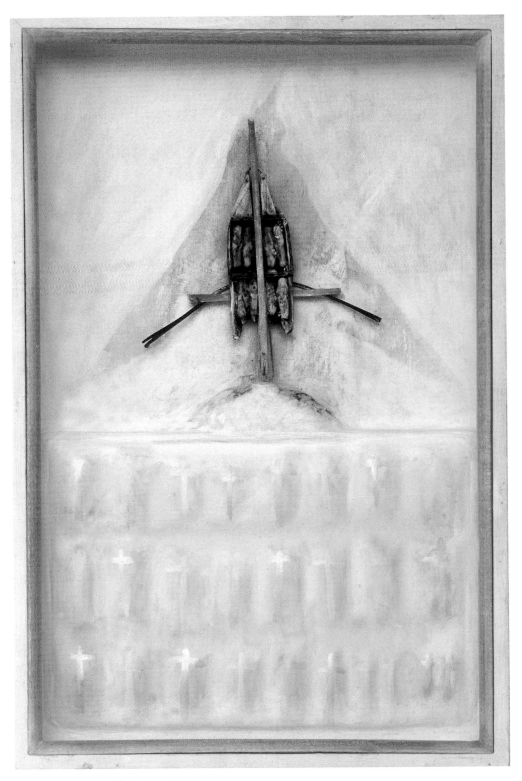

109. *Canada Passage/Cholera Bay* (1994)

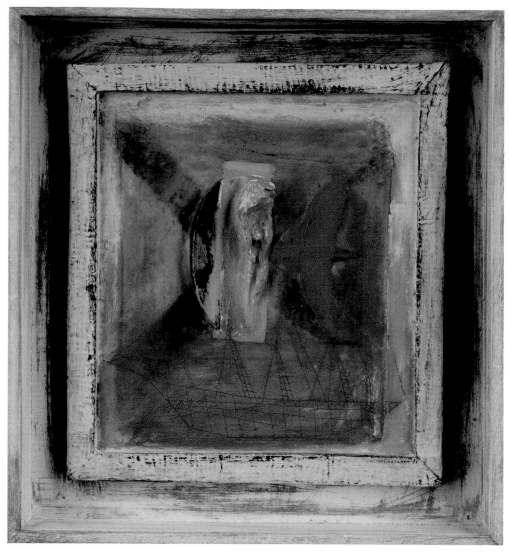

110. *Yellow Quarantine Bird II* (1995)

Brendan is the most famous, but surely not the only one who set out, like Jason, 'in search of a mysterious land beyond human ken'. But of Brendan it is said, not only that he eventually reached 'that paradise amid the waves of the sea', an immense region of the west, the 'Land of Promise', but also that he returned to tell the tale. In consequence St Brendan's Isle, like the mythical island of Hy-Brasil, featured on maps of the western ocean long before Columbus followed him across the sea almost a thousand years later.

One could say that Brendan was an explorer, but as he was manifestly also a holy man, it is clear that his motives must have included some kind of spiritual exploration. They were likely to have been akin to those of the monks who sought 'white martyrdom', martyrdom achieved, not by leaving this world in death, but by leaving the known world in life and setting off into the unknown across the sea. Countless remote

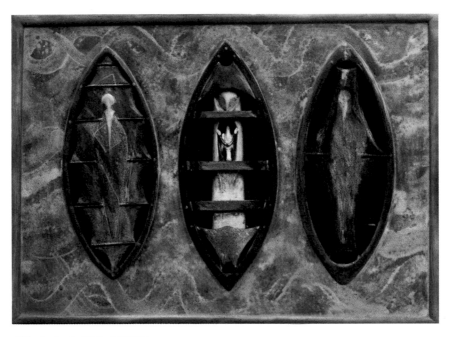

111. *Anchorite Triptych* (1996)

islands, sometimes little more than bare rocks, around the coasts of Scotland and Ireland are associated with Celtic saints who retreated in this way from the world to approach nearer to God in the sea's wilderness. This is within the early Christian tradition of asceticism, certainly, and the Celtic monks were contemporary with the anchorites who retreated to the deserts of the Middle East, but the way these saints undertook voyages that purposefully took them beyond the edge of the known world also restates in a radically open-ended form the ancient idea of pilgrimage: an earthly voyage can also be a spiritual quest. Sailing westwards, St Brendan was sailing towards the setting sun and, beyond it, the Land of the Dead.

All these ideas are given monumental form in two major works of 1996, *Voyage of the Anchorites* and *Anchorite Triptych* (1996, *Pl. 111*). These are closely connected and both use as their principal motif the shape

of a small boat seen from above. In one it is a single boat. In the other there are three side by side. In both works too these boat shapes are set in a flat plane painted in a way that suggests the wide surface of the sea. The boats are small, open and manifestly fragile. In them are figures that are at once human and birdlike. The ocean-going birds like the fulmar, the gannet and the petrel are the only companions these sailors would have had. Their sympathetic affinity is expressed in their appearance. The figures also have with them objects that suggest the kind of primitive equipment that a Celtic monk might take on a voyage of spiritual discovery to cover both spiritual and physical needs.

In *Sea Hermit* (1996, *Pl. 112*), it seems an anchorite stranded on some remote rock has become one with the birds whose home he shares, metamorphosis through sympathy. In this case the bird is a heron, sacred to St Columba. A heron's skull is set in a box like

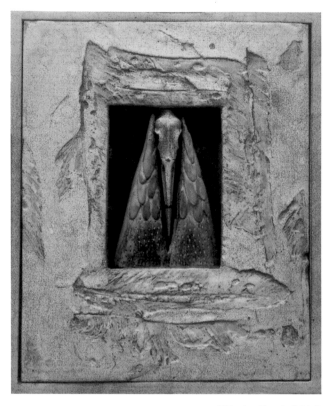

112. *Sea Hermit* (1996)

a reliquary, a form Maclean has so often used, and its surface is decorated with casts of feathers. He himself remarks that in a work like this he is quite consciously using the kind of bird-man-animal exchange that is a feature of Gaelic myth as it is of many ancient cultures. In Gaelic culture this exchange also includes marine creatures, especially of course the seal, but in *Nautilus Aground* (1998, *Pl. 113*) Maclean extends the idea to the realm of the fishes by using structure and detail that could be both boat and fish to suggest an analogy between the fragile boats with which these people braved the Atlantic and a delicate sea creature like the nautilus.

By invoking this kind of metamorphic exchange, Maclean borrows from very ancient ritual practices that ultimately express a sense of the connectedness of creation. In Africa, for instance, bird and animal masks were commonly used in ritual. In the European tradition this exchange between human, animal and divine was evidently equally a fundamental part of the common world view which expressed an instinctive sympathy between humanity and the natural world, even between hunter and hunted. This sympathetic exchange is the subject of one of the greatest works of classical literature, Ovid's *Metamorphoses*, and there the poet set down myths that were already ancient when he recorded them. But one should also never forget that Maclean is

dealing from within with the mainline language of modern art and so it is also pertinent that in Miró's work, particularly the marvellous *Constellations* that he made in 1940 at the very darkest moment of the Second World War, birds are the constant companions of his figures, symbolising, not only hope in a dark world, but also the freedom of the life of the spirit that can rise above oppression. In his late work, too, Braque used bird imagery in a similar way.

In their scale and grand simplicity the two *Anchorite* works follow on from *Temple Vessel*. They also share with it the theme of the spiritual voyage, but, although their imagery so strongly invokes the voyages of the Celtic saints, the artist himself describes how the starting point for the former work at least was a piece of African sculpture that he saw at a major African exhibition in 1995. His own work has a dark and polished finish that is deliberately intended to echo the dark, polished wood of African sculpture. Perhaps this African image itself also contained a remote memory of the Egyptian Ship of the Dead, or of Charon's boat across the Styx, or at least of some primeval common original, for it showed two figures in a boat crossing from this world to the next. The commentary in the exhibition suggested that as the kingdom of Ngoyo where the work originated was heavily involved in the slave trade this was also an image of a slave ship. With uncanny symmetry, matching both the beliefs that may have inspired St Brendan and the fate of the Highland emigrants, apparently the slave ships were seen as taking souls across the sea from Africa to the land of the dead on its further shore.

Characteristically, to prove on the one hand that there is nothing new under the sun, but on the other to suggest how, too easily, we lose sight of universals when we look at life through the long, narrow

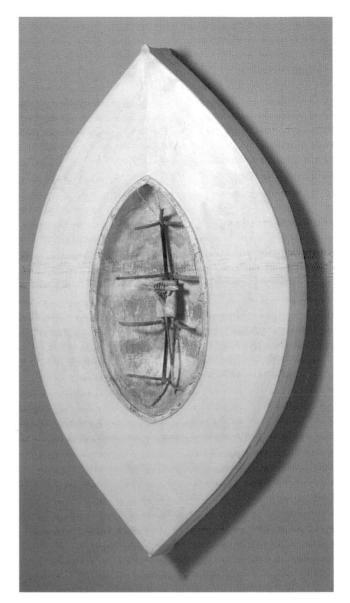

113. *Nautilus Aground* (1998)

perspective of written history, in another work, the *Blue Men of the Minch* (1995, *Pl. 114*), Maclean picks up on the echo in folk memory of the same sad story of the slave trade and how it might have touched the Highland shores long ago. The story is that the Vikings, who certainly traded in slaves

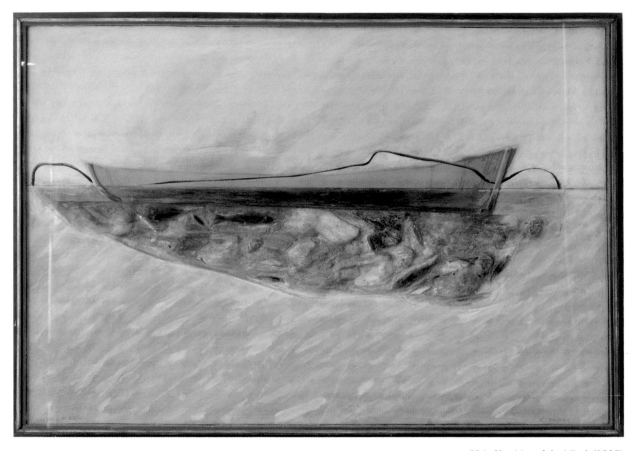

114. *Blue Men of the Minch* (1995)

between Ireland and Scandinavia, may also have gone much further afield and have brought African slaves through the seaways of the Scottish islands en route for Scandinavia. Whether they had escaped, been dumped or were simply kept temporarily in a kind of holding prison on some of the small islands, the story is that somehow the presence of these displaced Africans and Viking captives, mute witnesses from this remote time to man's perpetual inhumanity to man, gave rise to the legend of the blue men of the Minch.

It is easy to see how in Maclean's work there is a seamless connection between such diverse voyagers as the Celtic saints, the Highland emigrants and even the African slaves, all of whom faced the unknown as they traversed the wide Atlantic. Clearly the great explorers are part of this too and so it is no surprise to find that themes of exploration that had first appeared in his work much earlier are continued in a number of beautiful works during these very creative years of the 1990s. *The Last Voyage of Henry Hudson* (1994, *Pl. 115*), *North West Passage/Arctic Route* (1994, *Pl. 116*), *The Ice Master's Log* (1996, *Pl. 117*) and *Nansen's Log*, for instance, all reflect in different ways on the difficulties and dangers that these men faced in their voyages of exploration and on the courage that they displayed. In the first two works the artist contemplates the fate of Henry Hudson, the seventeenth-century explorer, whose story had

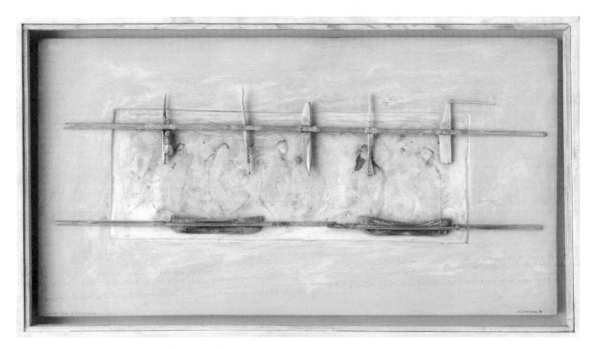

115. *The Last Voyage of Henry Hudson* (1994)

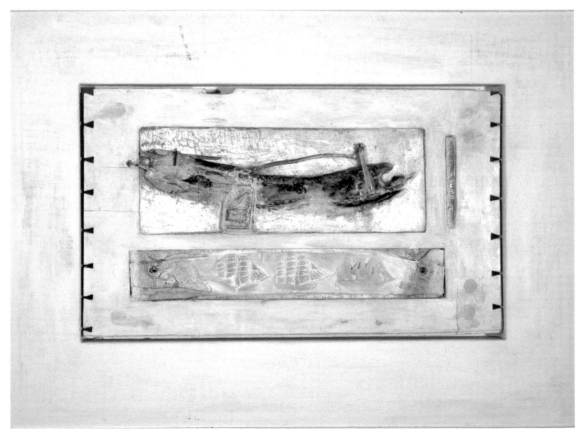

116. *North West Passage/Arctic Route* (1994)

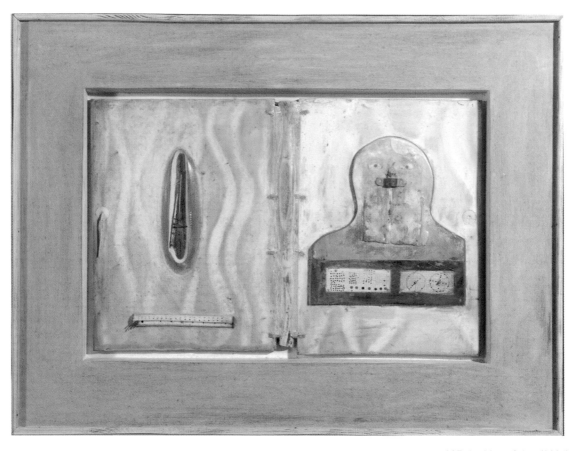

117. *Ice Master's Log* (1996)

fascinated him since childhood. Hudson gave his name to Hudson's Bay, which he sailed around, believing he had indeed reached the Pacific in his search for the North West Passage, the impossible goal of so many fruitless voyages. In *The Last Voyage of Henry Hudson*, Hudson and his companions, abandoned among the ice by a mutinous crew, appear as frozen figures, half buried in the snow. Other details suggest Inuit artefacts. Was Hudson no more than a clumsy trespasser into their territory, doomed because, as a European, even by the seventeenth century, he had already lost the affinity with the natural world that had once been common to all human societies and that still allowed the Inuit to survive even in these harsh conditions? Seen

in this perspective, the dislocation and inhumanity of the Clearances, which is so often referred to in Maclean's work, has an echo here and is only the symptom of a wider malaise.

Notably, too, it is not only the familiar explorers whose names we know who are commemorated here. One of these works, for instance, The *Ice Master's Log* is particularly beautiful, but is also anonymous. Ice masters were the pilots who specialised in the navigation of the difficult waters at the edge of the Arctic. Predominantly white in colour, as its name suggests it should be, this work is in two panels which are spread out like the open pages of a logbook. The skill of the anonymous, but presumably European, ice

pilot is portrayed in the right-hand panel, but that of his Inuit colleague, whose boat moves effortlessly through the cold currents, and on whose skill and knowledge the European in turn depended is given equal importance in the left-hand panel. In both panels, the artist has included a kind of pegboard calendar. Made of bone, a necessity in that harsh, paper-free environment, it was a way of recording time that was perhaps itself timeless and was apparently shared by Inuit and European sailors.

These works and pieces such as *Yellow Quarantine Bird I* and *II* (from a set of six) show how Maclean's way of working was itself becoming increasingly free and associative. This freedom allowed him to work around a subject or indeed a visual idea that was preoccupying him and to produce a series of works that reflected on it in a discursive way without repeating himself. He describes how he came to improvise much more than he used to. His work was never programmatic, but in recent years, instead of planning it and pursuing, as it were, a more or less linear course to its completion, he has given himself greater freedom and left the work to evolve under his hand. This allows for greater play of intuition and for the serendipity of accident. Through this freedom of approach he achieves a new kind of allusiveness.

Many of the works that he first exhibited in 1998 in the exhibition *Atlantic Messengers* display this new freedom. He had already been casting objects in resin for some time, but now he was also able to use a computer to generate images, or to capture and download images that he could then use in collage. The computer's power of duplication meant that, at least in two dimensions, he was now completely free from dependence on the uniqueness of the objects that he had previously collaged into his work and that by definition he could only use once. As *Pages*

from a Library makes clear, this meant that his range of reference was vastly enlarged.

In the exhibition *Atlantic Messengers*, there was a group of works in which these new techniques were used to incorporate star and tide charts. Layered in resin they have a mysterious quality. The charts change from being two-dimensional pages of print into three-dimensional objects, but a further dimension suggested is time. They appear ancient and of course the information they contain is as ancient as the study of the stars, which the astronomical alignments of monuments like Calanais suggest was the earliest field of reliable scientific inquiry. If it was in any sense science, however, it was science as a servant of religion; not as the only true knowledge as we are inclined to see it, but as an aspect of a greater understanding. This is the setting for works like *Little Star Atlas/Triangulum* (1998 *Pl. 118*), one in a sequence of three works with *Little Star Atlas/Sagitta* and *Little Star Atlas/Sextans*, or *Star Chart/Shaman Circle* (1998, *Frontispiece*), in which the artist reminds of us of the antiquity of this knowledge that once sought to link heaven and earth. The objects collaged onto the surface of the star maps double as primitive navigation instruments – like the cross staff, for instance, which was used by sailors to align stars and horizon, or the system of triangulation that still is used in navigation to plot a position – and as a shaman's tools of divination.

But the title works of the exhibition, the three *Atlantic Messengers*, *Sula Sgeir* (1998, *Pl. 119*), *Hirta* (1998, *Pl. 120*) and *Fulmarus* (1998, *Pl. 121*), are three-dimensional sculptural constructions. All three subtitles, and so the works themselves, refer directly to St Kilda, the little group of sheer and rocky islands that constitute the most remote of the Hebrides, fifty miles to the west of the Isle of Lewis and which, in spite of their remoteness, were

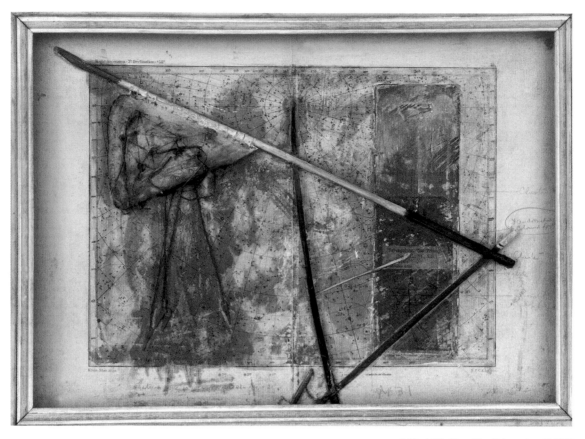

118. *Little Star Atlas/Triangulum* (1998)

inhabited from earliest times until 1930. The community lived a strange, independent and democratic life. They were like a colony of sea anchorites and like them lived in close communion with the birds on which they principally depended for food, especially the fulmar and the gannet.

The works are all similar in form, consisting of an open shrine with a group of three objects hung within, like offerings. Two of these are shaped like bladders and one is shaped like a miniature boat. These are also, like inflated bladders, transparent and within them other objects are visible, trapped like flies in amber. The reiteration of the bladder form is a specific reference to the unique kind of messengers they evoke, the St Kilda mail boats, miniature boats that were sent,

unpiloted, on voyages into the unknown. Loaded with a letter and a penny for the post, they were set adrift to be carried to the mainland by the prevailing wind, where, God willing, they would be found and their message consigned to the conventional postal system. These little boats were kept afloat and driven down the west wind by inflated bladders. But their message was far more than anything contained in the humble letters that they carried. They were like messengers from the remote past to the present, travellers with news from the kind of world untouched by civilisation that Eduardo Paolozzi memorably described as 'lost magic kingdoms'.

But each of the individual works also carries its own message. *Fulmarus* with its

119. *Atlantic Messengers/Sula Sgeir* (1998) 120. *Atlantic Messengers/Hirta* (1998) 121. *Atlantic Messengers/Fulmarus* (1998)

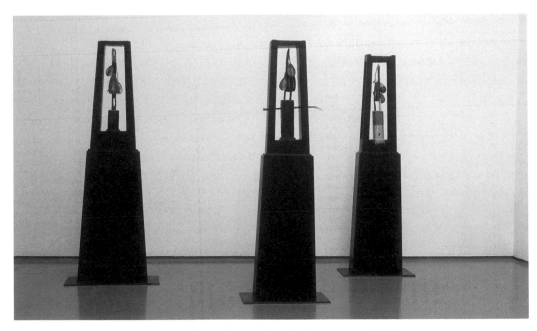

122. Installation Photograph, *Atlantic Messengers* (1988),
Driftworks, Dundee Contemporary Arts (2001)

123. *Journey 1*, from a series of six (2000–01)

124. *Journey 2*, from a series of six (2000–01)

bird's skull and oil sack commemorates the fulmar itself, whose oil provided the people of St Kilda with light. *Hirta* carries a fragment of a love song from St Kilda and *Sula Sgeir*, the Rock of the Gannet, the name of the loneliest of these lonely islands, includes a reference to an anchorite nun who it was believed sought 'white martyrdom' there and whose skeleton was later found with a bird nesting in her breast bone.

These are all specific references perhaps, but they are only made in a fragmentary way. They are not so much messages therefore as echoes of the voices, the sounds and the music of an ancient, once viable and even poetic and spiritual life, lived in extreme conditions at the very edge, but in harmony with nature even there. The St Kilda community did not collapse from within. It was disrupted and eventually ceased to be viable even in the eyes of its own people by intrusion from outside and the diseases it

brought with it. Thus these works reiterate a recurrent theme in Maclean's work, a theme of imbalance, of the failure of a system of life that depended on sympathy with nature, under pressure from the modern world where that sympathy is lost. The loss of a magic kingdom, indeed.

Maclean's major exhibition at DCA in 2001, *Driftworks*, took its title from the French philosopher Jean-François Liotard. It summarises the artist's idea of a voyage without certain destination, the voyages of the sea anchorites, of the emigrants, or of the little St Kilda mailboats, the Atlantic Messengers. Indeed he continued the St Kilda theme in the exhibition in *St Kilda Song*, a set of small reliefs carrying half-legible fragments of a love song whose words are tinged with sadness. The theme of the voyage was also carried on in a series of six images called *Journey 1–6* (2000–01, *Pl. 123 & 124*), where he used computer imaging to

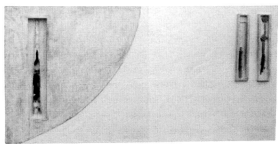

125. *Nomad Trace* (2001)

create collages which have a special imaginative fluidity. These six panels are evocative images of sailing ships taken from nineteenth-century illustrations and then combined with other textual and visual material and all worked over with resin like the transparent layers of memory, of time itself, the image embedded in the past. The result conjures up, not just the displaced world of the Highland emigrants of a hundred and fifty years ago, but something somehow still valid of the experience itself as though these really were our own memories in front of us.

There were also two works in this exhibition, *Sea Chant Diptych* (2000, *Pl. 127*) and *Nomad Trace* (2001, *Pl. 125*) which reflected a different development that was first hinted at in the two anchorite works. *Sea Chant Diptych* uses Japanese prayer sticks and miniature lead cups that suggest baptismal fonts or altars. They seem to record some kind of act of worship in a temple to the sea. *Nomad Trace* is similar in feeling. Against the outline of the cross section of a boat are various traces of a human presence. At the edge are small shrines for offerings. This is an image that at one level seems to go back to some of his earliest works where abandoned makeshift altars stood on an empty shore

against the sea. But what is quite new in both these works is the way that they are extended spatially. Indeed *Nomad Trace* is almost five metres across, but a large part of that is just uncluttered picture space. This certainly relates in a new way to the traditional concerns of painting. At a practical level, too, the artist himself sees it as a response to the freedom offered by the generous space of DCA, but given the way he works, we must also suppose that this new breadth has somehow grown out of those same poetic metaphors to which we constantly find him returning. After all, journeys need space. Voyages cross trackless oceans. Seen that way, space of a kind has been implicit in his work from an early date. Now, given expression, it adds a sense of scale and so of context to his work.

But the key works in the exhibition represented an even more radical departure in scale as well as technique. In them he used digital animation and the computer-generated moving image for the first time. The beauty of these works reflects his inventive adaptability. Lesser artists have often followed the temptation of these new technologies into a kind of narcissistic solipsism. But Maclean's respect for these new techniques and his ability to work

later. These have been edited into a videotape to create a sequence of images, each succeeding the other, not like the pages of a book, but through a process of transformation. A shutter opens and closes across the screen like a door. As it does so, in a steady continuous movement, each image becomes the next. There is a common theme or motif, a kind of altar with a cross above it which changes, but is sufficiently constant to provide continuity so that we understand this flow of images as a narrative. There is a musical soundtrack composed by Gerald Mair and the colour takes on the intensity of stained glass. It is like a journey through some magical cathedral and is the closest that he has ever come to the direct invocation of spiritual experience, though it is deliberately still far too vague to be called religious in any dogmatic way. That would be the last thing we would expect from him. An idea of spirituality certainly runs through his work, but it is generally clearly and radically opposed to the Christian dualism that objectifies the non-human world and provides us with such disastrous polarities as man and nature in opposition to each other.

The larger of these two animations, *Cod Requiem* (2001, *Pl. 128*), is one of the most ambitious things that the artist has done. In the exhibition it was projected on a full-sized cinema screen. The film is set under water in the world of fish. It is a requiem to the vanishing cod. Through the blue depths we follow a strange fish-like creature. It is in fact a cod-jigger, fish shaped, but armed with two savage hooks. It looks like a salmon gaff, multiplied and designed to be dropped on a line into the massed cod shoals. As this fierce object apparently swims effortlessly through the darkness, we realise that this is what the innocent fish once saw. The artist's wife, the painter Marian Leven found these brutal implements in a junk shop in St John's,

126. *Crux* (2001)

closely with the skilled people who operated them meant that they opened up for him new avenues in his search for vehicles of metamorphosis. Andy Rice was the artist's collaborator on the two animations. The use of such expensive technical resources for these and the other new media works was made possible by the Creative Scotland Award that Maclean received from the Scottish Arts Council, which was a piece of well-deserved recognition.

One of these two works, *Crux* (2001, *Pl. 126*), uses a set of collages that the artist had made in Italy in 1992 (see p. 94) and that were first exhibited as a series a few years

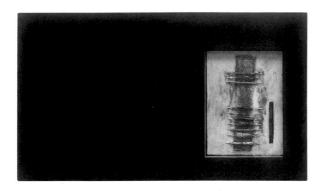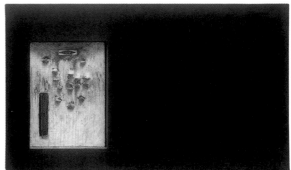

127. *Sea Chant Diptych* (2000)

Newfoundland. They are relics of the great cod fisheries of the Grand Bank that once sustained the maritime communities of Labrador and Newfoundland, indeed that had tempted Basque sailors to cross the Atlantic before Columbus. But then to make a wider connection, the opening sequence of the soundtrack to this film is made from a recording of men in the ring-net fishery calling to each other that the artist had made as part of the Ring Net project thirty years before. In the intervening time ring-net fishing had disappeared even more completely than the cod from the Grand Bank, both victims of accelerating change and the dangerously widening gap between man and nature. The rest of the track also includes the actual sounds that cod make recorded by Norwegian researchers. The fish sing their own requiem.

But in the end perhaps the most revealing works first displayed in this exhibition are those where the artist invites us to enter his own imaginary museum, *Painted Museum, New World Museum* (2000, *Pl. 132*) and *Objects of Unknown Use* (2001, *Pl. 129, 131, 133*), the latter

128. *Cod Requiem* (2001)

129. *Objects of Unknown Use* (2001)

130. *Fish Traps* (2000)

131. *Objects of Unknown Use* (2001)

a series that he dates from 1987 and which is still ongoing. All of his art is focused on the idea of creating things that can carry the imaginative aura of the great objects in museums. A museum is so called because it is a place of the muses. It should be the source of inspiration and not, as it so often seems to be, its final resting place. Like a library, it is one of the motors of the imagination on which we depend. This is the quality that Maclean captures so often in his work. 'The mystery of objects left over from some other culture' is a phrase he uses to describe the kind of fascination that he finds in such things and that he is trying to recreate for us, and in these various 'museum' works he actually assembled objects, both real and invented, as though in the glass cases in a museum. He has taken the mysterious vocabulary of Pictish symbols, for instance, potent, but illegible messages from the past, and from them he has created a sequence of tiny reliefs. Cut in negative like seal stones, these have the same minute delicacy as the cylinder seals used by the ancient Mesopotamians. They make a whole imaginary archaeology of carefully aged ceramic and bronze. He also creates boxes filled with real and imagined fishing gear and navigation instruments. In *Fish Traps* (2000, *Pl. 130*), for instance, he creates a whole fictitious fishing

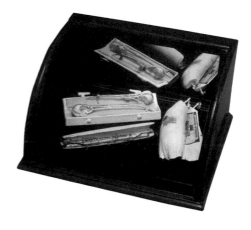

132. *New World Museum* (2000)

133. *Objects of Unknown Use (works in progress)* (2001)

system in which old-fashioned mousetraps are adapted to catch wooden fish. It is the sort of absurd invention – absurd but also imaginatively provocative – that you might really find in boys' books and magazines from a hundred years ago and that were still on bookshelves when the artist's generation was growing up in the 1940s. It is that kind of resource that he marshals in the catalogue *Driftworks* under the title *Pages from a Library* (*Pl. 135–140*). This is composed of a series of documents and pictures which, although conventionally placed on the page, are put together apparently as randomly as they would be in a collage. The individual images are not given titles. Nor are they arranged in any kind of narrative sequence, but are left to work with each other, creating their own imaginative space and their own narrative. They seem all to be from his own imaginary museum and some of them appear in a different guise in his work, like the graffiti ship from a Mull schoolhouse that appears in the *Emigrant Ship*, for instance, or some of the ships that appear in *Journeys 1–6*. There is, too, the illegible page from his diary that appears in homage to Nansen. Some, like a picture of Henry Hudson adrift among the ice floes, not only find an echo in the *Last Voyage of Henry Hudson*, but are also part of a store of images that go back to the artist's childhood. There is a drawing of a ring-net boat made for

him during his research by one of the fishermen to give him information on gear and stowage and there are strange totems that he has found in publications of the kind of imagery that we still generate in modern life even though we think we are civilised and far advanced beyond such things.

Together these things constitute a *musée imaginaire* and through them he is inviting us to consider the kind of thing that fed his own imagination in childhood and since. But of course these objects are never neutral or passive. They tell stories of another time, but by the continuities they reveal and by the way he tells them so poetically in all his work these are stories which can illuminate us still.

134. *Found Objects/Hooks*

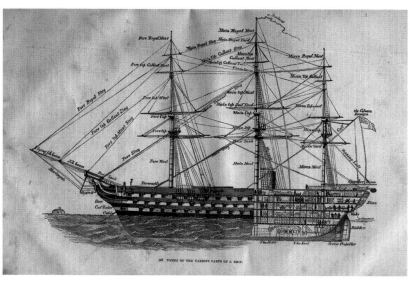

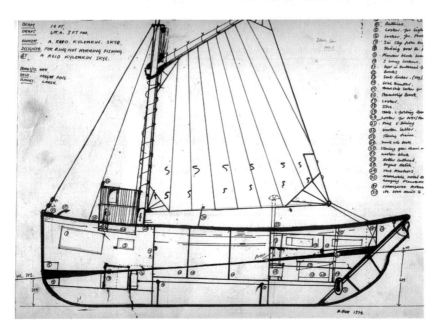

– LIST OF PLATES –

(Those without listed owners remain the property of the artist)

142

painted wood and found and painted objects 30 x 25 x 8 cm. McManus Gallery, Dundee (1974)

21. *Symbols of Survival*; yellow pine, bone and acrylic, 84 x 104 x 10 cm. Private Collection, Scotland (1976)

22. *Abigail's Apron*; painted wood, bone and metal, 214 x 50 x 15 cm. Private Collection, Cambridge (1980)

23. Sketch of the artist's aunt, Abigail Mackenzie; pen, 25.3 x 17.9 cm (1966)

24. *Portrait of Angus Mackenzie*; collage, slate, bone, canvas and wax, 46 x 56 x 7 cm. Private Collection, London (1982)

25. *Interior Wester Ross*; carved and painted wood, 137 x 56 x 23 cm. Private Collection, London (1980)

26. *Sabbath of the Dead*; oil and acrylic on wood with metal and bone, 38 x 69 x 15 cm. Private Collection, Glasgow (1978)

27. *Composite Memory (Vessel)*; painted wood, metal, resin and whalebone, 71 x 38 x 15 cm. Private Collection, London (1987)

28. *Calotype for Schwitters*; collage and resin on wood, 41 x 28 x 4 cm. Private Collection, London (1986)

29. *Memories of a Northern Childhood*; wood, slate and found objects, 48 x 35 x 15 cm. Private Collection, Cambridge (1977)

30. *Fladday Reliquary*; found objects, bird skull and bone, 55 x 43 x 10 cm. Inverness Museum and Art Gallery (1978)

31. *Icon for a Fisherman*; painted wood, metal and ceramic, 61 x 60 x 10 cm. Private Collection, New York (1978)

32. *Black Priest's Box*; painted wood, bone and found objects, 46 x 36 x 20 cm. Private Collection, New York (1982)

33. *Fire Figure*; laburnum wood and mixed media, 51 x 36 x 10 cm (1985)

34. *Settlement Site*; pencil on paper, 48 x 74 cm. Private Collection, UK (1982)

35. *Bottle Beach Settlement 1*; mixed media on board, five pieces: *Salt*, 41 x 23 x 5 cm; *Bone*, 41 x 23 x 5 cm; *Ritual*, 72 x 47 x 5 cm; *Shell*, 41 x 23 x 5 cm; *Bottle Find*, 41 x 23 x 5 cm (1988)

36. *Bottle Beach Settlement 2*; mixed media on board, five pieces: *Sand*, 41 x 23 x 5 cm; *Water*, 41 x 23 x 5 cm; *Measurements*, 87 x 36 x 5 cm; *Flint*, 41 x 23 x 5 cm; *Pigment*, 41 x 23 x 5 cm (1988)

37. *Bottle Beach Settlement 3*; mixed media on board, five pieces: *Bronze*, 41 x 23 x 5 cm; *Skin*, 41 x 23 x 5 cm; *Warfare*, 60 x 46 x 5 cm; *Clay*, 41 x 23 x 5 cm; *Charcoal*, 41 x 23 x 5 cm (1988)

38. *Fisherman Listening for Herring*; found objects and acrylic on board, 34 x 39 x 2.5 cm. Private Collection, London (1988)

39. *Nostalgic Locker*; carved and painted wood and found objects, 56 x 30 x 15 cm. Private Collection, Scotland (1976)

40. *Ray Fish Shrine*; painted wood, metal and bone, 61 x 41 x 15 cm. Arts Council of Great Britain, London (1976)

41. *Rudder Requiem*; painted wood and metal, 50 x 43 x 12 cm. Private Collection, Cambridge (1985)

42. *Skye Fisherman: In Memoriam*; collage, found objects and acrylic on board, 135 x 125 x 6 cm. McManus Gallery, Dundee (1989)

43. *Sea Lectern*; sculpture, painted wood, bone and resin, 27 x 20 x 30 cm. Private Collection, London (1989)

44. *Navigator's Locker*; carved and turned wood, bone and ivory, 64 x 56 x 25 cm. Private Collection, USA (1982)

45. *Diviner's Wall*; mixed media construction, 162 x 162 x 8 cm (1992)

46. *Window Visitation, North Uist*; carved and painted wood, 104 x 46 x 18 cm. Inverness Museum and Art Gallery (1980)

47. *Two Sights of the Sea*; pencil, 48 x 75 cm approx. Private Collection (1982)

48. *China Nights*; painted wood and mirrors, 85 x 61 x 10 cm. Glasgow Art Gallery and Museum (1983)

49. *Wheelhouse Triptych*; carved and painted wood, bone and slate, three parts (a) 122 x 91 x 16 cm; (b) 122 x 61 x 10 cm; (c) 122 x 61 x 10 cm. Private Collection, UK (1981)

50. *Wheelhouse Study II*; carved, painted wood and collage with resin, 96 x 71 x 7 cm. Kirkcaldy Museum and Art Gallery (1981)

51. The wheelhouse of the *Fortitude*; photograph for the Ring-Net taken by the artist (1973)

52. *Log Book I – Polar Voyage*; painted wood, canvas and mixed media, 112 x 82 x 7 cm. McMaster Museum, Hamilton, Ontario (1986)

53. *Log Book II – Winter Voyage*; painted wood, canvas and mixed media, 112 x 82 x 7 cm. McMaster Museum, Hamilton, Ontario (1986)

54. *Bard McIntyre's Box*; mixed media (leather, shell, resin, wood, wax), 61 x 46 x 7 cm. Scottish National Gallery of Modern Art, Edinburgh (1984)

55. *Pole Marker Triptych*; mixed media, carved and found objects, 3 pieces, each 160 x 19 x 7 cm. Private Collection, London (1987)

56. *Winter, North Atlantic*; painted wood and resin, 124 x 105 x 5 cm (1988)

57. *Arctic Sea Marker* – front; painted wood, lead, resin, bone and whalebone, 40 x 30 x 5 cm. Private Collection (1987)

58. *Stern-Sheet Icon*; painted wood, bone and resin, 36 x 33 x 4 cm. Private Collection (1987)

59. *Black Vessel Foundering*; mixed media sculpture, 30 x 39 x 58 cm (1994)

60. *Fisherman's Log*; mixed media and pencil on board, 122 x 122 x 10 cm. Private Collection, Germany (1987)

61. *Leviathan Elegy*; painted whalebone and found objects on three panels, each 76 x 46 x 10 cm – each. Aberdeen Museum and Art Gallery (1982)

62. *Arctic Signs No. 3 Line Box*; painted wood and bone, 48 x 33 x 7 cm. Collection Marian Leven, Tayport (1984)

63. Study for *Arctic Signs No. 3 Line Box*; page from a sketchbook, pen and blue wash, 14.4 x 20.8 cm (1984)

64. *Arctic Signs No. 4 – Mayday*; painted wood and bone, 38 x 28 x 7 cm. Private Collection (1986)

65. *I didn't go willingly, I went sadly* (Detail); carved and painted wood and photo-etching, 61 x 40 x 10 cm. Private Collection (1983)

66. *Death Fish Study II*; pencil, 34 x 56 cm. British Museum (1983)

67. *Death Fish*; collage and found objects, 42 x 69 x 5 cm. Collection David Gilbert, Germany (1983)

68. *Inner Sound*; painted wood, 70 x 50 x 10 cm. Private Collection (1984)

69. *Hebridean Cruise*; painted wood and found objects, 54 x 40 x 8 cm. Private Collection, Chicago (1985)

70. *Hunter's Vision*, pencil, 76 x 98 cm. Private Collection, London (1989)

71. *Winter Kyle Elegy*; pencil, 220 x 98 cm. BBC Scotland (1989)

72. *Central Park*; acrylic paste, plaster and wood on hardboard, 52 x 30 x 4.5 cm. (1989)

73. *Manhattan*; mixed media, acrylic casts and collage on wood and board, 90 x 24 x 6.5 cm. Private Collection, San Francisco (1988)

74. *Nantucket Front and Back*; mixed media sculpture, painted wood, bone and resin, 82 x 14 x 14 cm. Private Collection, London (1989)

75. *Fisherman with Coalfish*; painted resin and zinc, 33 x 36 x 4 cm. Private Collection (1990)

76. *Island Ferry – Cape Cod*; mixed media construction, 39 x 32 x 6 cm. Private Collection (1990)

77. *Bone Circle*; mixed media on board, 42 x 36 x 4 cm. (1990)

78. *Sea-Creed Banner*; found objects, painted wood and metal, 86 x 40 x 25 cm. (1984)

79. *Enigmatic Figure*; carved and painted wood, 128 x 30 x 41 cm. Private Collection, London (1984)

80. *Ancestor Figure*; painted wood, 152 x 18 x 6 cm. Upsala Ekeby Ltd, Stockholm (1986)

81. Study for *Ancestor Figure*, page from a sketchbook, pen and wash, 14.4 x 20.8 cms (1986)

82. *King Fisherman*; acrylic and acrylic casts on board, 42 x 33 x 3 cm. Private Collection, London (1989)

83. *The Archaeology of Childhood*; found objects and acrylic on paper and wood, 125 x 109 x 8 cm (1989)

84. *Red Ley Marker*; mixed media on board, 136 x 105 x 7 cm. Fleming Wyfold Art Foundation, UK (1989)

85. *Bird Altar*; acrylic and wood on board, 38 x 103 x 28 cm. Private Collection, London (1988)

86. *Memorial for a Clearance Village*; found and painted objects, wood and bone, 58 x 41 x 8 cm. Private Collection, Edinburgh (1974)

87. Study for etching, *The Melancholy of Departure*; page from a sketchbook, pen and wash, 14.4 x 20.8 cm (1986)

88. *The Melancholy of Departure*; etching, edition of 45, 46 x 35 cm (1986)

89. *Froach*, coloured etching from *A Night of Islands*, suite of ten, 80 x 55 cm (1991)

90. *The King's Fish*, coloured etching from *A Night of Islands*, suite of ten, 80 x 55 cm (1991)

91. *A Highland Woman*, coloured etching from *A Night of Islands*, suite of ten, 80 x 55 cm (1991)

92. *The Author of this is the Bard McIntyre*, coloured etching from *A Night of Islands*, suite of ten, 80 x 55 cm (1991)

93. *Trio*, coloured etching from *A Night of Islands*, suite of ten, 80 x 55 cm (1991)

94. *Strathnaver*, coloured etching from *A Night of Islands*, suite of ten, 80 x 55 cm (1991)

95. *Adam's Clan*, coloured etching from *A Night of Islands*, suite of ten, 80 x 55 cm (1991)

96. *The Emigrant Ship*; mixed media on board with slate and wood, 120 x 240.5 x 12 cm, Private Collection, UK (1992)

97. *Temple Vessel* (reworked); found objects and acrylic on board, 152 x 122 x 15 cm (1992)

98. *Ex-Voto South Minch*; mixed media construction, 182 x 147 x 3 cm. Private Collection, London (1993)

99. *Totem Head*; mixed media construction, 24 x 13.5 x 30.5 cm (2001)

100. *Ocean Letter* 43 x 35 x 6 cm. Private Collection, London (1999)

101. *Bureau Veritas*; mixed media construction, 87 x 56 x 7 cm. Private Collection, USA (1995)

102. Sketch for the *Pairc Cairn* (1994)

103. The *Aignish Cairn* (1996)

104. The *Griais Cairn* (1996)

105. *Religio Scotica/The Artifacts of Ceremony*; 3 parts, all mixed media and acrylic on wood, 35 x 26 x 8 cm. Complete work in a Private Collection, London (1992)

106. *Religio Scotica/The Mask of Absolution*; 3 parts, all mixed media and acrylic on wood, 35 x 26 x 8 cm (1992)

107. *Religio Scotica/The Rituals of Myth*; 3 parts, all mixed media and acrylic on wood, 35 x 26 x 8 cm (1992)

108. *Religio Scotica/The Salmon of Knowledge*; 3 parts, all mixed media and acrylic on wood, 35 x 26 x 8 cm (1992)

109. *Canada Passage/Cholera Bay*; mixed media construction, 54 x 36 x 7 cm. Private Collection, UK (1994)

110. *Yellow Quarantine Bird II*; mixed media construction, 46 x 41 x 7 cm (1995)

111. *Anchorite Triptych*; mixed media construction, 84 x 174 x 6 cm. Private Collection, UK (1996)

112. *Sea Hermit*; mixed media construction, 27 x 38 x 7 cm. Private Collection, London (1996)

113. *Nautilus Aground*; mixed media construction, 99 x 58 x 10 cm. Private Collection, London (1998)

114. *Blue Men of the Minch*; painted construction, 70 x 102 x 6 cm. Private Collection, London (1995)

115. *The Last Voyage of Henry Hudson*; mixed media construction, 44 x 78 x 8 cm. Private Collection, UK (1994)

116. *North West Passage/Arctic Route*; mixed media construction, 73 x 101 x 7 cm. Fleming Wyfold Art Foundation (1994)

117. *Ice Master's Log*; mixed media construction, 65 x 85 x 6 cm. Private Collection, London (1996)

118. *Little Star Atlas/Triangulum*; mixed media construction, 33 x 43 x 4 cm. Private Collection, UK (1998)

119. *Atlantic Messengers/Sula Sgeir*; mixed media sculpture, 106 x 30 x 16 cm (1998)

120. *Atlantic Messengers/Hirta*; mixed media construction, 104 x 30 x 15 cm (1998)

121. *Atlantic Messengers/Fulmarus*; mixed media construction, 108 x 34 x 15 cm (1998)

122. Installation photograph, *Atlantic Messengers* (1998), *Driftworks,* Dundee Contemporary Arts (2001)

123. *Journey 1*, from a series of six; mixed media construction, 88 x 70 x 3 cm (2000–01)

124. *Journey 2*, from a series of six; mixed media construction, 88 x 70 x 3 cm (2000–01)

125. *Nomad Trace*; mixed media on board, two panels: each 122 x 244 x 5 cm (2001)

126. *Crux* (in collaboration with Andy Rice and Gerald Mair); digital animation, projected to 236 x 156 cm (2001)

127. *Sea Chant Diptych*; mixed media construction, 72 x 122 x 10 cm. Private Collection, UK (2000)

128. *Cod Requiem* (in collaboration with Andy Rice); digital animation, projected to 3.4 x 4.5m (2001)

129. *Objects of Unknown Use*; gallery installation, 150 x 100 cm (2001)

130. *Fish Traps*; mixed media construction, 25 x 60.5 x 5 cm (2000)

131. *Objects of Unknown Use*; gallery installation, 4 x 24 x 40 cm (2001)

132. *New World Museum*; mixed media construction, 24 x 37.5 x 30.5 cm. Private Collection, UK (2000)

133. *Objects of Unknown Use (works in progress)*; studio installation (2001)

134. *Found Objects/Hooks*; Newfoundland cod-jiggers

135–140. *Driftworks: Pages from a Library* (2000), a collection of images published in *Driftworks* catalogue (2002)

– BIOGRAPHY OF THE ARTIST –

1941 Born Inverness
Education, Inverness Royal Academy

1957–59
HMS *Conway*, N. Wales
Midshipman, Blue Funnel Line, Liverpool
Received Able Seaman Certificate

1961–65
Diploma and Postgraduate diploma, Gray's
 School of Art, Aberdeen
Rowney Paint Prize; Hospitalfield
 Scholarship, Arbroath; George Davidson
 Memorial Scholarship

1966
Scottish Education Department,
 Travelling Scholarship to Greece, Italy
 and France
Studied at British School in Rome

1968
Ring-net fisherman, Skye
Married Marian Leven

1969
Elected Professional Member, Society of
 Scottish Artists
Dundee College of Education, Certificate of
 Secondary Education
Taught in various Fife primary schools

1971
Appointed teacher of art at Bell Baxter High
 School, Cupar, Fife

1973
Scottish Education Trust major bursary to
 study ring-net herring fishing
Elected Associate of the Royal Scottish
 Academy

1974
Worked on *Ring-Net* project

1979
Scottish Arts Council Visual Arts Bursary
Glasgow Group, Benno Schotz Prize

1981
Appointed Lecturer, Fine Art, Duncan of
 Jordanstone College of Art, Dundee
Moved to Tayport, Fife

1985
Scottish Arts Council Printmakers' Bursary,
 Dundee

1987
Publication of Catalogue Raisonné by Claus
 Runkel

1988
Visit to Maritime Museums in North
 America funded by Sir William Gillies
 Bequest, Royal Scottish Academy

1991
Elected Royal Scottish Academician
Publication of *A Night of Islands*, Paragon
Press

1992
Scottish Arts Council Award
Critics Award for Best Exhibition at the
Edinburgh Festival
Publication of *Symbols of Survival* by Duncan
Macmillan, S.A.C. Spring Book Award

1994
Senior Lectureship Drawing and Painting
Appointed Professor of Fine Art, Duncan of
Jordanstone College of Art, Dundee

1996
Member of The Royal Glasgow Institute of
the Fine Arts
Member of the Visual Arts Committee of
the Scottish Arts Council

1997
Civic Trust Award
Scottish Natural Heritage Supreme Award
for three memorial cairns
Member of the Royal Scottish Society of
Painters in Water-colour

1998
Spirit of Scotland Award for achievement in
Art, *Scotland on Sunday*/Glenfiddich

2000
Lottery fund/Scottish Arts Council *Creative
Scotland Award*
Honorary Doctor of Letters, University of St
Andrews
Emeritus Professor of Visual Arts, University
of Dundee
Senior Research Fellow, University of Dundee

2001
Publication of *Cardinal Points*, North Dakota
Museum of Art

2002
May Marshall Brown Award, Royal Scottish
Society of Painters in Water-colour

SOLO EXHIBITIONS
*indicates an exhibition which was
accompanied by a publication, details of
the most important catalogues are given
in the Bibliography.

1967
British School, Rome

1968
New 57 Gallery, Edinburgh

1970
Richard Demarco Gallery, Edinburgh

1971–73
Loomshop Gallery, Lower Largo, Fife

1978
Ring-Net, Third Eye Centre, Glasgow

1979
Compass Gallery, Glasgow
Gilbert Parr Gallery, London

1983
*Will Maclean: Constructions and Small
Sculptures*, Richard Demarco Gallery,
Edinburgh
Landmark Centre, Carrbridge

1984
Will Maclean: Constructions and Drawings,
Retrospective Loan Exhibition, Kirkcaldy
Museum and Art Gallery
Downing College, University of Cambridge

1986
The Ring-Net, Richard Demarco Gallery,
Edinburgh; Leeds Art Gallery; Inverness
Art Gallery; Campbeltown Museum and
Tarbert Gallery

1987
*Claus Runkel Fine Art, London
The Ring Net, one-man exhibition, Scottish
Gallery of Modern Art, Edinburgh

1990
*Runkel-Hue-Williams, Old Bond Street,
London

1991
Runkel-Hue-Williams, Old Bond Street,
London
Cyril Gerber Fine Art, Glasgow

1992
*Retrospective Exhibition, Edinburgh
Festival, Talbot Rice Gallery, Edinburgh;
Art Space, Aberdeen; Kelvingrove Art
Gallery, Glasgow; Highland Regional
Council tour

1993
Kelvingrove Art Gallery and Museum,
Glasgow
Tour to Wick, Thurso, Kingussie and
Inverness
*A Night of Islands/ Elegy to the Scottish
Landscape, Crawford Art Centre, St Andrews

1994
New Hall, St Andrews University
Comhairle Nan Eilean, Harris Festival

1995
*Voyages, Art First, London
Gallery Gilbert, Dorchester
*Eigse Carlow International Arts Festival
(invited artist), Eire
An Lanntair Gallery, Stornoway
Gallery Gilbert, Dorchester
*Selected Affinities, Professorial Exhibition,
Duncan of Jordanstone College of Art,
Dundee
'Scottish Festival' (invited artist with John
Bellany), State University of New York at
Binghampton

1998
Duan an T-Sean Mharaiche, Drawings for the
Ancient Mariner, An Lanntair Gallery,
Stornoway
*Cardinal Points, North Dakota Museum of
Art, Grand Forks, USA; toured to
McMaster Museum, Hamilton, Ontario,
Canada
*Atlantic Messengers, Art First, London

1999
Cardinal Points, Art Gallery of Newfoundland
and Labrador, St John's, Newfoundland,
Canada
Landmarks and Seamarks, Bourne Fine Art,
Edinburgh

2000
Seaways, Art First, London

2001
Driftworks, Dundee Contemporary Arts

2002
Driftworks, St Magnus Festival Exhibition,
Pier Art Centre, Stromness, Orkney
Driftworks, Art First, London

2003
Driftworks, Art First New York

SELECTED GROUP EXHIBITIONS
*indicates an exhibition which was
accompanied by a publication in which a
work or works is illustrated or reference is
made to the artist. The most important
are listed in the Bibliography.
Will Maclean exhibits annually at the Royal
Scottish Academy and has also exhibited
regularly at the SSA and RGI.

1972
Four Figurative Painters, Demarco Gallery,
Edinburgh
MacLeod/Maclean, New 57 Gallery,
Edinburgh

1974
Dallas Brown/Maclean, Stirling Gallery

1975
Six Coastal Artists, Saltire Society, Edinburgh
A Choice Selection, Fruitmarket Gallery
Opening Exhibition, Edinburgh
200 Years of Scottish Painting, Marjorie Parr
Gallery, London

1976
The Need to Draw, Scottish Arts Council
Touring Exhibition

1977
Inscape, Scottish Arts Council Exhibition, selected by Paul Overy, Fruitmarket Gallery, Edinburgh; Warehouse, Covent Garden; and Ulster Museum, Belfast

1978
Scottish Arts Council Travelling Gallery Opening Exhibition
Painters in Parallel, Scottish Arts Council, Edinburgh College of Art

1980/81/82
International Art Fair, Basle; represented by David Gilbert Gallery, London and Germany

1980
Compass Gallery, Glasgow, touring exhibition to Denmark

1981
Art and the Sea, Third Eye Centre, Glasgow, touring exhibition UK

1982
Inner Worlds, Arts Council of Great Britain, touring exhibition UK
Artists' Boxes, Xavier Berg Gallery, London
Artender '82, Bilbao, Spain
Mises en Boîte, touring exhibition, Belgium

1983
Dusseldorf Arts Fair, with Leinster Fine Art
Six Scottish Artists, Cavallino Gallery, Venice
Bath Arts Fair, with Leinster Fine Art
Leinster Fine Art, London

1984
Barbican Art Fair, with Leinster Fine Art
Scottish Contemporary Arts in London and Washington: Will Maclean/Barbara Rae, Leinster Fine Art, London and V.N. Gallery, Alexandria, Virginia
A Festival of Scottish Drawing, Fine Art Society, Edinburgh

1985
Hallaig, works for the film on the work of Sorley MacLean, directed by T. Neat

Focus on Landscape, Fremantle, Australia, touring exhibition
Scottish Contemporary Drawings, Fair Maids Gallery, Perth
10th Anniversary Exhibition, Third Eye Centre, Glasgow
Represented Leinster Fine Art at the Chicago International Art Exposition
Work for National Trust Collection exhibited at Scottish National Gallery of Modern Art

1986
Wood Works, touring exhibition, Liverpool, Edinburgh and Inverness Art Galleries
International Contemporary Art Fair, London
Group exhibition, Leinster Fine Art, London
Contemporary Art from Scotland, Leinster Fine Art
Group exhibition, Simon Neuman Gallery, New York
As An Fhearann (From the Land), An Lanntair Gallery, Stornoway; Royal Scottish Museum, Edinburgh; touring exhibition to Canada

1987
Will Maclean/Italio Scanga, Simon Neuman Gallery, New York
Scottish Contemporary Art, Clare College, Cambridge
Wood Works, mixed exhibition, Bluecoats Gallery, Liverpool; City Art Centre, Edinburgh
Group exhibition, Leinster Fine Art, London
Contemporary Art from Scotland, Leinster Fine Art, London
International Contemporary Art Fair, London
Mixed Exhibition, C.D.R Fine Art, London
Wrought Wood, Bolton Art Gallery
Dundee Artists, Clare College, Cambridge
The Chosen Few, Open Eye Gallery, Edinburgh
Round the Scottish Coasts, Peacock Printmakers, travelling exhibition

1988
The Scottish Show, touring exhibition, Wales
Garden Exhibition, Fine Art Society, Glasgow

Homage to MacDiarmid, Richard Demarco
 Gallery, Edinburgh
Edinburgh Printmakers, Workshop Festival
 Exhibition
Modern Masters I, Claus Runkel Fine Art Ltd
Modern Masters II, Claus Runkel Fine Art Ltd
Clean Irish Sea, Greenpeace, Dublin, Cardiff
 and touring England and Germany
Scottish Art, Middlesbrough Art Society
Opening Exhibition, Barbizon Gallery,
 Glasgow
State of the Art, Fine Art Society in
 Edinburgh and Glasgow
**Scottish Art Since 1900*, Scottish National
 Gallery of Modern Art and Barbican
 Gallery, London
Into the Highlands, Dundee City Art Gallery
A Song of the Sea, Barrack Street Museum,
 Dundee
The Stevenson Collection, Warwick Arts Trust,
 London

1990
From the Director's Chair, Open Eye Gallery,
 Edinburgh
Edinburgh Printmakers in London, Vanessa
 Devereux Gallery, London
Boxes and Totems, England & Co., London
London Contemporary Arts Fair, Olympia,
 with Runkel-Hue-Williams
Jordanstone Folio, a collaboration with
 Writer-in-Residence Valerie Gillies
 included in the *Kindred Spirits* exhibition,
 Ancrum Gallery and Dundee College of
 Art
**Boîtes et Reliefs* (four-person show), Gallerie
 de la Gare, Bonnieux, France
**Scotland's Pictures*: *The National Collection*,
 Royal Scottish Academy, Edinburgh
Gallery Artists, Runkel-Hue-Williams,
 London
**Glasgow's Glasgow: Art in the North*, The
 Arches, Glasgow
**Scotland Creates: 5,000 Years of Scottish Art
 and Design*, McLellan Galleries, Glasgow

1991
The Artist and the Whale, Dundee Art Gallery
Gallery Artists, Runkel-Hue-Williams,
 London
Wood Works, Warehouse Gallery, Covent

Garden, London
*Towards a New Decade: 20th Century Scottish
 Art*, Fine Art Society, Glasgow and
 Edinburgh
Scottish Art in Budapest, Richard Demarco
 Gallery, touring exhibition to Hungary
Will Maclean: A Night of Islands, Runkel-
 Hue-Williams, London
New Prints, Cyril Gerber Fine Art, Glasgow
Myth and Symbol, Highland Regional
 Council, touring exhibition
**20th Century Scottish Art*, South-West
 Academy of the Arts, Bristol
**Virtue and Vision: Sculpture and Scotland*,
 National Gallery of Scotland in the Royal
 Scottish Academy
Art in Boxes, England & Co., London
**The Artist as Voyager: Will Maclean and
 Richard Demarco*, Art Space, Aberdeen and
 Richard Demarco Gallery, Edinburgh
**The First 100 Years*, Society of Scottish
 Artists Centenary Exhibition
The Scottish Artists and Artist Craftsmen
 Exhibition (invited artist)

1992
*Scottish Selection, Counter Pointing – New Art
 from Scotland*, Collective Gallery,
 Edinburgh
Printmaking in Scotland, Westgate Gallery,
 North Berwick
Scotland in New Europe, Richard Demarco
 Gallery, Edinburgh
Sotheby's London Art Exhibition
The Scottish Gallery Christmas Exhibition,
 Edinburgh
Guardian Art, London
Private Art Market with Louise Pickering
 Gallery
Paragon Press Print Fair, Royal Academy,
 London
**The Line of Tradition: Watercolours,
 Drawings, Prints from the Collection of the
 Scottish National Galleries 1700–1990*,
 National Gallery of Scotland, Edinburgh
Launch Exhibition, Stones and Samson,
 Glasgow
Gallery Artists, Michael Hue-Williams Fine
 Art, London

1993

Netherbow Art Gallery, Edinburgh

The Winter Collection, Cyril Gerber Fine Art, Glasgow

Shore Lines: *The Sea's Influence in Scottish Art*, City Art Centre, Edinburgh

Celtic Connections, Glasgow Royal Concert Hall

Opening Exhibition, Gallery Artists, Art First, London

Personal Choice, Midlands Contemporary Art, Birmingham

1994

Worlds in a Box, Arts Council of Great Britain, South Bank Centre, London; City Art Centre, Edinburgh; Graves Art Gallery, Sheffield; Sainsbury's Centre for the Visual Arts, University of East Anglia; Whitechapel Gallery, London

Aberdeen Artists' Annual Exhibition

Artists' Sketch Books, Opening Exhibition, Nancy Smillie Gallery, Glasgow

Cancer Research Exhibition, Dundee University Gallery

Howard, McCulloch, Maclean: 3-Man Exhibition, Andrew Lamont Gallery, London

11 out of 10: Critics Choice, N.S. Gallery, Glasgow. Selected by Clare Henry

Artists' Responses to Beuys, The Demarco European Art Foundation, Edinburgh

Contemporary Scottish Prints, Peacock Printmakers, North Berwick

Invited Artist, Harris Festival Association, Rodel, Harris

Will Maclean: Religio Scotica, Front Room Focus, Art First, Cork Street, London

Scandex Scottish Sculpture, Opening Exhibition, Aberdeen Art Gallery, touring to Scandinavia

Mixed Exhibition, Cyril Gerber Fine Art, Glasgow

Absolute Secrets, Royal College of Art, London

1995

Celtic Connections, Glasgow Royal Concert Hall

Scottish Prints, Riverside Gallery, Stonehaven

London Contemporary Art Fair, Islington, with Art First

Recent Scottish Art, McManus Gallery, Dundee

Contemporary British Art in Print, Scottish National Gallery of Modern Art and Talbot Rice Gallery, Edinburgh

Scandex: Contemporary Scottish Sculpture, touring exhibition, Stavanger Kulturhus, Norway; Konstans Hus Lulea, Sweden; Kemin Taidemuseo, Kemi, Finland

Opening Exhibition, Gallery Gilbert, Dorchester

Calanais/The Atlantic Stones, An Lanntair Gallery, Stornoway; Interceltique Festival, Lorient, France

Gulbenkian Suite, Highland Printmakers, Inverness

Prints from Scottish Workshops, Crawford Art Centre, St Andrews

Strongly Recommended, Gallery Artists, Art First, London

Royal Hibernian Academy, Dublin (invited artist)

Gathering: *Scottish Printmaking*, Gallery Beeldspraak, Amsterdam

The Beltane Spirit, New Highland Art, Brown's Gallery, Tain

Drawings from the R.S.A., Riverside Gallery, Stonehaven

Found in Scotland: Harvey, Rae, Maclean, Lawrence, McAlister, Art First, London

The Call of the Sea, Invited Artist, Open Eye Gallery, Edinburgh

Winter Exhibition, Gallery Artists, Art First, London

Art Lotto, The Collective Gallery, Edinburgh, supported by the S.A.C.

Twelve Artists explore Alchemical Transformations, Cooper Gallery, Dundee

1996

Calanais/The Atlantic Stones, Talbot Rice Gallery, Edinburgh; Dundee Art Gallery, touring exhibition

Art Miami, Miami International Art Fair with Art First

London Contemporary Art Fair, Islington, with Art First

New Prints: The Day of The Dead, Galeria Otravez, East Los Angeles and Glasgow Print Studio

Contemporary Scottish Artists, Kirkcaldy Art Gallery

Jake Harvey and Will Maclean, New Sculpture and Constructions, Art First, London
*Peacock 21, Aberdeen Art Gallery

1997
Back to Nature, Art First, London
*Three Years On, Art First, London
Art '97, London Contemporary Art Fair, Islington, with Art First
*Six Irish/Six Scottish Artists, The Glebe Gallery, Kilkenny, Ireland
*River Deep and Mountain High: Scottish and Native American Artists, Highland Region Touring Exhibition
Homage to St Columba, Richard Demarco Gallery, Edinburgh

1998
Carmina Gadelica, Art.t.m., Inverness Art Gallery and touring
Artists' Books, Fruitmarket Gallery, Edinburgh
Moby Dick, Suite of etchings, James Dunn's House, Aberdeen; Edinburgh Book Festival and touring
The Scottish Collection, City Art Centre, Edinburgh
20th Century Art, The Smith Gallery, Stirling
Cabinet Paintings, Compass Gallery, Glasgow
Summer Exhibition, Royal Academy, London
*This Island Earth, Launch Exhibition, An Tuireann Gallery, Isle of Skye
Transistors: New Small Sculpture From Scotland, Morioka Hashimoto Museum of Art, Japan and Iwate Art Festival UK '98

1999
*Daimh – Affinity, Opening Exhibition, Arainn Chaluim Chille and An Tuireann Gallery, Isle of Skye
*Projects, Opening Exhibition, Dundee Contemporary Arts, print commission with John Burnside
*Liberation and Tradition: Scottish Art 1963–1975, Aberdeen Art Gallery, Dundee Art Gallery
Modern British and Contemporary Painting, Art First, London
'Spark 'o Nature's Fire': Contemporary British Art, Mercer Gallery, Harrogate

*Scotland's Art 1600–2000, City Art Centre, Edinburgh
Modern and Contemporary British Art, Art First, London
Transistors: Small Sculpture from Scotland, Royal Scottish Museum, Edinburgh and Trondheim, Trondhjems Kunstforeing, Norway
The Need to Draw, Open Eye Gallery, Edinburgh
Contemporary Icons, Riverside Gallery, Stonehaven
The 20th Century British Art Fair, Royal College of Art, London, with Art First
Cabinet Paintings, Compass Gallery, Glasgow

2000
Art 2000, London Contemporary Art Fair, Islington, with Art First
A Recent Gift, The Scottish Arts Council Bequest to the City of Edinburgh, City Art Centre, Edinburgh
*Expressions: Scottish Art 1976–1989, Aberdeen Art Gallery and Dundee Contemporary Arts
Mary R: Images of a Queen, touring exhibition, Bourne Fine Art, Edinburgh, and Paris

2001
Starting a Collection, Art First, London
Art First New York, New York, USA
St Kilda: Islands of Isolation, Taigh Chearsabhagh Gallery, North Uist with Elizabeth Ogilvie, Douglas Dunn and Kenneth Dempster

2002
H₂O Water's Edge, Art First, London
Starting a Collection, Art First, London
Summer at Art First New York: Contemporary British and American Painting, Art First, New York
Beyond Conflict, Richard Demarco touring exhibition
*NEW: Recent Acquisitions of Contemporary British Art, Scottish National Gallery of Modern Art, Edinburgh
*Kilkenny Arts Festival, Ireland (invited artist)
*An Leabhar Mor na Gaelic/The Great Book of

Gaelic, touring exhibition UK, USA and
Canada
Painting in Dundee, Fleming Wyfold
Foundation, London and Dundee
University

SITE INSTALLATIONS AND PUBLIC ART
1994
*Completion and opening of
Cuimhneachain Nan Gaisgeach Memorial
Cairn, the *Pairc Cairn*, Balallan, Isle of
Lewis

1996
*Completion and opening of the Memorial
Cairn at Aignish, Isle of Lewis and
Cuimhneachain Nan Gaisgeach Memorial
Cairn at Griais River, Isle of Lewis

WORKS IN PUBLIC AND CORPORATE
 COLLECTIONS
Aberdeen Art Gallery
Aberdeen City Libraries
Argyllshire Education Trust
Art Gallery of Newfoundland and Labrador
Arts Council of Great Britain
BBC Scotland
British Transport
British Museum
Broadford Hospital, Skye
Carlow Town Collection, Ireland
Contemporary Art Society
Clare College, Cambridge
Comhairle Nan Eilean, Isle of Lewis
Dumbarton Education Trust
Dundee District Council
Dundee University
Edinburgh City Art Gallery
Fanim Hall Collection, Vancouver, Canada
Ferens Art Gallery, Hull
Fife Education Authority
Fleming Wyfold Foundation, London
Fitzwilliam Museum, Cambridge
Glasgow Art Gallery, Kelvingrove
Government Art Collection, London
Highland Regional Council
Inverness Museum and Art Gallery
Inverness Education Authority
Isle of Man Arts Council

Kirkcaldy Museum and Art Gallery
King's College, Cambridge
Lille Art Gallery, Milngavie
McLaurin Art Gallery and Museum, Ayr
Maclean Art Gallery, Greenock
McManus Art Gallery, Dundee
McMaster University, Ontario, Canada
Motherwell District Council
Mitchell Library, Glasgow
National Library of Scotland
National Trust for Scotland
North Dakota Museum of Art, USA
Oldham Museum and Art Gallery
Perth Museum and Art Gallery
Peterhead Museum and Art Gallery
Reader's Digest Collection, USA
Royal Scottish Academy Collection
Rhode Island School of Design, USA
St Andrews University Collection
Scottish Arts Council
Scottish Craft Collection
Scottish Fisheries Museum
Scottish Life Collection, London
Scottish National Gallery of Modern Art
Scottish Office Collection, Edinburgh
Scottish Television
Smith Art Gallery, Stirling
Stoke on Trent Art Gallery
Scunthorpe Art Gallery
Texaco Collection
Westfield State Collection, Mass., USA
Western Isles Hospitals Collection,
 Stornoway
Yale Centre for British Art, New Haven, USA

CATALOGUES
(Catalogues of one- or two-person
 exhibitions, listed by author)

Gale, Iain, *Voyages*, Art First (London 1995)
Hunter, James, Macmillan, Duncan,
 Macdonald, Murdo, Normand, Tom,
 *Selected Affinities: A Collection of Articles on
 the Work of Will Maclean*, Duncan of
 Jordanstone College of Art (Dundee 1995)
Lucie-Smith, Edward, *Will Maclean and
 Barbara Rae, Scottish Contemporary Art in
 Washington and London*, Leinster Fine Art
 (London 1984)
McGrath, Tom and Maclean, Will, *Ring-Net*

Herring Fishing on the West Coast of Scotland: A Documentary Exhibition by Will Maclean, Third Eye Centre (Glasgow 1978), reissued by Runkel-Hue-Williams (London 1990)

Macmillan, Duncan, *Will Maclean: New Work*, Runkel-Hue-Williams (London 1990)

Neat, Tim and Maclean, Will, *Will Maclean: Constructions and Small Sculptures*, Richard Demarco Gallery (Edinburgh 1983)

Normand, Tom, *A Night of Islands*, Crawford Art Centre (St Andrews 1993)

Normand, Tom, *Atlantic Messengers*, Art First (London 1998)

Normand, Tom, *Will Maclean*, Taigh Chearsabhagh Trust (Lochmaddy 2001) – text extracted from *Atlantic Messengers*

Ness, Kim, *Driftworks*, Dundee Contemporary Arts (Dundee 2002)

Oliver, Cordelia, *Will Maclean: Constructions and Drawings*, Kirkcaldy Museum and Art Gallery (Kirkcaldy 1984)

Woods, Alan, *The Artist as Voyager: Will Maclean and Richard Demarco*, Peacock Printmakers (Aberdeen 1991)

OTHER IMPORTANT CATALOGUES WITH REFERENCES TO THE ARTIST

(Group, thematic exhibitions etc.)
Other catalogue references are indicated by an asterisk in the list of exhibitions

Campbell, Mungo, *The Line of Tradition*, National Galleries of Scotland (Edinburgh 1993)

Gordon, Lindsay (ed.), *Calanais*, An Lanntair Gallery, (Stornaway 1995)

Hartley, Keith, for the Scottish National Gallery of Modern Art, *Scottish Art Since 1900* (Edinburgh & London 1989)

Klepal, Jean, '*Boîtes et Reliefs*', Cahiers de la Gare, No. 15, Galerie de la Gare (Bonnieu 1990)

MacLean, Malcolm, (ed.), for An Lanntair Gallery, Stornoway, *As An Fhearann: From the Land* (Edinburgh 1986)

Macmillan, Duncan, *The Scottish Show*, Oriel (Bangor 1988)

Noble, Alexandra, for the South Bank Centre, London, *Worlds in a Box* (London 1994)

Oliver, Cordelia, *Painters in Parallel*, Scottish Arts Council (Edinburgh 1978)

Overy, Paul, *Inscape*, Scottish Arts Council (Edinburgh 1977)

Overy, Paul, *Inner Worlds*, ACBG (London 1982)

BOOKS/MONOGRAPHS

Macmillan, Duncan, *Symbols of Survival: The Art of Will Maclean* (Edinburgh 1992), paperback edition published as catalogue for *Retrospective Exhibition*, Talbot Rice Gallery, 1992

Reuter, Laurel, *Cardinal Points*, (North Dakota Museum of Art 2001)

Woods, Alan and Runkel, Claus, *Will Maclean: Sculptures and Box Constructions, 1974–1987*, with a Catalogue Raisonné, Claus Runkel Fine Art Ltd (London 1987)

REFERENCES AND ILLUSTRATIONS OF WORK IN BOOKS

Ashmore, Patrick, *Calanais: The Standing Stones* (Stornoway 1995)

Block, Jonathan and Leisure, Gerry, *Understanding Three Dimensions* (New York 1987), p60, black and white illustration of *Museum for a Seer*

Booth-Clibborn, Charles, *Contemporary British Art in Print*, (London 1995), pp154–9, colour illustrations of *A Night of Islands*

Buchanan, Joni, *The Lewis Land Struggle*, (Stornoway 1996), drawings by the artist

Gage, Edward, *The Eye in the Wind: Contemporary Scottish Painting Since 1945* (London 1977), pp74–5, black and white illustration of *Trap Image No. 3*

Gillies, Valerie, *The Chanter's Tune*, with pen drawings and cover by the artist (Edinburgh 1990)

Gillies, Valerie, *The Ringing Rock*, with pen drawings and cover by the artist (Aberdeen 1990)

Gillies, Valerie, *St Kilda Waulking Song*, with pen drawings and cover by the artist (Edinburgh 1998)

Hardie, William, *Scottish Painting from 1837*

to the Present (London 1990), pp196–206

Kaplan, Wendy (ed.), *Scotland Creates: 5,000 Years of Art and Design* (London 1990), pp178–80, colour illustrations of *Leviathan Elegy* and *Memories of a Northern Childhood*

McEwan, Peter, *Dictionary of Scottish Art and Architecture*, for the Antique Collectors Club (Suffolk 1994), p376

McGeoch, Brian and Porch, Steven, *Looking at Scottish Art* (Hove 1996), p28, colour illustration of *Leviathan Elegy*

McMaster University, *The Levy Legacy, McMaster Museum of Art* (Ontario 1987)

Macleod, Angus, *Cuimhneachain Nan Gaisgeach/ The Pairc Cairn* (Stornoway 1994) cover illustration and p2

Macleod, Angus, *Cuimhneachain Nan Gaisgeach/The Aignish Cairn* (Stornoway 1996)

Macmillan, Duncan, *Scottish Art 1460–2000* (Edinburgh 2000), pp396–8, colour illustration of *Skye Fisherman: In Memoriam*; p425, colour illustration of *Voyage of the Anchorites*

Macmillan, Duncan, *Scottish Art in the 20th Century* (Edinburgh 1994), p138, colour illustration of *Abigail's Apron*, p173, colour illustration of *The Emigrant Ship*, and second edition (Edinburgh 2001), p189, colour illustration of the *Pairc Cairn*, Lewis

O'Driscoll, Robert (ed.), *The Celtic Consciousness* (Edinburgh 1981), pp306–8, black and white illustrations of *The Elders*

Orel, Harold, Snyder, Henry and Stokstad, Marilyn, *The Scottish World* (London 1981) pp306–8, black and white reproduction of *Plate Rack*

Patrizio, Andrew, *Contemporary Sculpture in Scotland* (Sydney 1999), pp111–15, colour illustrations of *Calanais*, *Leviathan Elegy*; black and white illustrations of *Symbols of Survival* and the *Griais Cairn*

Spalding, Frances, *A Dictionary of Twentieth-Century British Art* (London 1991), p306

Spalding, J., *The First Years* (Glasgow 1996), p87, colour illustration of *China Nights*

Stephen, Ian, *A Semblance of Steerage* (Edinburgh 1991) an artist's book, poems by Ian Stephen with drawings by Will Maclean

Stephen, Ian, *Buoyage*, (Edinburgh 1993) an artist's book, poems by Ian Stephen with drawings by Will Maclean

Wishart, Anne and Oliver, Cordelia eds., *The Society of Scottish Artists: the First 100 Years* (Edinburgh 1990), p60, black and white illustration of *Window Visitation, North Uist*

SELECTED ARTICLES AND REVIEWS

Beaumont, Mary-Rose, 'Will Maclean at Runkel Fine Art', *Arts Review* (12 Sept 1987)

Beaumont, Mary-Rose, 'Will Maclean at Runkel-Hue-Williams', *Arts Review* (5 June 1990)

Cameron, Neil, 'Jet-set and Flotsam', *The Scotsman* (11 August 1999)

Cameron, Neil, 'They've Been Framed', *The Scotsman* (26 September 2000)

Cameron, Neil, 'Hooked Into Our Memories', *The Scotsman* (27 November 2001)

Campbell, Angus Peter, 'An Canan', *West Highland Free Press*, art supplement (March 1997)

Carr, Richard, 'Memorabilia of a Box Maker', *Craftwork* (May 1980)

Carr, Richard, 'The Work of Will Maclean', *Glasgow Herald* (13 April 1983)

Carr, Richard, 'Constructions that Disturb', *The Scotsman* (20 March 1990)

Clough, Juliet, 'Elegy for Fish', *Times Educational Supplement* (23 August 1974)

Cowan, Amber, 'Best Nationwide Shows', *The Times* (24 November 2001)

English, Shirley, 'New Pages of Gaelic History', *The Times* (26 August 2000)

Gage, Edward, 'Painting by Will Maclean at the New 57 Gallery', *The Scotsman* (19 April 1968)

Gale, Iain, 'Scotching the Myth', *The Independent* (3 September 1992)

Gale, Iain, 'Will Maclean', *Contemporary Art* (Winter 1995/6)

Gilchrist, Jim, 'Gael Power', *The Scotsman* (29 August 2000)

Gillies, Valerie, 'Will Maclean: Symbols of Survival', *The Green Book*, Vol. VIII, no. 9 (1991) with black and white illustrations of *Hallaig No. 4*, *Nantucket Front and Back* and *Pole Marker Triptych*

Henry, Clare, 'Will Maclean at the Richard

Demarco Gallery', *Glasgow Herald* (24 March 1983)

Henry, Clare, 'Will Maclean: The *Ring-Net* at the Scottish National Gallery of Modern Art'. *Glasgow Herald* (22 March 1986)

Henry, Clare, 'The Rise and Rise of the Scots', *Glasgow Herald* (7 June 1991)

Henry, Clare, 'These lands are our lands', *The Herald* (14 August 1999)

Hujer, Elaine, 'Cardinal Points', *McMaster Courier*, Canada, (8 March 1999)

Jeffrey, Moira, 'The Highland Gatherer', *The Herald* (30 November 2001)

Keller, Victoria, 'The Work of Will Maclean', *Scottish Life*, Vol. 4, No. 1 (1989) including colour illustrations of *Memorial for a Clearance Village*, *Memories of a Northern Childhood*, *Abigail's Apron* and *Leviathan Elegy*

Lack, Jessica, 'Pick of the week', *The Guardian* (26 November 2001)

Macdonald, Murdo, 'The Social Space in Scottish Art: A Study of David Wilkie', William MacTaggart, Will Maclean and George Wyllie', *Edinburgh Review* (November 1991), pp27–8

Mackenzie, Janet, 'Will Maclean: Driftworks' *Studio International*, www.studio-international.co.uk (January 2002)

Maclean, Will, 'The Artist's Eye', *Art Review* (November 1996)

Macmillan, Duncan, 'Monumental Struggle: The Lewis Cairns', *The Scotsman* (20 May 1996)

Macmillan, Duncan, 'Heads on a Block', *The Scotsman* (1 August 2000)

Macmillan, Duncan, 'The Survival of the Artist', *business a.m.*, (13 September 2000)

Mahoney, Elizabeth, 'Liberation and Tradition', *Scotland on Sunday* (14 June 1999)

Michie, Eileen, 'Will Maclean RSA', *Royal Scottish Academy Publication No. 19* (1991)

Mills, Karen, 'Cardinal Points', *Hamilton Spectator*, Canada (20 March 1999)

Murphy, Hayden, 'Allegories of a Dramatic Imagination', *Times Educational Supplement* (17 March 1995)

Neat, Timothy, 'Monumental Achievements', *The Sunday Times* (12 January 1997)

Oliver, Cordelia, 'Will Maclean at the Richard Demarco Gallery', *The Guardian* (20 April 1984)

Oliver, Cordelia, 'Will Maclean at the Third Eye Centre', *Artscribe*, No. II (1978)

Packer, William, 'Modern in Their Time: Christopher Wood and Will Maclean', *Financial Times* (10 June 1995)

Smith, W. Gordon, 'Poetry in Motion', *Scotland on Sunday* (7 June 1991)

Stephen, Ian, 'Letters from the Nor'west: Poetry and Prose from the Outer Hebrides', *Edinburgh Review* (1994), p131 illustration from artist's book *Buoyage*

Stephen, Ian, 'Lewis Land Raid Memorials', *Edinburgh Review* (June 1998)

Stevenson, Sylvia, 'Will Maclean at Claus Runkel Fine Art', *Galleries Magazine*, Vol. V, No. 4 (1987)

Stevenson, Sylvia, 'Will Maclean', *Apollo* (March 1990) including black and white illustrations of *Kyle of Little Bernera* and *Red Ley Marker*

Sutherland, Giles, 'Reeling In A Sea Change', *Sunday Herald* (25 November 2001)

Taylor, John Russell, 'Voyages: Will Maclean', *The Times* (23 May 1995)

Vaizey, Marina, 'Scottish Contemporary Art in Washington and London', *Arts Review* (November 1984)

Wenzowaki, Allyson, 'Cardinal Points', *Dundas News*, Canada (17 March 1999)

Wilson, Sue, 'Driftworks', *Metro* (4 January 2002)

Woods, Alan, 'Interview with Will Maclean', *Alba*, No. 9 (1988) with colour illustrations of *Pole Marker Triptych*, *Leviathan Elegy* and *Landscape and Totems*

FILM, RADIO AND TELEVISION

Will Maclean, produced by Nigel Finch, *Arena Fine Art*, BBC2 (1978)

Will Maclean, produced by Michael Paterson, *The Scottish Picture Show*, STV (1987)

Will Maclean, Grampian Television (1990)

Hallaig: Sorley MacLean, STV feature (1990)

A Night of Islands: Will Maclean, NB Arts Programme, STV (1992)

Will Maclean, Grampian Television feature (1992)

An Ataireachd Bhuan (The Eternal Sea) BBC Gaelic (1992)

Will Maclean, Strathclyde Region Video for Schools (1993)

Craobh An Eolais (The Tree of Knowledge), STV Series (1993)

An Oir (The Cave of Gold), Edinburgh Film Workshop Trust (1993)

Gach Stri A'rinn Iad: The Pairc Cairn and the Lewis Land Raids, STV, (1994)

Canan Nan Gailheal, STV (1994)

The Tree of Knowledge, Gaelic Arts, STV (1994)

BBC Radio Kaleidoscope Interview (1994)

8 Artists Around Scotland, BBC Scotland (1995)

Ian Anderson Show, BBC Scotland (1995)

Tacsi Gaelic Arts, Grampian Television (1997)

Nightwaves Interview, BBC Radio 3 (1998)

Conversation Pieces: Contemporary British Sculpture, BBC 2 (1998)

Shorelines, STV Film by Handpict Films, Edinburgh (1999)

Scottish Artists, Grampian Television (2000)

Brian Morton Show, with Marian Leven, BBC Radio Scotland (2001)

Ian Anderson Show, BBC Radio Scotland (2002)

DISSERTATIONS

Allerston, Patricia, *The Ring-Net by Will Maclean*, University of St Andrews (1990)

Ballantyne, P., *Will Maclean: A Night of Islands*, University of Aberdeen (1998)

Donaldson, Lara, *Images of the Highland Clearances: MacTaggart and Maclean*, University of Edinburgh (1992)

Frazier, R., *Seed of a World: The Art of Will Maclean*, National College of Art and Design, Ireland (1999)

Martin, C., *Will Maclean and Gaelic Culture*, University of Dundee (1999)

Payne, Judith, *Individual Constructs of Cultural Identity*, South West Polytechnic, Plymouth (1991)

– FOOTNOTES –

1. Ian Finlay, *Art in Scotland* (Oxford 1948)
2. Sir Archibald Geikie, *Scottish Reminiscences* (Glasgow 1908), p226
3. Ibid., p227
4. Neil Gunn, *Highland River* (London 1960), p121
5. Sorley MacLean, *The Cullin, From Wood to Ridge: Collected Poems in English & Gaelic* (London 1991), p111
6. Ibid., pxvi
7. Angus Martin, 'Dancers', *The Larch Plantation* (Edinburgh 1990), p53
8. MacLean, 'Hallaig', *Collected Poems*, p229
9. *Ken Dingwall*, Scottish Arts Council (1977), p14
10. *Sunday Times*, 9 March 1975
11. In *Inner Worlds* (ACGB) 1982
12. Lewis Grassic Gibbon, 'The Antique Scene', *Scots Hairst* (London 1967), p124
13. Ibid., p75
14. Jessie Weston, *From Ritual to Romance* (New York 1957), p124
15. Gunn, *Highland River*, p255
16. Ibid., p55
17. *A Drunk Man Looks at the Thistle, Complete Poems of Hugh MacDiarmid*, 2 vols., (London 1978), p139. As he so often does, MacDiarmid is here collaging someone else's poetry into his own and, as he indicates in a footnote, the first four lines are by the late nineteenth-century Anglo-Scottish poet, Robert Buchanan.
18. MacLean, 'The Selling of a Soul', *Collected Poems*, p15
19. MacDiarmid, *To Circumjack Cencrastus, Complete Poems*, I, p281
20. John Milton, *Comus*, lines 115–6
21. Gunn, *Highland River*, p215
22. Weston, *From Ritual to Romance*, p125
23. Ibid., 124
24. MacDiarmid, *To Circumjack Cencrastus, Complete Poems*, I, p289
25. John Gregorson Campbell, *Superstition of the Highlands and Islands of Scotland* (Glasgow 1900)

26 John Gregorson Campbell, *Witchcraft and Second Sight in the Highlands and Islands of Scotland: Tales and Traditions collected entirely from oral sources* (Glasgow 1902), p172

27 William J. Watson (ed.), *Scottish Gaelic Texts, Vol. I, Scottish Verse from the Book of the Dean of Lismore*, (Edinburgh 1937), p219

28 MacLean, *Collected Poems*, pp308–9

29 Ibid., p227

30 Gunn, *Highland River*, p125

31 MacLean, *The Cuillin, Collected Poems*, p121

32 George Campbell Hay, 'Clann Adhaimh', *Fuaran Sleibh* (Glasgow 1947), p20